PORTRAIT PHOTOGRAPHER'S HANDBOOK

Second Edition

Bill Hurter

AMHERST MEDIA, INC. ■ BUFFALO, NY

ABOUT THE AUTHOR

Bill Hurter is the editor of *Rangefinder* magazine. He is the former editor of *Petersen's PhotoGraphic,* and is a graduate of Brooks Institute of Photography, from which he holds a BFA in professional photography and an honorary Masters of Science degree. He has been involved in professional photography for more than twenty-five years. Bill is also the author of *The Best of Adobe® Photoshop®, Group Portrait Photography Handbook, The Best of Wedding Photography, The Best of Portrait Photography, The Best of Children's Portrait Photography, The Best of Wedding Photojournalism, The Portrait Photographer's Guide to Posing,* and *The Best of Teen and Senior Portrait Photography,* all from Amherst Media.

Copyright © 2005 by Bill Hurter
All rights reserved.

Front cover photograph by Fuzzy Duenkel.
Back cover photograph (top) by David Anthony Williams.
Back cover photograph (bottom) by Jennifer George Walker.

Published by:
Amherst Media, Inc.
P.O. Box 586
Buffalo, N.Y. 14226
Fax: 716-874-4508
www.AmherstMedia.com

Publisher: Craig Alesse
Senior Editor/Production Manager: Michelle Perkins
Assistant Editor: Barbara A. Lynch-Johnt

ISBN-13: 978-1-58428-140-5
Library of Congress Control Number: 2004101347

Printed in Korea.
10 9 8 7 6 5 4 3 2 1

Table of Contents

Introduction

Over the years, portrait and wedding photographers have moved away from the traditional style of portraiture. Contemporary styles have become more relaxed and less formal. What is gained is a level of spontaneity and naturalness that people seem to like. What is lost is the idyllic, structured ways of rendering the human form.

There are many reasons for the move to more casual styles. The influence of fashion photography, with its heavily diffused lighting and untraditional posing, is one. Another is the move by professional photographers to smaller formats—the medium format and 35mm. Film emulsions have improved dramatically over the last 15 years, making the 35mm and medium formats the preferred choices of the portrait photographer. The smaller format cameras give photographers a level of flexibility that lends itself toward shooting lots of film and many variations, including more spontaneous poses. Also, the advent of portable electronic flash, both on-camera and studio-type units, have made the modern-day portrait something that can be made anywhere, not just in a studio.

There is also no doubt that digital cameras have influenced the world of professional portraiture. Digital offers the portrait photographer flexibility and speed and, perhaps most important, the ultimate in creative control. The photographer can change from color to black & white on the fly, change white balance similarly, and there is no delay for processing, proofing, and printing. Both the photographer and the client can examine the captured images instantly, capitalizing on the excitement of the just-finished portrait session. Additionally, the daunting task of traditional retouching has all but been eliminated by Adobe® Photoshop® and its many tools and techniques. The special effects that were once the province of the accomplished darkroom technician are now routinely created quickly and expertly by the photographer in Photoshop.

Despite these technological advances, though, many of the techniques of the old-time portraitist have survived and are useful to today's photographers. The rudiments of posing and composition are timeless and date back to the beginnings of Greek civilization. This book attempts to com-

The advent of digital makes altering the reality of the image simple. In this award-winning image by Marcus Bell, the time of day and lighting angle have been altered in Photoshop. Even the location itself has been made to look more theatrical by the manipulations. Marcus darkened the image, which originally was rather flat, using traditional dodging and burning in Photoshop. He then combined a duplicate sepia layer and duplicate Gaussian blur layer until the final effect was achieved. He says of this image, "It's important for photographers to understand that capturing the image is only the first stage of many to produce a final image. I wanted to emphasize their fairy tale dresses, so I printed the image to reflect this."

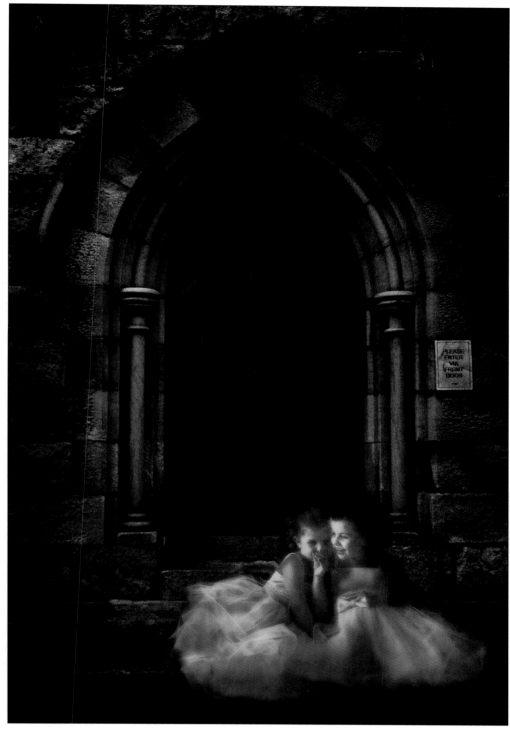

bine some of the time-tested disciplines with more contemporary methods in such a way that they will be useful to the modern-day photographer. The emphasis will be on techniques rather than on sophisticated studio equipment. After all, if a specific type of portrait can be made with two lights just as simply as with five lights, why not use the simpler setup?

It is not the intent of the author to impart a series of rules that must be followed without exception. Instead, this book was created to give photographers an understanding of the traditional rules so they may incorporate what they will into their individual repertoire of techniques. It is my hope that after reading this book and studying the award-winning images, you will

have a battery of knowledge that will enable you to produce pleasing, lasting portraits.

Author's Note:
This is the second edition of the *Portrait Photographer's Handbook*. While the focus of this new edition remains essentially on lighting, posing, and creativity for professional portraiture, one cannot ignore the fact that the world of professional photography has changed drastically in the past few years. When the first edition was published, digital capture and output were in use by only a select handful of photographers. Now, the digital medium is the order of the day. While the goal of the portraitist is still, above all other aims, to idealize the subject, the tools of today are not only more convenient, but they are vital to that primary task. As a result, many of the changes in both the imagery and text of this new edition of *Portrait Photographer's Handbook* reflect the ongoing move from film to digital.

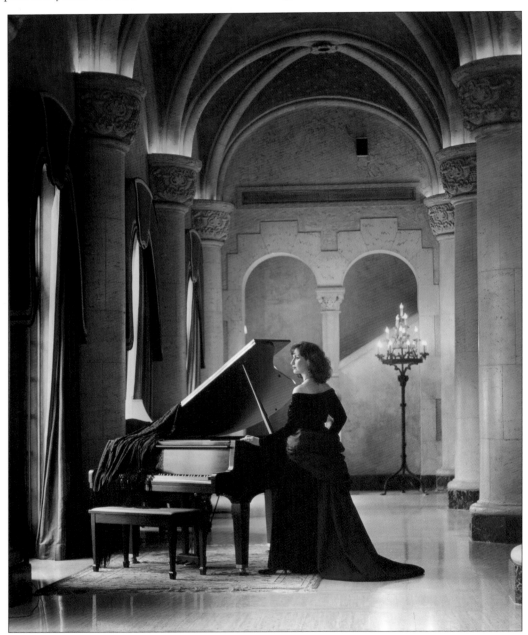

The fine portrait is a lasting work of art. Elegant posing and lighting and an acute sense of the environment make an outstanding image. Robert Lino used a Bronica SQ-Ai camera with a PS 80mm lens to create this image on Kodak Portra 400VC film. He then shot for $^1/_{15}$ second at f/4 using available light from windows and lamps plus a Lumedyne 50 watt-second barebulb flash as a fill light.

To illustrate this book, I have called upon some of the finest and most decorated portrait and wedding photographers in the country.

Some, like Monte Zucker and Bill McIntosh, are living legends among modern-day photographers. Most are not only gifted photographers but teachers as well, professionals who lecture throughout the country. Some are newcomers to the limelight. In all cases, though, their photography is exemplary. Many of the photographers included in this book have been honored by the country's top professional organizations, the Professional Photographers of America (PPA) and Wedding and Portrait Photographers International (WPPI).

I want to thank all of the photographers for their participation in this book. Without them, it would not have been possible. I would also like to thank my illustrator and wife, Shell, who provided the drawings throughout and helped me organize and fine-tune many facets of this book.

Michael J. Ayers, PPA-Certified, M.Photog.,Cr., APM, AOPA, AEPA, AHPA—WPPI's 1997 International Portrait Photographer of the Year, Michael Ayers is a studio owner from Lima, OH. He has lectured to other photographers about portraiture and his "Album Architecture" all across North America and has been a featured speaker in Europe.

Becker—Chris Becker, who goes by only his last name, is a gregarious, likeable wedding photojournalist who operates a hugely successful studio located in Mission Viejo, CA. He has been a featured speaker at WPPI (Wedding and Portrait Photographers International) and has also competed and done well in international print competition.

David Bentley—David Bentley owns and operates Bentley Studio, Ltd. in Frontenac, MO. With a background in engineering, he calls upon a systematic as well as creative approach to his assignments. Thirty years of experience and numerous awards speak to the success of this system.

Marcus Bell—There's something compelling about Marcus Bell's photography. His creative vision, fluid natural style, and sensitivity have made him one of Australia's most revered photographers. It's this talent combined with his natural ability to make people feel at ease in front of the lens that attracts so many of his clients. Bell's comprehensive portfolio of work clearly illustrates his natural flair and versatility. His work has been published in numerous magazines in Australia and overseas including *Black White*, *Capture*, *Portfolio Bride*, and countless other bridal magazines.

Don Blair—For about 50 years, the name Don Blair has been synonymous with fine portraiture, craftsmanship, and extraordinary contributions to the industry. Blair, is a master craftsman. Beyond that, he is a gifted and caring educator—hailed as a leader in this field—who has been unstinting in sharing his knowledge with pho-

tographers throughout the United States and in numerous other countries. It's no accident that in professional circles such as PPA (Professional Photographers of America), Camera Craftsmen of America, and WPPI he is among the most respected of all portrait photographers—affectionately known to many as "Big Daddy." Blair is also the author of *Seeing Light: The Art of Portrait Photography* (Amherst Media, 2004).

Anthony Cava B.A., MPA, APPO—Born and raised in Ottawa, Ontario, Canada, Anthony Cava owns and operates Photolux Studio with his brother Frank. Photolux was originally founded by their parents as a wedding and portrait studio 30 years ago. Anthony joined WPPI and the Professional Photographers of Canada 10 years ago. At 31 years old, he is the youngest Master of Photographic Arts (MPA) in Canada. He won the Grand Award at WPPI with the first print he ever entered in competition.

Michele Celentano—Michele Celentano graduated from the Germain School of Photography in 1991. She spent the next four years assisting and photographing weddings for other studios. In 1995, she started her own business photographing only weddings. In 1997, she received her certification from PPA. Michele has recently moved to Amaheim, AZ, where she is building a thriving business.

Tony Corbell—The owner of Corbell Productions in San Diego, CA, and former Director of Photographic Education for Hasselblad USA, Tony has spent over 24 years in the photographic industry. He came to be known as the "dean" of Hasselblad University, founded the International Wedding Institute, and prior to joining Hasselblad in 1993, was a faculty member at the prestigious Brooks Institute of Photography in Santa Barbara, CA. He is the author of *Basic Studio Lighting: The Photographer's Complete Guide to Professional Techniques* (Amphoto, 2001).

Jerry D—Jerry D owns and operates Enchanted Memories, a successful portrait and wedding studio in Upland, CA. Jerry has had several careers in his lifetime, from licensed cosmetologist to black-belt martial-arts instructor. Jerry has been highly decorated by WPPI and achieved many national awards since joining the organization.

Stephen Dantzig, Psy.D—Dr. Stephen Dantzig owns and operates a small commercial studio just north of Los Angeles. His work ranges from commercial fashion, to products and interiors, to executive portraits. He is the author of *Lighting Techniques for Fashion and Glamour Photography* (Amherst Media, 2005).

Terry Deglau—Terry Deglau has been a professional portrait photographer for over 40 years. He is the former manager of trade relations at Eastman Kodak Company and currently operates his own business in Pittsburgh, PA. Terry is a Rochester Institute of Technology graduate with a degree in photographic science, and also holds a marketing degree from the University of Pittsburgh. Terry has lectured extensively throughout the U.S. and the world.

William L. Duncan, M.Photog. CPP, APM, AOPM, AEPA—Bill Duncan was one of the original members of WPPI with three levels of achievement. He has been a consistent winner in print competitions from all organizations, and he is known around country for his unique images. He is an instructor of "Artistry in the Language of Light" seminars.

Fuzzy Duenkel, M.Photog., Cr., CPP—Fuzzy and Shirley Duenkel of West Bend, WI, operate a thriving portrait studio concentrating primarily on seniors. Fuzzy has been highly decorated by PPA, both nationally and in Wisconsin, having won nine Photographer of the Year, Best of Show, and Photographers' Choice awards at Wisconsin PPA senior folio competitions. Fuzzy has had twelve prints selected for the National Traveling Loan Collection, two for Disney's Epcot Center, one for Photokina in Germany, and one for the International Photography Hall of Fame and Museum in Oklahoma.

Scott Eklund—Scott Eklund makes his living as a photojournalist for the Seattle *Post-Intelligencer*. His work has appeared in numerous national publications. He specializes in sports, spot news, and feature stories, but recently got interested in photographing weddings, deciding that his skill set was "portable." He has now won numerous awards for his wedding photography, which relies on a photojournalist's sense of timing and storytelling.

Deborah Lynn Ferro—A professional photographer since 1996, Deborah calls upon her background as a watercolor artist. She has studied with master photographers all over the world, including Michael Taylor, Helen Yancy, Bobbi Lane, Monte Zucker, and Tim Kelly. In addition to being a fine photographer, she is also an accomplished digital artist. With her husband, Rick Ferro, she is the coauthor of *Wedding Photography with Adobe Photoshop* (Amherst Media, 2003).

Rick Ferro, CPP—Rick Ferro has served as senior wedding photographer at Walt Disney World. In his 20 years of photography experience, he has photographed over 10,000 weddings. He has received many awards, including Loan Collection and numerous awards from WPPI. He is the author of *Wedding Photography: Creative Techniques for Lighting and Posing* and coauthor of *Wedding Photography with Adobe Photoshop*, both published by Amherst Media.

Jennifer George Walker—Jennifer George Walker runs her studio out of her home in the San Diego, CA, community of Del Mar. The affluent neighborhood is close to the beach and a variety of beautiful shooting locations, and is lush with prospective clients. She has won the California Photographer of the Year, and been the winner of the People's Choice Award 2001 at the Professional Photographers of California Convention. In 2003, Jennifer was the Premiere category Grand Award winner. You can view more of Walker's images at www.jwalkerphotography.com.

Jerry Ghionis—Jerry Ghionis of XSiGHT Photography and Video started his professional career in 1994 and has quickly established himself as one of Australia's leading photographers. His versatility extends to the wedding, portrait, fashion, and corporate fields. Jerry's efforts were recognized in the industry, being honored with the 1999 AIPP (Australian Institute of Professional Photography) award for best new talent in Victoria. In 2002 Jerry won the AIPP Victorian Wedding Album of the Year, and in 2003 he won the Grand Award in the Album competition at WPPI.

Dale P. Hansen, PPA Certified, APM, AOPA—Dale Hansen holds bachelor's degree from Brooks Institute of Photography and has had many of his photographs published nationally, in such publications as *Audubon, National*

Geographic, World Book and the cover of *PPA Storyteller* in March 1999.

Claude Jodoin—Claude Jodoin is an award-winning photographer from Detroit, MI. He has been involved in digital imaging since 1986 and has not used film since 1999. He is an event specialist, and also shoots numerous weddings and portrait sessions throughout the year. You can e-mail him at claudej1@aol.com.

Giorgio Karayiannis—Giorgio Karayiannis is one of those rare photographers who specializes in editorial, fashion, advertising, commercial, *and* portrait photography—and is successful at each. He has been a technical photographic adviser for the Ilford Imaging Group International. He is recognized for his very strong ability to produce graphically intense images. He loves his work and has an unsurpassed enthusiasm for any assignment. His commitment to excellence has been widely recognized, and he was recently awarded the Australian Institute of Australian Photographers Editorial Photographer of the Year and AIPP Victorian Portrait Photographer of the Year. He has also been an award winner at WPPI.

Tim Kelly—Tim Kelly has won almost every available photography award (including PPA Loan Collection, Kodak Gallery, Gallery Elite, and Epcot Awards) and holds both the Master of Photography and Photographic Craftsman degrees. Kelly, a long time member of Kodak's Pro Team, has been under the wing of their sponsorship since 1988. In 2001, Kelly was awarded a fellowship in the American Society of Photographers and named to the prestigious Cameracraftsmen of America. Kelly Studio and Gallery in the North Orlando suburb of Lake Mary, FL, is the epitome of a high-end creative environment.

Brian King—Brian King of Cubberly Studios in Ohio began accumulating awards for his artwork in elementary school. He attended the Ohio Institute of Photography, graduating in 1994. He went straight to work at Cubberly Studios in Ohio, where he is still employed. Earning both his Certified Professional Photographer and Master of Photography degrees from PPA, he is a member of PPO-PPA Senior Photographers International and The American Society of Photographers.

Craig Larsen—Craig Larsen holds a degree in commercial/technical photography. In his 14 years as a professional photographer he has worked all over the world photographing weddings and events. He has received numerous awards from WPPI and is a frequent lecturer. He currently writes a column for the WPPI's *Photography Monthly* newsletter.

Robert Lino, M. Photo., Cr., PPA Cert., APM, AOPM, AEPA, FDPE, FSA—Robert Lino of Miami, FL, specializes in fine portraiture and social events. His style is formal and elegant, and his ability to capture feeling and emotion is evident in every image. Lino is a highly decorated photographer in national print competitions and is a regular on the workshop and seminar circuit.

Robert Love, APM, AOPA, AEPA, M.Photog, Cr. CPP and **Suzanne Love, Cr. Photog.**—Robert Love is a member of Cameracraftsmen of America, one of 40 active members in the world. He and his wife, Suzanne Love, create all of their images on location. Preferring the early evening "love light," they use no artificial lighting outdoors. This gives their images a feeling of romance and tranquillity.

Rita Loy—Rita Loy is the co-owner of Designing Portrait Images, along with her husband, Doug, in Spartanburg, SC. Rita is a 17-time recipient of Kodak's Gallery Award of Photographic Excellence, an eight-time winner of the Fuji Masterpiece Award, and she has been voted South Carolina's Photographer of the Year a record eight times. She has won awards, both national and regional, too numerous to mention. Rita is also a member of Kodak's prestigious Pro Team.

Charles and Jennifer Maring—Charles and Jennifer Maring own and operate Maring Photography Inc. in Wallingford, CT. Charles is a second-generation photographer, his parents having operated a successful studio in the New England area for many years. His parents now operate Rlab (www.resolutionlab.com), a digital lab that does all of the work for Maring Photography, as well as for other discriminating photographers needing high-end digital work. Charles Maring is the winner of the WPPI 2001 Album of the Year award.

Heidi Mauracher, M. Photog., Cr. CPP, FBIPP, AOPA, AEPA—The late Heidi Mauracher was one of the most acclaimed portrait and wedding photographers of our day. Her unique style earned her more accolades and awards from the professional organizations (PPA and WPPI) than any other contemporary photographer. Sadly, she lost her battle with cancer in 2003. She will be missed by all who knew her and knew her work—and especially by those of us fortunate enough to spend a few late nights talking with her about her passion and greatest love: photography.

William S. McIntosh, M.Photog., Cr., F-ASP—Bill McIntosh photographs executives and their families all over the U.S. and travels to England frequently on special assignments. He has lectured all over the world. His popular book, *Location Portraiture: The Story Behind the Art* (self-published) is sold in bookstores and other outlets around the country. His latest book, *Classic Portrait Photography: Techniques and Images from a Master Photographer,* was published in 2004 by Amherst Media.

Caresse Muir—Caresse Muir, of San Diego, CA, began her home-based business seven years ago specializing in family, high school senior, and children's portraits. Four years ago she began photographing weddings as well. She strives to get to know her clients during their photo sessions, believing that it helps her obtain more natural expressions from them. She belongs to several professional photographic organizations.

Ferdinand Neubauer, PPA Certified, M.Photog.Cr., APM—Ferdinand Neubauer, started photographing weddings and portraits over 30 years ago. He has won many awards for photography on state, regional, and international levels. He is also the author of *The Art of Wedding Photography* and *Adventures in Infrared* (both self-published). His work has appeared in numerous national publications and he has been a speaker at various photographic conventions and events.

Dennis Orchard—Dennis Orchard is an award-winning photographer from Great Britain. He has been a speaker and an award winner at WPPI conventions and print competitions. He is a member of the British Guild of portrait and wedding photographers.

Parker Pfister—Parker Pfister is the consummate wedding photographer. Located in Hillsboro, OH, he also shoots weddings in neighboring states and is quickly developing a

national celebrity. He is truly passionate about what he does and can't imagine doing anything else (although he also has a beautiful portfolio of fine-art nature images). Visit: www.pfisterphoto-art.com

Norman Phillips, AOPA—Norman Phillips has been awarded the WPPI Accolade of Outstanding Photographic Achievement (AOPA). He is a registered Master Photographer with Britain's Master Photographers Association, a Fellow of the Society of Wedding and Portrait Photographers, and a Technical Fellow of Chicagoland Professional Photographers Association. He is a frequent contributor to photographic publications, a print judge, and a guest speaker at seminars and workshops across the country. Phillips is also the author of *Lighting Techniques for High Key Portrait Photography, Lighting Techniques for Low Key Portrait Photography,* and The Wedding and *Portrait Photographer's Legal Handbook* (all from Amherst Media).

Joe Photo—Joe Paulcivic III is a second-generation photographer who goes by the name of Joe Photo, his license plate in high school. He is an award-winning wedding photojournalist from San Juan Capistrano, CA. Joe has won numerous first place awards in WPPI's print competition and his distinctive style of wedding photography reflects the trends seen in today's fashion and bridal magazines. The images are spontaneous and natural rather than precisely posed.

Fran Reisner—Fran Reisner is an award-winning photographer from Frisco, TX. She is a Brooks Institute graduate and has twice been named Dallas Photographer of the Year. She is a past president of the Dallas Professional Photographers Association. She runs a highly successful low-volume portrait and wedding business from the studio she designed and built on her residential property. She has won numerous state, regional, and national awards for her photography.

Patrick Rice, M.Photog.Cr., CPP, AHPA—Patrick Rice is an award-winning portrait and wedding photographer with over 20 years experience. A popular author, lecturer, and judge, he presents programs to photographers across the United States and Canada. He has won numerous awards in his distinguished professional career, including the International Photographic Council's International Wedding Photographer of the Year Award, presented at the United Nations. He is the author of *Professional Photographer's Guide to Success in Print Competition* and *Professional Digital Imaging for Wedding and Portrait Photographers* (both from Amherst Media).

Kimarie Richardson—Kimarie Richardson owns and operates Fantasy Stills by Kimarie in Ukiah, CA. She is a professionally trained makeup artist and self-taught photographer who made the transition to full-time photography nine years ago. She is well known in the Northern California area, and more recently nationally, for her hand-painted Angel Baby portraits, children's portraits, and 1940's style Hollywood glamour photographs. Last year, she entered an international print competition for the first time and won the Grand Award for her print *Angelica's Light.* She is the author of *Fantasy Portrait Photography,* from Amherst Media.

Brian and Judith Shindle—Brian and Judith Shindle own and operate Creative Moments in Westerville, OH. This studio is home to three enterprises under one umbrella: a working photography studio, an art gallery, and a full-blown event planning business. Brian's work has received numerous awards from WPPI in international competition.

Joseph and Louise Simone—Joseph and Louise Simone of Montreal, Quebec, Canada, are two marvelous international photographers and teachers. They have been a team since 1975, the year they established their Montreal studio. The Simones constantly strive to give their clients a true work of art, a portrait that will pull at their heartstrings and command a very special position within the home or office—much like painted portraits have throughout history. When such a portrait is created, pricing is not an issue. The Simones have lectured in France, Italy, Spain, Belgium, Germany, Austria, Martinique, Guadeloupe, and the United States.

Kenneth Sklute—Beginning his wedding photography career at 16 in Long Island, NY, Kenneth quickly advanced to shooting an average of 150 weddings a year. He purchased his first studio in 1984 and soon after received his masters degree from PPA. In 1996, he moved to Arizona, where he enjoys a thriving business. Kenneth is much decorated, having been named Long Island Wedding Photographer of the year 14 times, PPPA Photographer of the year, and APPA Wedding Photographer of the Year. He has also won numerous Fuji Masterpiece Awards and Kodak Gallery Awards.

David Anthony Williams, M.Photog. FRPS—David Anthony Williams owns and operates a wedding studio in Ashburton, Victoria, Australia. In 1992, he achieved the rare distinction of Associateship and Fellowship of the Royal Photographic Society of Great Britain (FRPS) on the same day. Through the annual Australian Professional Photography Awards system, Williams achieved the level of Master of Photography with Gold Bar—the equivalent of a double masters degree. In 2000, he was awarded the Accolade of Outstanding Photographic Achievement from WPPI. He was also a Grand Award winner at the WPPI annual convention in both 1997 and 2000.

Robert Williams—Robert Williams operates a successful studio in northeast Ohio with two state-certified professional photographers, each with over 15 years experience. His studio photographs children, families, seniors, and corporate clients (including General Tire, Xerox, and Holiday Inn). For further information, visit www.robertwilliamsstudio.com.

Monte Zucker—When it comes to perfection in posing and lighting, timeless imagery, and contemporary yet classic photographs, Monte Zucker is world famous. He's been bestowed every major honor the photographic profession can offer, including WPPI's Lifetime Achievement Award. In his endeavor to educate photographers at the highest level, Monte has become a partner with Gary Bernstein in producing how-to information on their web site, www.Zuga.net.

1. Equipment and Basic Techniques

A good portrait conveys information about the person's "self." Through controlled lighting, posing, and composition, the photographer strives to capture the essence of the subject, all at once recording the personality and the likeness of the subject.

With a solid knowledge of professional equipment, portrait techniques, and a good rapport with your subject, you can create an image that is pleasing and salable—one that the subject will cherish.

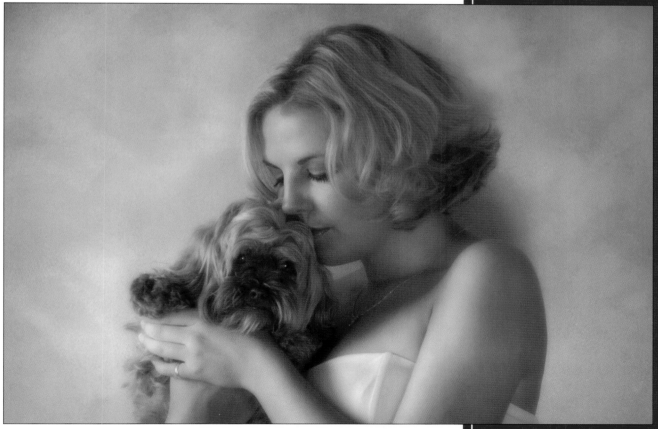

The days of needing medium format to create a large enough negative to accommodate retouching are pretty much over. Digital files can be made to virtually any size and the retouching and artistry that are possible in Adobe Photoshop and Corel Painter are more comprehensive than could have ever been accomplished traditionally. This beautiful portrait was made by Fuzzy Duenkel.

□ CAMERA/FILM SIZE

Large Format. Large-format cameras and films—4 x 5-inches and larger—were traditionally used in portrait studios to provide greater technical accuracy and the ability to retouch the film. However, there are a great many limitations to using large format. In addition to the high costs and technical skill involved, spontaneity suffers as a result of the subject having to remain motionless once the image is focused on the camera's groundglass.

Small and Medium Format. Small- and medium-format cameras have fully replaced larger formats in professional portraiture. Soft-focus lenses, diffusion filters, matte boxes, vignetters, bellows lens shades and many other professional accessories are now available in the smaller formats, making them every bit as versatile as large-format cameras.

In the past, one of the biggest drawbacks of the 35mm format was the inability to retouch the negative. Problems like wrinkles, lines, and age spots, simply cannot be retouched out on a 35mm negative. On medium-format negatives, you can do minimal retouching, provided the head size is large enough on the negative. The small-format user, knowing the limitations of traditional retouching tools, would opt for some alternative method.

Digital. One of the greatest assets of digital capture is the ability to instantly preview images on the camera's LCD screen. If you miss the shot for whatever reason, this means that you can delete that file and redo it right then and there. That kind of insurance is priceless. For example, imagine you are working outdoors using flash-fill. You examine the first couple of frames and find that the color balance is too cyan because of the color of the shade you are working in. Having noticed the problem immediately, you can just

Medium- and small-format cameras make it possible to see the subject's expressions right up to the precise moment of exposure, making spontaneity possible. Here, available light was combined with a silver reflector used from the side. The image was shot by Michele Celentano using a Bronica SQ-Ai camera with a 110mm lens. The film was Fuji NHG II 800, and the image was exposed at $^1/_{15}$ second at f/8.

make a quick adjustment to the white balance and be ready to continue shooting. When you review the next frame, though, you find the flash output is a half stop too weak. You can then review the image histogram (a graphic representation of the tones captured in the digital file) to confirm that there's a problem, then simply adjust your flash output to correct it. With digital, instead of waiting a week or two to see that you blew it, you can adjust things and move on with the knowledge that your exposures and lighting will be flawless.

□ LENSES

Image Stabilization. One of the greatest enhancements in lens design has been the advent of the image stabilization lens, which counteracts camera movement, allowing the photographer to handhold the

camera and shoot at impossibly slow shutter speeds of $\frac{1}{15}$, $\frac{1}{8}$, or $\frac{1}{4}$ second without encountering any image-degrading camera movement. Such lenses provide the ability to shoot in low light at maximum apertures and still obtain sharp images in very low light levels. Currently Nikon and Canon offer such lenses for their systems.

Focal Length. Portraiture requires that you use a longer-than-normal lens, particularly for head-and-shoulders portraits. The rule of thumb with film cameras and lenses is to choose a lens that is twice the diagonal of the film format you are using. For instance, with the 35mm format, a 75–85mm lens is a good choice for portraits; for the 2¼-inch square format (6x6cm), a 100–120mm lens is fine; for 2¼ x 2¾-inch cameras (6x7cm), a 110–135mm lens is a good choice.

A short telephoto provides normal perspective without subject distortion. If you are using a "normal" focal-length lens (50mm in the 35mm format, 75–90mm in the medium formats) you have to move too close to the subject to provide an adequate image size for a head-and-shoulders portrait. This proximity to the subject tends to exaggerate the subject's features—the nose appears elongated, the chin often juts out, and the back of the subject's head may appear smaller than normal. The short telephoto provides a greater working distance between camera and subject, while increasing the image size to ensure the proper perspective.

You can achieve good results with a much longer lens—if you have the working room. A 200mm lens, for example, is a beautiful portrait lens for 35mm be-

The fast film, lenses, motor drives, and shutter speeds of the 35mm SLR, the photojournalist's predominant tool, make it possible to create wonderfully spontaneous images like this. Photograph by Craig Larsen.

When making three-quarter- or full-length portraits, the camera's "normal" lens provides the most visually acceptable perspective. Here, a 100mm lens was used on a Hasselblad (6x6cm) camera. A Leon Vignetter in a Lindahl lens shade was used darken the corners of the image on the negative, thus focusing more attention on the bride. Kodak T400CN film, rated at 320 ISO, was used. To create the shot, Ferdinand Neubauer used a Speedotron flash system, employing four lights (a hair light, background light, key light, and fill light).

cause it provides very shallow depth of field and allows the background to fall completely out of focus, providing a backdrop that won't distract from the subject. When used at wide-open apertures, this focal length provides a very shallow band of focus that can be used to accentuate just the eyes, for instance, or just the frontal planes of the subject's face. Alternately, it can be used to selectively throw certain regions of the face out of focus.

You should avoid using extreme telephotos (longer than 300mm for the 35mm format), however, for several reasons. First, the perspective becomes distorted.

Depending on the working distance, the subject's features may appear compressed, with the nose often appearing pasted to the subject's face, and the ears of the subject appearing parallel to the eyes. Second, when you use such a lens, you have to work a long distance away from the subject, making communication next to impossible. You want to be close enough to the subject so that you can converse normally without shouting out posing instructions.

When making three-quarter- or full-length portraits, it is advisable to use the normal focal-length lens for your camera. This lens will provide normal perspective because you are farther away from your subject than when making a head-and-shoulders shot. The only problem you may encounter with the normal lens is that the subject may not separate visually from the background. It is desirable to have the background slightly out of focus so that the viewer's attention is drawn to the subject, rather than to the background. With the normal lens, the depth of field is slightly greater, so that even when working at relatively wide lens apertures like f/4, it may be difficult to separate subject from background. This is particularly true when working outdoors, where patches of sunlight or other distracting background elements can easily detract from the subject.

When making group shots, you are often forced to use a wide-angle lens. The background problems discussed above can be even more pronounced with such a lens, but a wide-angle is often the only way you can fit the entire group into the shot and still maintain a decent working distance for good composition.

Digital Cameras and Focal Length. Digital cameras use sensors and not film. This is an obvious point, but it has important consequences for lens selection. Although full-size image sensors now exist (the same size as a 35mm frame), most imaging sensors are smaller. While this does not necessarily affect image quality or file size, it does affect the effective focal length of the lens. With sensors that are smaller than a 35mm frame, all lenses get effectively longer in focal length. This is not usually a problem where telephotos and telephoto zooms are concerned, but when your expensive wide-angles or wide-angle zooms become significantly less wide on the digital camera body, it can be

somewhat frustrating. With a 1.4x focal-length factor, for example, a 17mm lens becomes a 24mm lens.

Focusing. Generally speaking, the most difficult type of portrait to focus precisely is a head-and-shoulders portrait. It is important that the eyes and frontal features of the face be tack sharp. It is usually desirable for the ears to be sharp as well (but not always).

When working at wide lens apertures where depth of field is reduced, you must focus carefully to hold the eyes, ears, and tip of the nose in focus. This is where a good knowledge of your lenses comes in handy. Some lenses will have the majority of their depth of field behind the point of focus; others will have the majority of their depth of field in front of the point of focus.

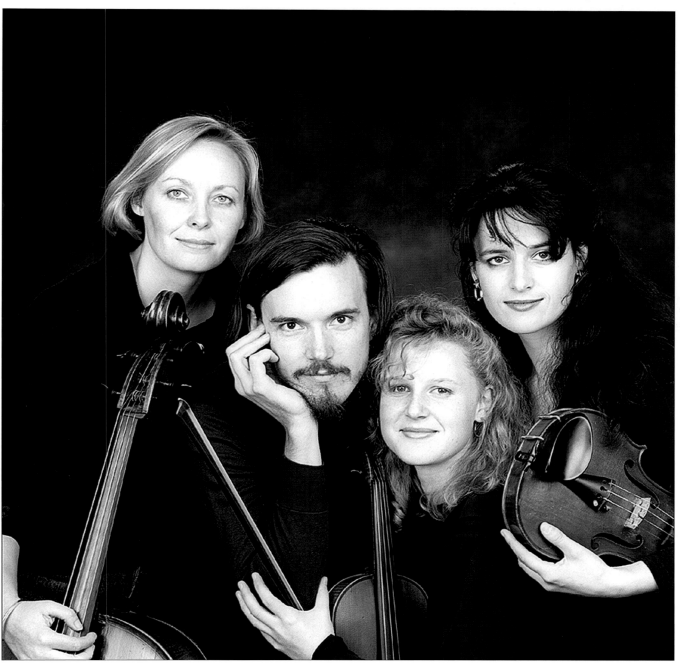

When shooting digitally, the size of the imaging chip (often smaller than the conventional 35mm frame) increases the effective focal length of your lens by a factor of 1.2 to about 1.8. Thus, a 50mm f/1.2 "normal" lens becomes an f/1.2 portrait lens in the 75–80mm range. This marvelous portrait of a string quartet was made by Australian photographer David Williams with a Fujifilm FinePix S2 digital camera and Sigma DG 24–70mm f/2.8 zoom.

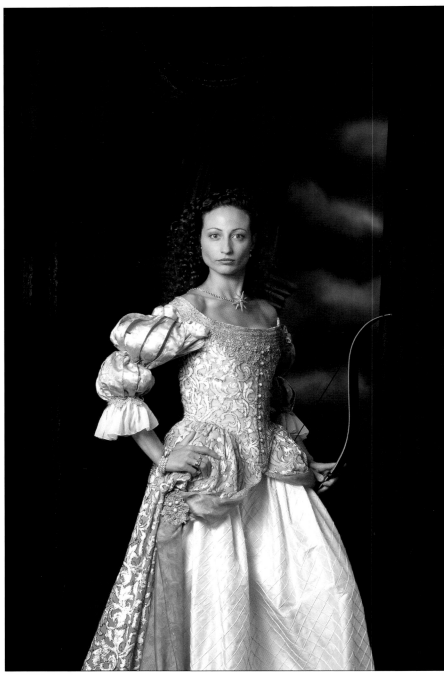

This image by David Williams, entitled *Winter* was inspired by Vivaldi's *The Four Seasons*—its passions, the visuals it can create, its elegance, and its varieties. The subject is portrayed as *Diana the Huntress*, after the painting by Sir Peter Lely (1618–1680). The image was made as a 17.8Mb TIFF file with a Fujifilm Finepix S1 Pro and Sigma DG 24–70mm zoom lens. Studio lighting was used. The image required very sharp focus to hold the distance from the right hand to the left, which holds "Dianna's" bow. Beyond that, Williams wanted the background to fall out of focus, offering only shapes and color, but no vivid details. An f/8 aperture provided the necessary depth of field. As this portrait demonstrates, knowing what areas must be sharp and what areas should not be sharp is essential to creating a memorable portrait.

This will generally keep the full face and the main center of interest, the eyes, in focus. The eyes are a good point to focus on because they are the region of greatest contrast in the face, and thus make focusing simple. This is particularly true for autofocus cameras that often seek areas of contrast on which to focus.

Focusing a three-quarter- or full-length portrait is a little easier because you are farther from the subject, where depth of field is greater. Again, you should split your focus, halfway between the forward most and farthest points that you want sharp on the subject.

Autofocus (AF), once unreliable and unpredictable, is now thoroughly reliable and extremely advanced. Some cameras feature multiple-area autofocus so that you can, with a touch of a thumbwheel, change the active AF sensor area to different areas of the viewfinder (the center or outer quadrants). This allows you to "de-center" your images for more dynamic compositions. Once accustomed to quickly

In most cases, the depth of field is split 50–50; half in front of and half behind the point of focus. It is important that you know how your different focal-length lenses operate. And it is important to check the depth of field with the lens stopped down to your taking aperture, using your camera's depth-of-field preview control.

Assuming that your depth of field lies half in front of and half behind the point of focus, it is best to focus on the subject's eyes in a head-and-shoulders portrait.

changing the AF area, this feature becomes an extension of the photographer's technique.

Autofocus and moving subjects used to be an almost insurmountable problem. While you could predict the rate of movement and focus accordingly, the earliest AF systems could not. Now, however, almost all AF systems use a form of predictive autofocus, meaning that the system senses the speed and direction of the movement of the main subject and reacts by tracking the focus of the moving subject. This is an ideal feature for activity-based portraits, where the subject's movements can be highly unpredictable.

A new addition to autofocus technology is dense multiple sensor-area AF, in which an array of AF sensor zones (up to 45 at this writing) are densely packed within the frame, making precision focusing much faster and more accurate. These AF zones are user selectable or can all be activated at the same time for the fastest AF operation.

Depth of Field. This is a good place to discuss some basic points about lenses and depth of field.

First, shorter lenses have much greater apparent depth of field than telephotos. This is why so much attention is paid to focusing telephoto lenses accurately in portraiture.

Second, the closer you are to your subject, the less depth of field you will have. When you are shooting a tight face shot, be sure that you have enough depth of field at your working lens aperture to hold the focus fully on the subject's face.

Third, medium-format lenses have less depth of field than 35mm lenses. A 50mm lens on a 35mm camera will yield more depth of field than the equivalent focal-length lens (75mm) on a medium-format camera—even if the lens aperture and subject distance are the same. This is important because many photographers feel that going to a larger format will improve the quality of their portraits. While this is true in as much as the image will appear improved simply by the increase in film size, it must also be noted that focusing becomes much more critical with the larger format.

Learn to use your lens's depth of field scale. When the lens is stopped down with the depth of field preview, the viewfinder screen is often too dim to gauge depth of field accurately. So learn how to read the scale quickly, and practice measuring distances mentally. Better yet—learn the characteristics of your lenses. You should know what to expect, in terms of both sharpness and depth of field, at your most frequently used lens apertures and shooting distances.

Shooting Apertures. Choosing the working lens aperture is often a function of exposure level. In other words, you often don't always have much of a choice in the aperture you select, especially when using electronic flash or when shooting outdoors.

Here is an example of an incredible job of focusing and use of available depth of field. The eyes and highlighted regions of the face are the primary points of focus, but sharp focus extends throughout the image. Careful adjustment of the point of focus will make optimum use of the depth of field of the shooting aperture, in this case, f/8. Norman Phillips used a Pentax 645 camera with a 150mm lens to create this image. Kodak VPS, rated at ISO 100, was exposed for $^1\!/_{60}$ second at f/8. The main light was a double-scrimmed (diffused) 28-inch softbox set at f/8. A "snooted" hair light set at f/8 was used slightly behind subject. (Note: a snoot is a conical reflector that is placed on the lamp housing to narrow the beam of light.)

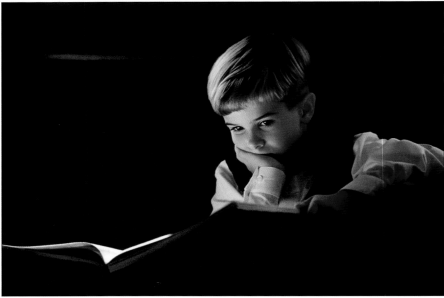

TOP—An image like this would not be possible without the action-stopping power of electronic flash. According to the photographer, Dale Hansen, "This photograph illustrates the importance of catching the peak of action. If you try to capture the peak of action as you see it, you will miss it. If you've seen it with your eyes, you've missed it with the camera. I always anticipate the peak of action so when it happens, my finger is already depressing the shutter." Dale used a Hasselblad camera with an 80mm lens to create this image. The lighting was overcast with flash fill. The exposure was $1/500$ second at f/8, with the flash set to f/5.6 output. The portrait was created using Kodak PMC 400 film.

BOTTOM—Norman Phillips created this dynamic portrait in the boy's home. Norman has been photographing this boy for his parents since the boy was a baby. The light emanates from two large bay windows on either side of the room. The lighting produced an aperture of f/6.3 (key side of face) and f/5.6 (fill side). The exposure was $1/60$ second at f/6.3 on a Pentax 645 camera with 150mm lens.

When you do have a choice, though, experts say to choose an aperture that is $1\frac{1}{2}$ to 2 full f-stops smaller than the lens's maximum aperture. For instance, the optimum lens aperture of an f/2 lens would be around f/4. A lens used wide open (at its maximum aperture) theoretically suffers from spherical aberration; a lens at its smallest apertures—f/16 or f/22—suffers from diffraction. Both of these conditions reduce the overall sharpness of the recorded image.

Expert portrait photographer Fuzzy Duenkel always shoots at f/4, even though his lenses are all

f/2.8 or faster. The reason, he says, is to cover any autofocusing errors that may occur. The slight increase in depth of field afforded by the smaller lens aperture can compensate for minor focusing errors.

The optimum aperture, however, may not always be small enough to provide adequate depth of field for a head-and-shoulders portrait, so it is often necessary to stop down. These apertures are small enough to hold the face in focus, but not small enough to pull the background into focus. They usually also allow for the use of a fast enough shutter speed to stop subtle camera or subject movement. Note that the use of optimum lens apertures is dependent on the overall light level and the ISO you are using.

The trend in contemporary portraiture is to use wide apertures with minimal depth of field. The effect is to produce a thin band of focus, usually at the plane of the eyes. One of the by-products of shooting wide open is a blurred background, which can be quite appealing when working outdoors.

▫ SHUTTER SPEEDS

The old studio portrait photographers used to have a saying, "Shoot everything at $\frac{1}{10}$ at ten." This meant use a shutter speed of $\frac{1}{10}$ second at an aperture of f/10, the optimum aperture for the slower, large-format portrait lenses. If your camera is tripod-mounted and the subject is completely still during exposure, $\frac{1}{10}$ second is a suitable shutter speed. This combination, however, is *not* suitable for virtually any other situation.

You must choose a shutter speed that stills camera and subject movement. If you are using a tripod, $\frac{1}{30}$–$\frac{1}{60}$ second should be adequate to stop average subject movement. If you are using electronic flash, you are locked into the flash-sync speed your camera calls for unless you are "dragging" the shutter, meaning, working at a slower than flash sync speed to bring up the level of ambient light. This effectively creates a flash exposure blended with an ambient-light exposure.

When working outdoors you should generally choose a shutter speed faster than $\frac{1}{60}$ second, because slight breezes will cause the subject's hair to flutter, producing motion during the moment of exposure.

If you are not using a tripod, the general rule is to use a shutter speed that is the reciprocal of the focal

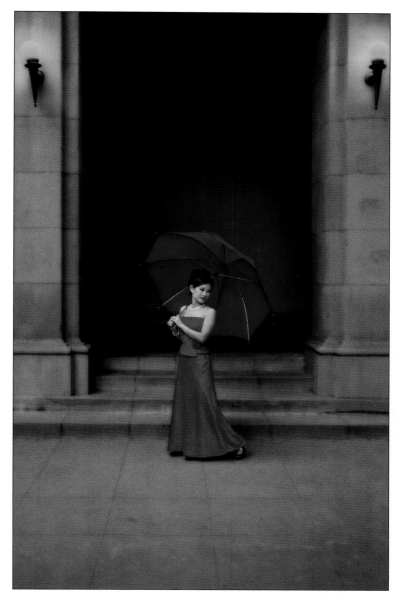

Jerry D likes to work late in the day—almost at dusk—to incorporate different light sources in his images, like the globe lights in this image. His shutter speeds are long, from $\frac{1}{30}$ to $\frac{1}{8}$ second, and his apertures are minimal—usually around f/4. This image was made in open shade at a government building in Riverside, CA. In Photoshop, he darkened and softened the stone work and added texture with grain. He also enhanced the contrast and saturation of the subject and umbrella. He helped the lights out by adding a touch of yellow to the globes.

length of the lens you are using for a shutter speed. For instance, if using a 100mm lens, use $\frac{1}{100}$ second (or the next highest equivalent shutter speed, like $\frac{1}{125}$ second) under average conditions. If you are very close to the subject, as you might be when making a tight face shot, you will need to use a faster shutter speed. When far-

ther away from the subject, you can revert to the shutter speed that is the reciprocal of your focal length.

When shooting candids, or action-type portraits, use a faster shutter speed and a wider lens aperture. It's more important to freeze the subject's movement than it is to have great depth of field for such a shot.

When shooting candid portraits or when your subject is moving, choose a shutter speed fast enough to still subject movement. If you have any question as to which speed to use, always use the next fastest speed to ensure sharp images.

□ FILM

Good quality portraits can be made on any type of film stock. However, extremely slow and extremely fast films should be avoided. Black & white and color films in the ISO 25 range tend to be slightly too contrasty for portraits, and exposure latitude tends to be very narrow with these films. With trasty films, you tend to lose de light detail if the exposure is ev

Faster films, particularly in a greater margin for error in th development, but they are ofte successfully in portraiture. The often lower than what is desiral at least in the case of fast black trast can be suitably altered in d ing the negatives onto variabl larging papers.

Today's color negative film range have an almost nonexistel their exposure latitude often stops from normal. Of course still and will always be recommended, but to say that these films are forgiving is an understatement.

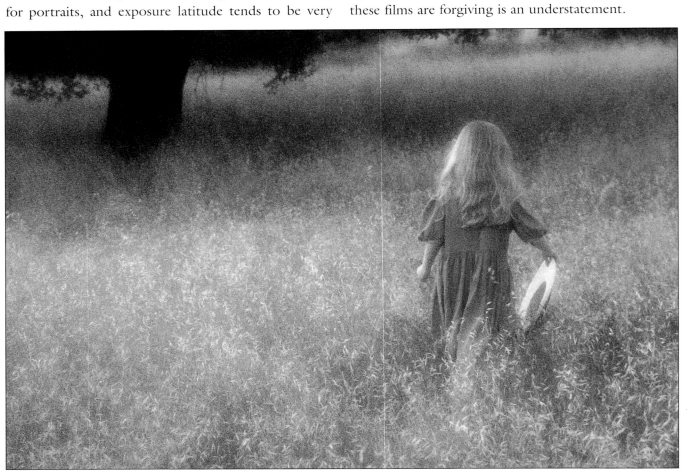

Today's color films provide a wide range of tools for the contemporary portrait photographer. Here, the low inherent contrast of Kodak Ektapress 1600 film and its pleasing "pointillist" grain structure make an ideal romanticized portrait. Diffused sun setting to the left of camera illuminated the little girl's hair in this portrait, shot using a Canon EOS with a Tamron 28–200mm lens at the 100mm setting. Photograph by Robert and Suzanne Love.

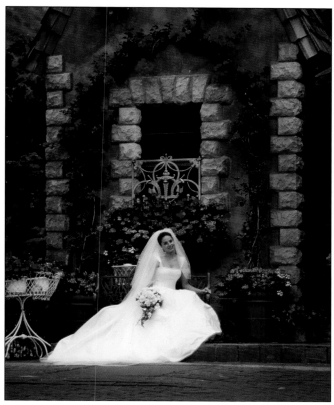

Consistently perfect exposures make it possible to reveal the highlights in a white wedding dress and the detail in the shadowy dark wooden door. This image was photographed in the early morning before the sun came up over the surrounding trees. According to photographer Dale Hansen, "There was a lot of open sky that acted as a giant soft box. I added a small amount of flash fill to give a little more punch to her gown and add a little more life to her eyes." Dale used a Hasselblad camera with a 180mm lens to create this portrait using morning light with flash fill (flash set to f/5.6). The exposure was $^1/_{250}$ second at f/11 on Kodak PMC 400 film.

Film Families. Kodak and Fujifilm, offer "families" of color negative films. Within these families are different speeds, from ISO 160 to 800, for example and either varying contrast or color saturation, but with the same color palette. Kodak's Portra films include speeds from ISO 160 to 800 and are available in NC (natural color) or VC (vivid color) versions. Kodak even offers an ISO 100 tungsten-balanced Portra film. Fujicolor Portrait films, available in a similar range of speeds, offer similar skin-tone rendition among the different films as well as good performance under mixed lighting conditions because of a fourth color layer added to the emulsion. These films are ideal for portrait photographers, because different speeds and format sizes can be used in the same session with only minimal differences observed in the final prints. Another advantage of these films is that they have similar printing characteristics and identical scanner settings, meaning that different speed films can be scanned at the same settings.

Black & White. Contrast is a more important ingredient in black & white portraits than in color ones. In color, you are locked in to the degree of contrast you can produce in the image. The color paper can only hold so much contrast, and it cannot be significantly altered. With black & white negatives, on the other hand, contrast can be increased or decreased in development (increasing the negative development increases contrast; decreasing the development reduces contrast).

This is important to know, because the contrast in your portraits will vary a great deal. Those shot in bright sunlight with a minimum of fill-in illumination, or those shot in other types of high-contrast lighting situations, should be altered in development by decreasing development a minimum of 10 percent. Portraits made under soft, shadowless light, such as umbrella illumination, will have low contrast, so the development should be increased at least 10 percent—sometimes even 20 percent. The resulting negatives will be much easier to print than if developed normally and will hold much greater detail in the important tonal areas of the portrait.

◻ DIGITAL CAPTURE

ISO Settings. Digital ISO settings correlate closely to film speeds—but they can be increased or decreased between frames, making digital capture inherently more flexible than shooting with film, where you are locked into a film speed for the duration of the roll.

As with film, the lower the ISO setting, the less noise (the digital equivalent of grain) and the more contrast. Shooting at the higher ISOs, like ISO 1600, produces a lot of digital noise in the exposure. Many digital image-processing programs contain noise-reduction filters that automatically function to reduce noise levels. New products, such as nik Multimedia's Dfine, a noise reducing plug-in filter for Adobe Photoshop, effectively reduce image noise, post-capture.

Contrast. Unlike film, contrast is a variable you can control at the time of capture when shooting digitally. Professional-grade digital SLRs have a setting for contrast, which most photographers keep on the low side. According to award-winning wedding photographer Chris Becker, "Contrast should be set to the lowest possible contrast setting. It's always easy to add contrast later, but more difficult to take away."

Black & White Mode. Some digital cameras offer a black & white shooting mode. Most photographers find this mode convenient, since it allows them to switch from color to black & white in an instant. Of course, the conversion can also easily be done later in Photoshop.

File Format. When you shoot with a digital camera, your digital file is your "negative." Digital SLRs offer the means to shoot files in many formats, but the two most popular ones are RAW and JPEG.

The advantage of shooting RAW files is that they retain the highest amount image data from the original capture. If you are shooting on the go and need faster burst rates, however, then RAW files will slow you down. They will also fill up your storage cards or microdrives much quicker because of their larger file size. Opening files in the RAW format also requires the use of special RAW file-processing software that converts the data to a useable format. If you shoot in RAW mode, backup your files as RAW files, as these are your original images.

Other cameras give you the option of shooting in the JPEG Fine (sometimes called JPEG Highest Quality) mode. Shooting in the JPEG mode creates smaller files, so you can save more images per card or storage device. It also does not take as long to write the JPEG files to memory. This allows you to work much faster. The biggest drawback to JPEG files is that they are compressed using a "lossy" format, meaning that the images are subject to degradation by repeated opening and closing. Most photographers who shoot in JPEG mode either save a new copy of the file each time they work on it, or save it to the TIFF format, which uses "lossless" compression so it can be saved again and again without degradation.

White Balance. On digital cameras, white-balance settings allow the photographer to correctly balance the color of the image capture when shooting under a variety of different preset lighting conditions, including daylight, strobe, tungsten, and fluorescent lighting. Some digital cameras also allow the photographer to select color-temperature settings in Kelvin degrees. These are often related to a time of day. For example, pre-sunrise lighting might call for a white-balance setting of 2000°K and heavy, overcast light might call for a white-balance setting of 8000°K. Most digital SLRs also have a provision for creating custom white-balance settings, which is essential in mixed light conditions, most indoor available-light situations, and with studio strobes.

Accurate white balance is particularly important if you are shooting highest-quality JPEG files. It is not as important if shooting in RAW file mode, since these files contain more data than the compressed JPEG files and are easily remedied later.

When shooting in a scene where they are unsure of the lighting mix, a system that many photographers follow is to select a white area in the scene and neutralize it with the camera's custom white-balance settings. If you do this, you can be assured of a fairly accurate rendition in your ensuing image captures.

> Accurate white balance is particularly important if you are shooting highest-quality JPEG files.

An accessory that digital pros swear by is the Wallace Expo Disc (www.expodisc.com). The Expo Disc attaches to your lens like a filter and provides perfect white balance and accurate exposures. The company also makes a Pro model that lets you create a warm white balance at capture. Think of this accessory as a meter for determining accurate white balance, crucial for digital imaging.

❏ EXPOSURE

Black & White. In black & white, your aim is to achieve consistent fine-grain negatives with the maximum possible highlight and shadow detail. If you find

that your normally exposed negatives are consistently too contrasty, or not contrasty enough, decrease or increase development accordingly.

If your negatives come out consistently over- or underexposed, then you must adjust the film speed you are using to expose the film. For instance, if you use an intermediate-speed film (ISO 100 or 125), for example, and your negatives are consistently underexposed, lower the ISO (to a setting 80 or 64). If your negatives are consistently overexposed, increase the ISO setting on your meter.

Before you begin fine-tuning your exposure and development, however, you should be sure you know the difference between errors in *exposure* and errors in *development*. Underexposed negatives lack sufficient shadow detail; underdeveloped negatives lack sufficient contrast. Overexposed negatives lack highlight detail; overdeveloped negatives have excessive contrast but may have sufficient highlight detail. If you are unsure, and most people *do* become unsure in the areas of overdevelopment and overexposure, make a test print from the suspect negative. If you cannot obtain highlight detail by printing the negative darker, then the negative is overexposed. If highlight detail appears but only when the negative is printed down, then you have overdeveloped the negative.

Color Negative. Most current color negative films have outstanding exposure latitude—from −2 to +3 stops. This often leads to sloppy habits, since you know you can count on the film to handle exposure errors. The best negative, however, is always one that is properly exposed. A properly exposed negative will yield rich shadow detail and delicate highlight detail.

Digital. Digital exposures are not nearly as forgiving as color negative film. The latitude is simply not there. Most digital photographers compare shooting digital to shooting transparency film, in which exposure latitude is usually ±½ stop. With transparency film, erring on either side of correct exposure is bad; with digital, underexposures are still salvageable, but overexposed images (where there is no highlight detail) are all but lost forever. You will never be able to restore highlights that don't exist in the original exposure. For this reason, most digital images are exposed to ensure good detail in the full range of highlights and mid-

Knowing the effect of backgrounds on exposure meters is crucial for a scene like this. Anthony Cava shot this image as a commercial portrait for a clothing-design catalog. He metered the available light, decided to underexpose his background by almost a full f-stop, and fired an umbrella-mounted studio flash to provide brilliance and facial modeling. The light was positioned above and to the right of the model, creating a "loop"-like pattern. No fill was used. The image was made with a Nikon D1X, 80–200mm zoom (at 80mm setting) at an exposure of $^1/_{30}$ second at f/3.5.

tones. The shadows are either left to fall into the realm of underexposure or they are filled in with auxiliary light or reflectors to boost their intensity.

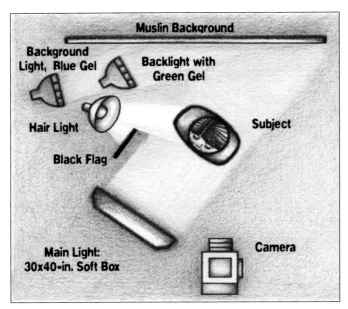

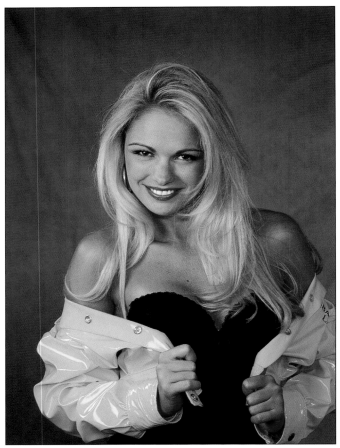

Fashion lighting calls for large, diffused light sources. In this case the photographer, Stephen Dantzig, used a 30x40-inch softbox as a main light. The hair and background lights are smaller and less diffused, but still soft. In the case of the "kicker" that is placed to the left of the model, a black flag was used to block light from striking the lens, which could cause image-degrading flare. Large lights are best used close to the subject to keep the light soft—the farther back the light is, the sharper and less diffuse it becomes. The main light was set to produce an output of a f/11. No fill light was used. The hair light was set to f/8. The dual background lights, also set to f/8 output, were gelled—one blue and one green, to create a blend on the background. The exposure was ¹/₁₂₅ second at f/11.

To evaluate the exposure of a digitally captured image you can evaluate the histogram and/or the image itself on the camera's LCD screen. By far, the more reliable is the histogram, but the LCD monitor provides a quick reference (and is particularly useful for checking to ensure that the image is sharp).

The histogram is a graphic representation of the tones in an image file, indicating the number of pixels that exist for each brightness level. The scale of brightness levels range from 0–255, with 0 indicating solid black and 255 indicating pure white.

In an image with a good range of tones, the histogram will fill the complete length of the scale (i.e., it will have detailed shadows and highlights and everything in between). When an exposure has detailed highlights, these will fall in the 235–245 range; when an image has detailed blacks, these will fall in the 15–30 range. The histogram may show detail throughout (from 0–255) but it will trail off on either end of the scale (as the tones approach solid black and pure white).

Histograms are scene-dependent. In other words, the amount of data in the shadows and highlights will directly relate to the subject and how it is illuminated and captured. The histogram also gives an overall view of the tonal range of the image, and the "key" of the image. A low-key image will have a high amount of data in the shadows, since this is where its tones are concentrated; a high-key image, on the other hand, will have its tones concentrated in the highlights. An average-key image has its tones primarily in the midtones. An image with full tonal range has a significant amount of data in all areas of the histogram.

□ METERING

Reflected-Light Meters. Because exposure is so critical to producing fine portraits, it is essential to meter the scene properly. Using the in-camera light meter may not always give you consistent and accurate

results. Even with sophisticated multi-pattern in-camera reflected meters, brightness patterns can influence the all-important flesh tones. Usually these meters are center-weighted because that's where most people place their subjects within the frame.

The problem with these meters arises from the fact that they are designed to average all of the brightness values in a scene to produce a generally acceptable exposure. To be precise, the in-camera meter is designed to suggest a reading that will render the metered tone as 18-percent gray. This is rather dark even for a well-suntanned or dark-skinned individual. Therefore, if you are using the in-camera meter, be sure to meter from an 18-percent gray card held in front of the subject, using a card that is large enough to fill most of the frame. If using a handheld reflected-light meter, do the same thing.

Incident-Light Meter. Another type of meter that is ideal for portraiture is the handheld incident-light meter. This does not measure the reflectance of the subject, but rather measures the amount of light falling on the scene. Simply stand where you want your subject to be, point the hemisphere dome of the meter directly at the camera lens, and take a reading. Be sure that the meter is held in exactly the same light that your subject will be in. This type of meter yields extremely consistent results, because it measures the light falling on the subject rather than the light reflected from the subject. It is less likely to be influenced by highly reflective or light-absorbing surfaces.

Incident Flashmeter. A handheld incident flashmeter is essential for working indoors and out, but particularly crucial when mixing flash and daylight. It is also useful for determining lighting ratios. Flashmeters are invaluable when using multiple strobes and when trying to determine the overall evenness of lighting in a large-size room. Flashmeters are also ambient incident-light meters, meaning that they measure the light falling on them and not light reflected from a source or object as the in-camera meter does.

☐ LIGHTS AND LIGHT MODIFIERS

Continuous Light vs. Strobe. There are many choices when it comes to lighting equipment, and the subject of light sources can be a topic of endless debate.

The three basic types of lighting equipment, however, are portable flash, continuous light units, and studio strobes.

In professional portraiture, portable flash units are usually appropriate only as a source of fill light. On-camera flash should especially be avoided, as the light produced is too harsh and flat to create roundness or contouring on the subject's face. Additionally, these units have no modeling lights to show you the lighting effect, making predictable results difficult, if not impossible. Using continuous light sources or studio strobe with built-in modeling lights, on the other hand, allows you to see the effect of the lighting while you are shooting. With either of these systems, there is also much more light available for focusing than when using portable flash.

When it comes down to a decision between continuous light sources and studio strobes, the choice is yours. You can achieve excellent results with either type of lighting.

A handheld incident flashmeter is essential for working indoors and out . . .

Continuous light sources do have one major advantage over instantaneous ones: you can see exactly the lighting you will get, since the light source is both the modeling light and the actual shooting light. When using continuous light sources to shoot color film, however, you must use either a tungsten-balanced film or a filter to color-correct the light for daylight-balanced film. Consult your film data sheet to determine exactly which filter you need to color balance your lighting equipment. Of course, when using digital, achieving the correct color balance is a simple matter of changing the white balance to the proper color temperature setting or, for more precise results, creating a custom white-balance setting.

When you use studio strobe lighting, you can use any daylight-balanced film (flash is the same approximate color temperature as daylight). These units also

require substantially less power to operate than continuous light sources, and there is little or no heat from the lights—which can be a major factor in subject comfort when several units are used. With strobe lighting, the modeling light (a continuous light source) is only a guide to the lighting and it is not the actual light source that exposes the film. In most cases, however, the modeling light is very accurate.

Light Modifiers. Umbrella and softbox lighting are by far the most popular light modifiers for portraiture, used to soften the light and create a more flattering look. Lights with these modifiers may be used over the camera for a fashion-type effect, or to either side for a more traditional portrait lighting. While these light sources are very soft, it is still usually necessary to fill in the shadow side of faces to prevent the shadow areas from going "dead."

Umbrellas. You can use umbrella lighting with either flash or continuous light sources. If using tungsten or quartz lighting with umbrellas, be very careful not to get the light in too close to the material, as it may catch fire.

Photographic umbrellas normally have either a white or silver lining. A silver-lined umbrella produces a more specular, direct light than does a matte white umbrella. When using lights of equal intensity, a silver-lined umbrella can be used as a main light because of its increased intensity and directness. It will also pro-

duce wonderful specular highlights in the overall highlight areas of the face. A matte-white umbrella can then be used as a fill or secondary light. (Some umbrellas, called "zebras," have a lining of alternating white and silver for an effect that is soft like a white-lined umbrella, but still offers a bit of the sparkle of a silver-lined model.)

You can also experiment with the placement of the light within the umbrella to obtain different degrees of softness. Most photographers prefer to place the light far enough up the shaft of the umbrella that the full beam of light is within the curve of the umbrella surface. The light is aimed at the center of the umbrella for the most even lighting. This is called "focusing" the umbrella and results in the most efficient use of the light.

Some photographers use the umbrella in the reverse position, turning the light and umbrella around so that the light shines *through* the umbrella and onto the subject (rather than being reflected out of the umbrella onto the subject). This gives a more directional light than when the light is turned away from the subject and aimed into the umbrella. Of course, with a silver-lined umbrella, you can't shine the light through it, because the silvered material is almost fully opaque.

Softboxes. Softboxes are black fabric boxes with a layer of white diffusion material on the front. Some softboxes are double-diffused, with a second scrim used over the lighting surface. When using a softbox, the light unit is placed *inside* the box and its output is directed through the diffusion material on the front of the box. Because the light unit is placed within the modifier, most softboxes can be used only with strobes (which, as noted above, produce much less heat than continuous sources). Some softbox units accept multiple strobe heads for additional lighting power and intensity.

HINTS AND TIPS

Because umbrellas and softboxes produce a broad beam of light, the light scatters, often eliminating the need for a background light. But this is also subject to how far the background is from the light source and the tone of the background. The farther it is from the light, the darker it will record.

T he guidelines for subject posing are for-malized and steeped in tradition. These rules have been refined over the cen-turies and have come to be accepted as standard means to render the three-dimensional human form in a two-dimensional medium.

The rules of posing and composition need not be followed to the let-ter, but should be understood because they offer ways to show subjects at

Even when photographing uncooperative subjects like kids, good head and shoulder positioning is important. Here, the photographer posed the boy in a typical mascu-line pose with the head facing in the same direction as the shoulder axis. Photograph by David Bentley.

their best. Like all rules—especially artistic rules—they are, however, made to be broken. Without innovation, portraiture would be a static, scientific discipline, devoid of emotion and beauty.

□ SUBJECT COMFORT

The first thing the photographer must do for a subject is to make the person comfortable. Posing stools and benches are commercially available that make the subject feel comfortable while also ensuring a good, upright posture. These are fine for studio work, but what about outdoors where no such tools exist? You must find a spot—a patch of grass under a tree or a fence, for example—which will be comfortable for the duration of the shooting session. Pose your subject naturally—a pose that feels good to the subject. If your subjects are to appear natural and relaxed, then the poses they strike must be natural for them.

□ THE HEAD AND SHOULDERS AXIS

One of the fundamentals of portraiture is that the subject's shoulders should be turned at an angle to the camera. To have the shoulders facing the camera straight on makes the person look wider than he or she really is and can yield a static composition. Sometimes, the head is turned a different direction than are the shoulders. With men, the head is more often turned the same direction as the shoulders, but with women, the head is often at a slightly different and opposing angle.

In a head-and-shoulders portrait, the subject's arms should not be allowed to fall to the subject's sides, but should project outward to provide gently sloping lines and a "base" to the composition. This is often achieved by asking the subject to put their hands together and position them close to waist height. In the case of a standing man, for instance, you can sim-

The basic head positions are the seven-eighths view, the three-quarter view (shown here), and the profile. The three-quarter view is a dynamic pose but one must be careful to position the smaller of the subject's eyes closest to the camera so that the perspective is used to make both eyes appear to be the same relative size, as is shown in this image. Photograph by Fuzzy Duenkel.

ply have him put his hands in his pockets to separate his arms from his torso. Posing subjects in this way creates a slight space between their upper arms and their torsos, slimming the appearance of the torso and avoiding a flattening effect on the outer surface of the arm. It also creates a triangular base for the composition. This attracts the viewer's eye upward, toward the subject's face.

Subjects should sit or stand upright, but be sure that they do not look rigid.

□ HEAD POSITIONS

There are three basic head positions in portraiture: the seven-eighths, three-quarters, and profile views. With all three of these head poses, the shoulders should be at an angle to the camera. The only exception is when you want to emphasize the mass of the subject, such as an athlete, or when the person is very thin or petite. In that case, picturing them head-on will not make them appear overly big. One of the basic requirements of a good working model is that she be thin so that, if need be, she can be photographed head-on without looking unnatural. Even when photographing someone head-on, however, the face should still be slightly turned to one side or the other to avoid the dreaded "mug-shot" look.

The Seven-Eighths View. The seven-eighths view is when the subject is looking just slightly away from the camera. In other words, you will see just a little more of one side of the face than the other when looking through the camera. You will still see both of the subject's ears in a seven-eighths view.

The Three-Quarter View. With a three-quarter view, the far ear is hidden from the camera and more of one side of the face is visible. With this type of pose, the far eye will appear smaller because it is naturally farther away from the camera than the near eye. It is

This dramatic pose combines a three-quarter facial view and a profile. Notice how in the profile pose, the boy's face is turned just far enough away from camera so his eyebrows and eyelashes on the right side of his face disappear. Notice, too, how the photographer masterfully lit only the frontal planes of both faces, creating a dramatic lighting ratio in keeping with the nature of the portrait. Photograph by David Bentley.

important when posing the sitter in a three-quarter view to position him or her so that the smaller eye (people usually have one eye that is slightly smaller than the other) is closest to the camera. This way, the perspective is used to make both eyes appear to be the same size in the photograph.

The Profile View. In the profile, the head is turned almost 90 degrees to the camera. Only one eye is visible. In posing your subject in a profile position, have him or her turn their head gradually away from the camera position just until the far eye and eyelashes disappear from view. If you cannot see the eyelashes of the far eye, then you have a good profile pose.

□ TILTING THE HEAD

Your subject's head should be tilted at a slight angle in literally every portrait. By doing this, you slant the natural line of the person's eyes. When the face is not tilted, the implied line of the eyes is straight and parallel to the bottom edge of the photograph, leading to a static composition. By tilting the person's face right

or left, the implied line becomes diagonal, making the pose more dynamic.

Whether to tilt the subject's head toward the near shoulder or the far shoulder is a sometimes-controversial issue among portrait photographers. In men's portraits the traditional rule is to tilt the head toward the far shoulder (the one farthest from the camera). In women's portraits, the head is traditionally tilted toward the near shoulder for a supposedly feminine look. These rules are frequently broken, because individuals and lighting usually determine the most flattering direction for the head to be tilted, but the rule is mentioned here so that you can decide for yourself.

In any case, for a natural look, the tilt of the person's head should be slight and not overly exaggerated.

□ THE EYES

It is said that the eyes are the "mirrors of the soul." While that might be a cliché, there is no doubt that the area of primary visual interest in the human face is the eyes. The portrait photographer must live by those words—truly, the eyes are the most expressive part of

the face. If the subject is bored or uncomfortable, you will see it in his or her eyes.

The best way to keep the subject's eyes active and alive is to engage him or her in conversation. Look at the person while you are setting up and try to find a common frame of interest. People almost always enjoy the opportunity to talk about themselves! If the person does not look at you when you are talking, he is either uncomfortable or shy. In either case, you have to work to relax your subject and encourage him to trust you. Try a variety of conversational topics until you find one he warms to and then pursue it. As you gain his interest, you will take his mind off of the portrait session.

The direction of the person's gaze is all-important. Start the portrait session by having the person look at you. Using a cable release with the camera tripod mounted forces you to become the host and allows you to physically hold the subject's attention. It is a good idea to shoot a few shots of the person looking directly into the camera, but most people will appreciate some variety. Looking into the lens for too long a time will bore your subject, as there is no personal contact when looking into a machine.

One of the best ways to enliven the subject's eyes is to tell an amusing story. If they enjoy it, their eyes will smile. This is one of the most endearing expressions a human being can make.

The colored part of the eye, the iris, should border the eyelids. In other words, there should not be a white space between the top or bottom of the iris and the eyelid. If there is a space, have the subject lower his gaze.

Pupil size is also important. If working under intense lights, the pupil will be very small and the subject will look beady-eyed. A way to correct this is to have them shut their eyes for a moment prior to expo-

One of the best ways to make great portraits is to establish a great rapport with the subject. Here, the photographer and bride have obviously "connected," because the bride's eyes are animated and her mouth relaxed in a beautiful smile. A high camera angle was used to produce an unusual but pleasing perspective. Michele Celentano used a Bronica SQ-Ai camera with a 110mm lens to create this image. Using Fuji NHG II 800 film, exposed at $^1/_{30}$ second at f/5.6, the portrait was lit by window light plus a silver reflector under the bride's face.

sure. This allows the pupil to return to a normal size for the exposure.

Just the opposite can happen if you are working in subdued light. The pupil will appear too large, giving the subject a vacant look. In that case, have the subject stare momentarily at the brightest nearby light source to close the pupil.

□ THE MOUTH

Generally, it is a good idea to shoot a variety of portraits, some smiling, some serious (or at least not smiling). People are often self-conscious about their teeth and mouths, but if you see that the subject has an attractive smile, get plenty of shots of it.

Natural Smiles. One of the best ways to produce a natural smile is to praise your subject. Tell him or her how good they look and how much you like a certain feature of theirs. Simply saying "smile!" will produce that lifeless, "say cheese" type of portrait. By sincere confidence building and flattery, on the other hand, you will get the person to smile naturally and sincerely and their eyes will be engaged.

Moistening the Lips. It will be necessary to remind the subject to moisten his or her lips periodically. This makes the lips sparkle in the finished portrait, as the moisture produces tiny specular highlights.

Avoiding Tension. People's mouths are nearly as expressive as their eyes. Pay close attention to your subject's mouth to be sure there is no tension in the muscles around it, since this will give the portrait an unnatural, posed look. Again, an air of relaxation best relieves tension, so talk to the person to take their mind off the session.

Gap Between the Lips. Some people have a slight gap between their lips when they are relaxed. Their mouth is neither open nor closed but somewhere in between. If you observe this, let them know about it in a friendly way. If they forget, politely say, "Close your mouth, please." When observing the person in repose, this trait is not disconcerting, but when it is frozen in a portrait this gap between the lips will look unnatural because the teeth show through it.

Laugh Lines. An area of the face where problems occasionally arise is the front-most part of the cheek— the areas on either side of the mouth that wrinkle when a person smiles. These are called furrows or laugh lines. Some people have furrows that look unnaturally deep when they are photographed smiling. You should take note of this area of the face. If necessary, you may have to increase the fill-light intensity to fill in these deep shadows, or adjust your main light to be more frontal in nature. If the lines are severe, avoid a "big smile" type of pose altogether.

□ CHIN HEIGHT

You should be aware of the psychological value put on even subtle facial positions, such as the height of the subject's chin. If the person's chin is too high, he may look haughty—like he has his nose up in the air. If the person's chin is too low, he may look afraid or lacking in confidence.

Beyond the psychological implications, a person's neck will look stretched and elongated if the chin is too high. The opposite is true if the chin is held too low; the person may appear to have a double chin or no neck at all.

> One of the best ways
> to produce a natural smile
> is to praise your subject.

The solution is, as you might expect, a medium chin height. Be aware of the effects of too high or too low a chin height and you will have achieved a good middle ground. When in doubt, ask the sitter if the pose feels natural, this is usually a good indicator of what is natural.

□ POSING HANDS

Posing the hands properly can be very difficult, because, in most portraits, they are closer to the camera than the subject's head. Thus, they appear larger. One thing that will give hands a more natural perspective is to use a longer lens than normal. Although holding the focus of both hands and face is more difficult with a longer lens, the size relationship between them will appear more natural. Additionally, if the hands are

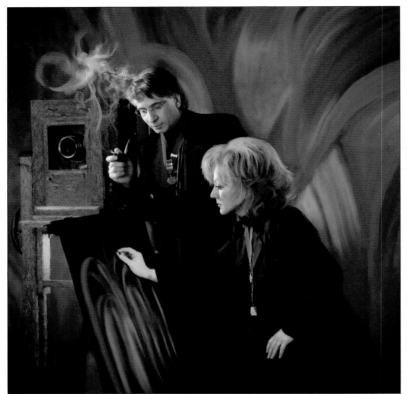

TOP LEFT—Don Blair created this lovely image of master photographers Joseph and Louise Simone. Notice the hand of the artist as it is gracefully poised over the canvas. In the same portrait, notice the rugged and manly pose of Joseph's right hand. It is strong and yet comfortably posed.

ABOVE—Terry Deglau is a posing master. Notice how the right hand is elevated upward, the fingers separated and graceful. The eye is drawn upward towards the model's face, the primary center of interest. The line of the wrist and hand produces a gentle break, and while the hand does not dominate the portrait, it is as character-defining as any other part of the pose.

LEFT—In this senior portrait, the photographer posed the hands expertly. The left hand is out of view of the camera, but helps build the composition. The right hand is curved gently, fingers separated, a slight break at the wrist—a very elegant pose for a young lady. Photograph by Fuzzy Duenkel.

slightly out of focus, it is not as crucial as when the eyes or face are soft.

Throughout this book you'll see great examples of hand posing, pleasing images that render the hands with good dimension and form—but also in a way that seems to reveal the personality of the subject.

It is impossible here to cover every possible hand pose, so it is necessary to make a few generalizations (and keep in mind that these are just that—generalizations, not hard and fast rules):

- Avoid photographing a subject's hands pointing straight into the camera lens. This distorts the size and shape of the hands. Instead, keep the hands at an angle to the lens.
- Photograph the outer edge of the hand whenever possible. This gives a natural, flowing line to the hands and eliminates the distortion that occurs when hands are photographed from the top or head-on.
- Try to "break" the wrist, meaning that you should bend the wrist slightly so there is a gently curving line where the wrist and hand join.
- Try to photograph the fingers with a slight separation in between. This gives the fingers form and definition. When the fingers are closed together, they can appear as a two-dimensional blob.
- When posing women's hands, you should generally strive to create a sense of grace. When photographing men, you will normally look to create an appearance of strength. (Obviously, the type of portrait and the subject must also be considered. For example, the hands of a female soldier in uniform would more logically be posed to convey strength than delicate grace.)

Jennifer George Walker's portrait called *Embrace* is a masterpiece, and within the portrait is a wonderful treatment of the woman's right hand. The hand is integral to the embrace, yet there is no clutching or desperation. Instead, the hand conveys a sense of unity and emotional oneness, as well as a sense of safety and satisfaction. The delicate lighting on the separated fingers makes the hand a beautiful and fundamental part of the portrait.

Here are six examples of good hand posing. In each case, the hand is at an angle to the lens. In most images, a woman's hands should look graceful and elegant. Similarly, a man's hands should usually be depicted as strong and dignified. The pose should always appear natural and never contrived. While these are only examples of formal hand posing, and need not always be followed, they offer good illustrations of how the hands can be used to enhance a portrait. They are also a means to photograph hands without distortion.

Study the drawings above for suggestions on how to handle portraits in which the hands appear.

□ THREE-QUARTER- AND FULL-LENGTH POSES

As you probably understand by now, the more of the human anatomy you include in a portrait, the more problems you encounter. When you photograph a person in a three-quarter- or full-length pose, you have arms, legs, feet, and the total image of the body to contend with.

Three-Quarter-Length Portraits. A three-quarter-length portrait is one that shows the subject from the head down to a region below the waist. Usually, this type of portrait is best composed by having the bottom of the picture be mid-thigh or below the knee and above the ankles. Never break the portrait at a joint, as this has a negative psychological impact.

Full-Length Portraits. A full-length portrait shows the subject from head to toe. Whether the person is standing or sitting, it is important to remember to slant their body (shoulders) to the lens, usually at a 30- to 45-degree angle. Never photograph the person head-on, as this adds mass and weight to the body. The old adage about the camera adding 10 pounds is indeed true—and if certain posing guidelines are not followed, you will add a lot more than 10 pounds.

For standing poses, have the subject put their weight on the back foot rather than distributing their weight evenly on both feet (or, worse yet, on their front foot). There should be a slight bend in the front knee if the person is standing. This helps break up the static line of a straight front leg. The back leg can remain straightened; since it is less noticeable than the front leg, it does not produce a negative visual effect.

Just as it is undesirable to have the hands facing the lens head-on, so it is with the feet, but even more so. Feet tend to look stumpy when they are photographed head-on.

When the subject is standing, the hands become a real problem. If you are photographing a man, folding the arms across his chest is a good strong pose. Remember, however, to have the man turn his hands slightly so the edge of the hand is more prominent than the top of the hand. In such a pose, have him

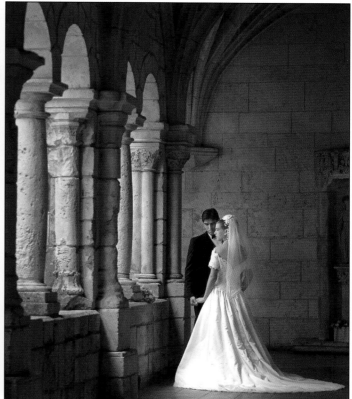

ABOVE—One of the masters of posing subjects elegantly is Robert Lino. Here, the bride is bent at the waist, producing a dynamic line in the photo, while her hands, with wrists "broken" perfectly, balance the composition. It is important that a pose be realistic. Here, the bride gently holds her veil away from the dress so it can be admired. Lino photographed this image using a Bronica SQ-Ai camera with a PS 80mm lens. Kodak 400 PMC film was exposed for $1/30$ second at f/4 by available light.

TOP RIGHT—This elegant full-length pose of a bride and groom is a study in static and flowing lines. The straight arm and "break" of the bride's wrist serve to complement the wonderful flowing lines of her dress and the arches in the architecture. Another fine point: the line of the bride's arm and dress form a powerful diagonal line that rivets your attention on the center of interest. Photograph by Rick Ferro.

RIGHT—This is a decidedly masculine pose. Even though the back of the hand is photographed, the lighting is excellent in delineating form and contours. The chin is gripped lightly but not held. The look is confident, as is the pose. The angle of the eyes is slightly tipped to produce a diagonal line in the composition and the crop is tight, eliminating much of the subject's forehead. Photograph by David Williams.

lightly grasp his biceps, but not too hard or it will look like he is cold and trying to keep warm. Also, remember to instruct the man to bring his folded arms out from his body a little bit. This slims down the arms, which would otherwise be flattened against his body and appear larger. Separate the fingers slightly.

With a standing woman, one hand on a hip and the other at her side is a good standard pose. Don't let the free hand dangle, but rather have her twist the hand so that the outer edge shows to the camera. Always create a break in the wrist for a more dynamic line.

When the subject is sitting, a cross-legged pose is often desirable. Have the top leg angled and not facing into the camera lens. With a seated woman, it is a particularly good idea to have her tuck the calf of her front leg in behind her back leg. This reduces the size of the calves, since the back leg, which is farther from the camera, becomes the most important visually. Always have a slight space between the leg and the chair, where possible, as this will slim the thighs and calves.

It should be noted that in any discussion of subject posing the two most important points are that the pose appear natural (one that the person would typically fall into), and that the person's features be undistorted. If the pose is natural and the features look normal, then you will have achieved your goal and the portrait will be pleasing to both you and the subject.

This is a decidedly feminine portrait with the subject cloaked in mystery. Only one eye is visible and the plane of focus is very shallow—only the mask of her face is sharp. Her hands are graceful yet posed in such a way that your eye is drawn back to her face, toward the focal point of the portrait, the subject's eye and slightly parted lips. Fran Reisner made this image using a Kodak SLR/n digital SLR with a Nikkor 80–200mm f/2.8 VR (vibration reduction) lens. A Photogenic strobe head in a Larson 4 x 6-foot softbox was used along with a Larson reflector. The exposure was $1/60$ second at f/6.7 at 200mm.

□ COMPOSITION

Composition in portraiture is no more than proper subject placement within the frame. There are several schools of thought on proper subject placement, and no one school is the only answer. Several formulas are given here to help you

The rule of thirds (left) and the golden mean (right) are two ways of achieving dynamic compositions. In each case, the center of interest, the face or eyes, should be placed on or near an intersection of two lines within the picture rectangle.

best determine where to place the subject in the picture area.

The Rule of Thirds. Many photographers don't know where to place the subject within the frame. As a result, they usually opt for putting the person in the center of the picture. This is the most static type of portrait you can produce.

The easiest way to improve your compositions is to use the rule of thirds. Examine the diagram above. The rectangular viewing area is cut into nine separate squares by four lines. Where any two lines intersect is an area of dynamic visual interest. The intersecting points are ideal spots to position your main point of interest. The main point of interest in your portrait can also be effectively placed anywhere along one of the dividing lines.

In head-and-shoulders portraits, the eyes are the center of interest. Therefore, it is a good idea if they rest on a dividing line or at an intersection of two lines. In a three-quarter- or full-length portrait, the face is the center of interest. Thus, the face should be positioned to fall on an intersection or on a dividing line.

In most vertical portraits, the head or eyes are two-thirds from the bottom of the print. This is also true in most horizontal compositions, unless the subject is seated or reclining. In that case, they may be at the bottom one-third line.

Direction. Sometimes you will find that if you place the main point of interest on a dividing line or at an intersecting point, there is too much space on one side of the subject, and not enough on the other. Obviously, you would then frame the subject so that he or she is closer to the center of the frame. It is important, however, that the person not be placed dead center, but to one side of the center line.

Regardless of which direction the subject is facing in the photograph, there should be slightly more room in front of the person (on the side of the frame toward which he is facing). For instance, if the person is looking to the right as you look at the scene through the viewfinder, then there should be more space to the right side of the subject than to the left of the subject in the frame. This gives the image a sense of visual direction.

Even if the composition is such that you want to position the person very close to the center of the frame, there should still be slightly more space on the side toward which the subject is turned. This principle also applies when the subject is looking directly at the camera. He should not be centered in the frame; there should be slightly more room on one side to enhance the composition.

The Golden Mean. A compositional principle similar to the rule of thirds is the golden mean, a concept first expressed by the ancient Greeks. Simply, the golden mean represents the point where the main cen-

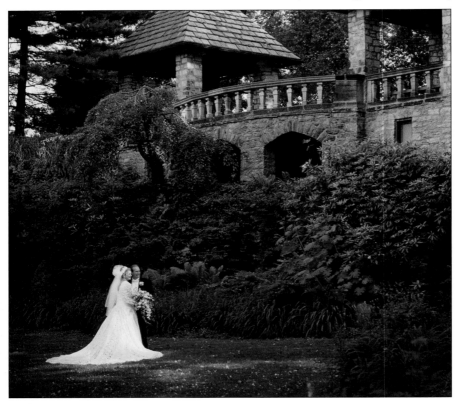

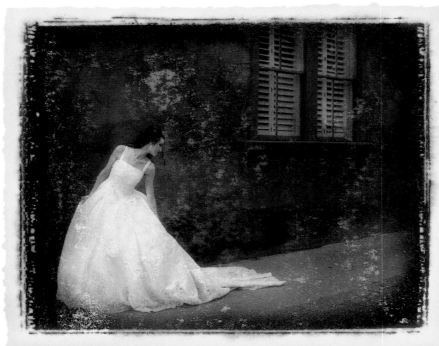

TOP—This is an elegant composition expertly employing the rule of thirds. Notice how the couple is situated near an intersecting point and the bridge above is placed on another intersection. The two main areas of interest create a subtle balance in the composition that invites the viewer's eye to go back and forth between the two areas. By virtue of subject tone, the couple is by far the dominant area of visual interest. Photograph by Patrick Rice.

BOTTOM—This is a collaborative effort between master photographer Ken Sklute and master printer Jonathan Penney. The overall look, suggested by Jonathan, was to replicate a Polaroid transfer print. The original film image was made using a Canon A1 with a 35–105mm lens at $^1/_{60}$ sec. and f/16, using a yellow filter. Jonathan scanned the negative in grayscale on an Imacon Photo Flex-Tite scanner, brought it into Adobe Photoshop, adjusted for contrast and density using the Levels command, and then converted it to RGB. Using Curves, he adjusted the red and blue channels to the desired color to produce the split-tone effect. The border effect is from the Auto FX Photographic Edges collection, a Photoshop plug-in. What is fascinating about this image, apart from its technology, is the pure simplicity of its design. The placement of the bride in the frame, her direction, and the shape her body creates (a C shape) combine to create a pleasing dynamic composition.

ter of interest should lie and it is an ideal compositional type for portraits. The golden mean is found by drawing a diagonal from one corner of the frame to the other. Then draw a line from one or both of the remaining corners so that it intersects the first line perpendicularly (see the drawing on page 39). By doing this you can determine the proportions of the golden mean for both horizontal and vertical photographs. It should be noted that if the subject is facing right, then you should position him or her on the left side of the frame. If facing left, the subject should be positioned on the right. This provides the necessary direction in the portrait.

Compositional Forms. The S-shaped composition is perhaps the most pleasing of all compositions. The gently sloping S shape is used to lead the viewer's eye to the point of main interest, which should still be placed according to the rule of thirds or the golden mean.

Another pleasing type of composition is the L shape or inverted L shape. This type of composition is ideal for reclining or seated subjects. Again, the center of interest should still be placed according to the rule of thirds or the golden mean.

Even in closeup views when the subject is looking directly at the camera, the dynamic rules of composition should apply. In this portrait of a little angel, photographer Becker introduced the diagonal line of the eyes and a higher placement of them in the frame to strike these chords of good composition. He made the image with a Fujifilm FinePix S2 Pro and an 80–200mm Nikkor zoom. The exposure was made at $^1/_{60}$ second at f/3.2 using the 105mm zoom setting.

Subject Tone. The rule of thumb is that light tones advance visually, while dark tones retreat. It is a natural visual phenomenon. Therefore, elements in the picture that are lighter in tone than the subject will be distracting. To reduce this effect, bright areas, particularly at the edges of the photograph, should be darkened in printing, in the computer, or in the camera (by

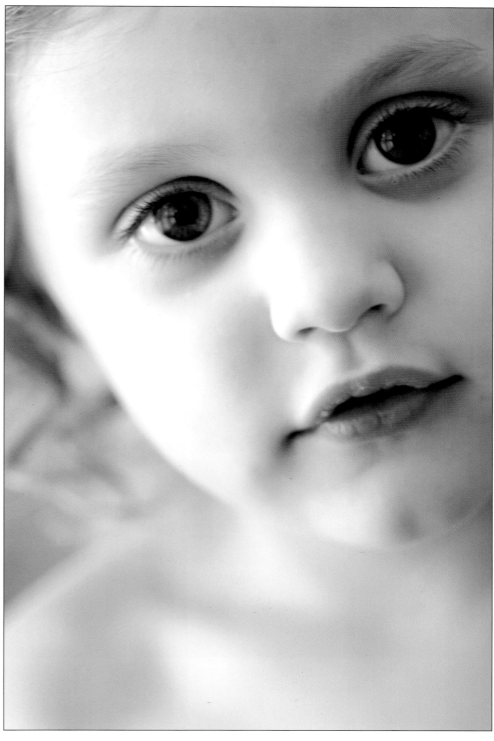

masking) so that the viewer's eye is not brought away from the subject.

Of course, there are portraits where the subject is the darkest part of the scene, such as in a high-key portrait with a white background. This is really the same principle at work as above, because the eye will go to the region of greatest contrast in a field of white or on a light-colored background.

The guiding principle is that, regardless of whether the subject is light or dark, it should visually dominate the rest of the photograph either by brightness or by contrast.

Focus. Whether an area is in focus or out of focus has a lot to do with the amount of visual emphasis it will receive. For instance, imagine a portrait in which a subject is framed in green foliage, yet part of the sky is visible in the scene. In such a case, the eye would ordinarily go to the sky first. However, if the sky is soft and out of focus, the eye will revert back to the area of greatest contrast—hopefully the face.

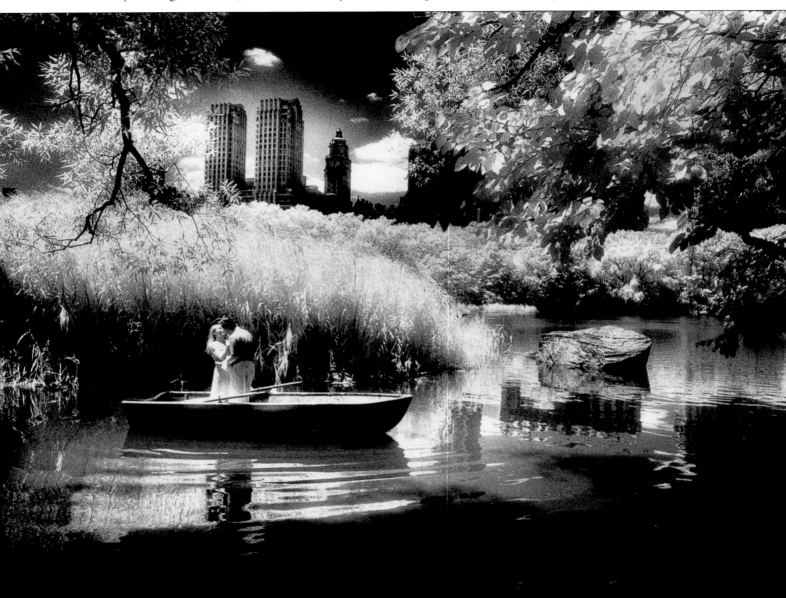

In this surreal infrared portrait made in Central Park in New York City, the subject tones draw your eye to the couple, despite the other bright image tones within the scene. This defines the couple and the boat as the most important thing to look at in this wide-angle portrait. Ferdinand Neubauer made this image using Kodak black & white infrared film in a Contax 35mm camera with a 25mm Zeiss lens.

The same is true of foreground areas. Although it is a good idea to make them darker than your subject, sometimes you can't. If the foreground is out of focus, however, it will detract less from a sharp subject.

Line. To effectively master the fundamentals of composition, the photographer must be able to recognize real and implied lines within the photograph. A real line is one that is obvious—a horizon, for example. An implied line is one that is not as obvious; the curve of the wrist or the bend of an arm is an implied line.

Real lines should not intersect the photograph in halves. This actually splits the composition in half. It is better to locate real lines at a point one-third into the photograph. This weights the photo more appealingly.

Lines, real or implied, that meet the edge of the photograph should lead the eye into the scene and not out of it, and they should lead toward the subject. A good example of this is the country road that is widest in the foreground and narrows to a point where the subject is walking. These lines lead the eye straight to the subject.

Implied lines, such as those of the arms and legs of the subject, should not contradict the direction or emphasis of the composition, but should modify it. These lines should present gentle, not dramatic changes in direction, and again, they should lead to the main point of interest—either the eyes or the face.

It's often been said that part of being a great photographer is being a great observer. Fuzzy Duenkel creates masterpieces of his senior subjects, photographing them in their own homes by available light. Here, he found the afternoon sun highlighting the arches in her home, creating the perfect compositional echo for this portrait. Fuzzy coordinated the tones of her hair and skin with the wall colors, creating a masterful composition.

3.
Basic Portrait Lighting

This chapter will cover the basic forms of conventional portrait lighting. They are conventional in that they are used day in and day out by professional portrait photographers to produce salable portraits. They are basic in that they represent a starting point for any photographer. Once you have mastered the basic forms of lighting, you can refine them and vary them to meet the needs of your subject and to meet the artistic demands of your photography.

A photograph is only a two-dimensional representation of three-dimensional reality, thus the aim of the photographer is to produce a portrait that shows roundness and form of the human face. This is done primarily with highlights (areas that are illuminated by the light source) and shadows (areas that are not). Just as a sculptor models clay to create the illusion of depth, so light models the shape of the face to give it depth and form.

In the studio, the portrait photographer has more control of highlights and shadows than in any other portrait situation—plus the ability to manipulate the placement and intensity of these features. Still, although numerous lights may be used, one light must dominate, establishing a pattern of shadows and highlights on the face. All other lights should be secondary to this main light and modify it. The placement of this key light (also called the main light) is what determines the lighting pattern in studio portraiture.

The shape of the subject's face usually determines the best lighting pattern to use. You can widen a narrow face, narrow a wide face, hide poor skin, and disguise unflattering facial features (such as a large nose) all by thoughtful placement of your key light.

☐ THE LIGHTS

These lighting techniques can be done with very basic equipment. A full set of four lights with stands and parabolic reflectors can be purchased quite reasonably. If you shop for used equipment, you can get lights even

cheaper. The lights can be electronic flash units or they may be incandescent lights. The latter is preferred in learning situations, because what you see is exactly what you get. With strobes, a secondary modeling light is used within the lamp housing to approximate the effect of the flash.

The key and fill lights should be high-intensity bulbs seated in parabolic reflectors. Usually 250–500 watts is sufficient for a small room. If using electronic flash, 200–400 watt seconds is a good power rating for portraiture. Reflectors should be silver-coated on the inside to reflect the maximum amount of light. If using diffusion, umbrellas or soft boxes, the entire light assembly should be supported on sturdy stands to prevent them from tipping over.

The key light, if undiffused, should have barn doors affixed. These are black, metallic, adjustable flaps that can be opened or closed to control the width of the beam of the key light. Barn doors ensure that you light only the parts of the portrait you want lit. They also keep stray light off the camera lens, which can cause lens flare.

The fill light should be equipped with a diffuser, which is nothing more than a piece of frosted plastic or acetate in a screen that mounts over the reflector. When using a diffuser over a light, make sure there is

Broad and short lighting are seen in the same portrait. Notice the differences in how the faces are rendered. Broad lighting flattens out facial features, while short lighting produces a more dramatic rendering with greater roundness. The main light was a double-scrimmed (diffused) 35-inch softbox at an output of f/8. A snooted hair light was used at f/8 from directly behind the kids. For fill, a Halo Mono (a type of enclosed umbrella) was bounced off the rear wall at a setting of f/2.8. The exposure was at $1/60$ second at f/8. PXP film was used at ISO 100. Photograph by Norman Phillips.

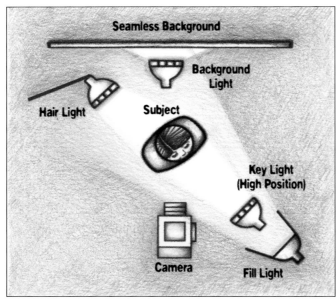

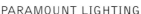

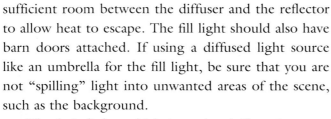

PARAMOUNT LIGHTING

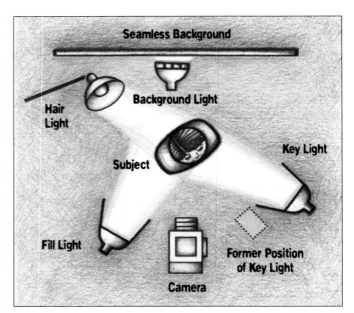

LOOP LIGHTING

sufficient room between the diffuser and the reflector to allow heat to escape. The fill light should also have barn doors attached. If using a diffused light source like an umbrella for the fill light, be sure that you are not "spilling" light into unwanted areas of the scene, such as the background.

The hair light, which is optional if you're on a budget, is a small light. Usually, a scaled-down reflector with barn doors for control and a reduced power setting is used, because hair lights are almost always undiffused. Barn doors are a necessity, as this light is placed behind the subject to illuminate the hair; without barn doors, the light will flare.

The background light is also a lower-powered light. It is used to illuminate the background so that the subject and background will separate tonally. The background light is usually used on a small stand placed directly behind the subject, out of view of the camera lens. It can also be placed on a higher stand and directed onto the background from either side.

Kickers are optional lights used very much like hair lights. These add highlights to the sides of the face or body to increase the feeling of depth and richness in a portrait. Kickers produce highlights with great brilliance since the light from them just glances off the skin or clothing. Because kickers are set behind the subject, barn doors or snoots (conical black reflectors used to shrink the beam of emitted light) should be used.

□ BROAD AND SHORT LIGHTING

There are two basic types of portrait lighting: broad lighting and short lighting.

Broad lighting means that the key light is illuminating the side of the face turned toward the camera. Broad lighting is used less frequently than short lighting because it tends to flatten out and de-emphasize facial contours. It is often used to widen a thin or long face.

Short lighting means that the key light is illuminating the side of the face turned away from the camera. Short lighting emphasizes facial contours, and can be used as a corrective lighting technique to narrow a round or wide face. When used with a weak fill light, short lighting produces a dramatic lighting with bold highlights and deep shadows.

□ BASIC LIGHTING SETUPS

There are five basic portrait lighting setups. As you progress through them from Paramount to split lighting, each progressively makes the face slimmer. Each also progressively brings out more texture in the face because the light is more to one side. Additionally, as you progress from paramount to split lighting, you'll notice that the key light mimics the course of the setting sun—at first high, and gradually lower in relation to the subject. It is important that the key light never dip below subject/head height. In traditional portrai-

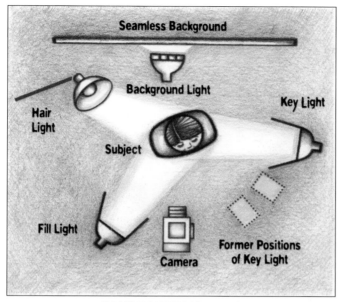

REMBRANDT LIGHTING

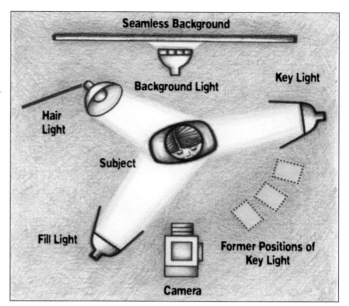

SPLIT LIGHTING

The diagrams here and on the facing page show the five basic portrait lighting setups. The fundamental difference between them is the placement of the key light. Lighting patterns change as the key light is moved from close to and high above the subject to the side of the subject and lower. The key light should not go below eye level, as lighting from beneath does not occur in nature. You will notice that when the key and fill lights are on the same side of the camera, a reflector is used on the opposite side of the subject to fill in the shadows.

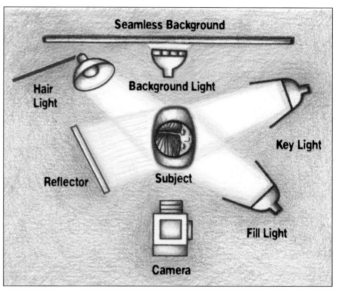

PROFILE OR RIM LIGHTING

ture this does not occur, primarily because it does not occur in nature, since light from the sun always comes from above.

Paramount Lighting. Paramount lighting, sometimes called butterfly lighting or glamour lighting, is a traditionally feminine lighting pattern that produces a symmetrical, butterfly-like shadow beneath the subject's nose. It tends to emphasize high cheekbones and good skin. It is generally not used on men because it tends to hollow out their cheeks and eye sockets.

The key light is placed high and directly in front of the subject's face, parallel to the vertical line of the subject's nose (see diagram). Since the light must be high and close to the subject to produce the wanted butterfly shadow, it should not be used on women with deep eye sockets, or no light will illuminate the eyes. The fill light is placed at the subject's head height directly under the key light. Since both the key and fill lights are on the same side of the camera, a fill card must be

used opposite these lights and in close to the subject to fill in the deep shadows on the neck and shaded cheek.

The hair light, which is always used opposite the key light, should light the hair only and not skim onto the face of the subject. The background light, used low and behind the subject, should form a semi-circle of illumination on the seamless background (if using one) so that the tone of the background grows gradually darker the farther out from the subject you look.

Loop Lighting. Loop lighting is a minor variation of Paramount lighting. The key light is lowered and moved more to the side of the subject so that the shad-

ow under the nose becomes a small loop on the shadow side of the face. This is one of the more commonly used lighting setups and is ideal for people with average, oval-shaped faces.

In loop lighting, the fill light is positioned on the camera–subject axis. It is important that the fill light not cast a shadow of its own in order to maintain the one-light character of the portrait. The only place you can really observe if the fill light is doing its job is at the camera position. Look to see if the

TOP—Bill McIntosh created this homage to Hollywood lighting using a 31-inch umbrella as a key light and a weak umbrella fill light, about three stops less than the key light intensity. You can see the Paramount lighting pattern on the man produces a small butterfly-like shadow under the nose. The woman's face, because her head was turned slightly to the light, displays more of a loop lighting pattern. A characteristic of the Hollywood style was the weak fill light, which enhanced the lighting contrast as well as the dramatic nature of the lighting.

BOTTOM—Of their portraits, Joseph and Louise Simone say, "Our subjects are photographed under carefully monitored lighting, incorporating refined and meticulous rules of composition that enable one's personality to express itself." In this image, made with a Contax 645 camera using a Kodak 645 digital pro back, the key light, precisely placed in a softly lit loop lighting pattern, defines the character of this elegant portrait. Although the portrait has been extensively "painted," in Painter and Photoshop, it still maintains its photographic roots by nature of the dramatic lighting and perfect posing. The title of this image is *Who Am I*.

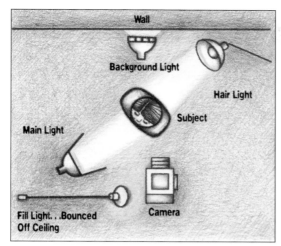

This is a variation of the loop lighting pattern, but with the key light set fairly low. This lighting pattern is ideal for people with average oval-shaped faces. To create this portrait, Robert Lino used a Mamiya RB67 camera with a Mamiya Sekor SF 150mm lens. The film used was Kodak Portra NC160, exposed for $1/125$ second at f/8. The main light was a Speedotron Force 10 with a Beauty Light parabolic reflector, and the fill was a Norman 808 (used at full power and bounced against ceiling). The background light was a Norman 808 (set at one-quarter power); the hair light was also a Norman 808, but used at full power and fitted with a cone diffuser.

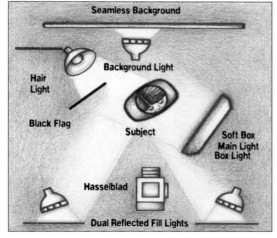

Soft light still has a lighting pattern that mimics nature. Here, dual reflected fill lights are placed behind the camera, pointed towards each other at 45-degree angles. The subject sits at a slight left angle to the camera, with a hair light above her head, a background light directly behind her, and a softbox main light 90 degrees to her left. Note the use of her hands and the harp, which "frame" the face. Michael Ayers used a Hasselblad camera with a 150mm lens. Fuji NHG II 120 film was shot at ISO 800, using an exposure of $1/60$ second at f/11.

fill light is casting a shadow of its own by looking through the viewfinder.

The hair light and background light are used in the same way as they are in Paramount lighting.

Rembrandt Lighting. Rembrandt lighting (also called 45-degree lighting) is characterized by a small, triangular highlight on the shadowed cheek of the subject. The lighting takes its name from the famous Dutch painter who popularized this dramatic style of lighting. This type of lighting is dramatic and more often a masculine lighting. It is commonly used with a weak fill light to accentuate the shadow-side highlight.

The key light is moved lower and farther to the side than in loop and Paramount lighting. In fact, the key light almost comes from the subject's side, depending on how far the head is turned away from the camera.

The fill light is used in the same manner as it is for loop light-

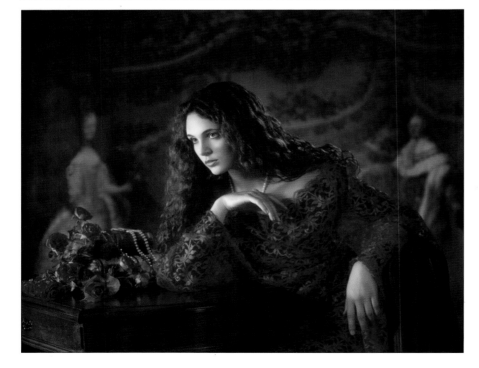

TOP—Classic Rembrandt lighting is characterized by the triangle-shaped highlight on the shadow side of the face. Anthony Cava employed basic window light and a single silver reflector to produce this classic image using a Hasselblad camera with an 80mm lens and a Lindahl drop-in filter in a Lindahl lens shade.

BOTTOM—This image, by Joseph and Louise Simone, is entitled *Mona Lisa*. It features strong lighting in a near-Rembrandt pattern with a very soft fill to lessen the drama of that lighting. The pose is extremely elegant and refined—the curve of the right hand points directly at the left hand, indicating to the viewer that the hands are significant keys to interpreting this young woman's character. The bold hair light enlivens her hair and the background, a hand-painted tapestry projected using the Scene Machine, a background projection system. The image was captured with a Contax 645 and a Kodak 645 digital pro back.

TOP—David Williams' Melbourne studio features a huge south-facing window (like our north-facing windows above the equator). It provides bright soft light and plenty of it. To create a beautiful split-lighting pattern he merely uses a small reflector or sometimes umbrella flash to augment the daylight and tighten up the lighting ratio. Here, a small reflector was used on the shadow side of the bride's face.

BOTTOM—David Williams likes realistic portraits in which you can almost reach out and touch elements in the image. Here, he used soft side light that creates a 45-degree lighting pattern on the subject's face. This also reveals texture in the spackle on the door and the contractor's tools. Note too, that David maintained the shadows of the image by careful exposure—you can see detail in the shadows that reveal the unfinished room. This image was made with a FujiFilm FinePix S2 Pro camera and a Sigma DG 24–70mm f/2.8 zoom lens.

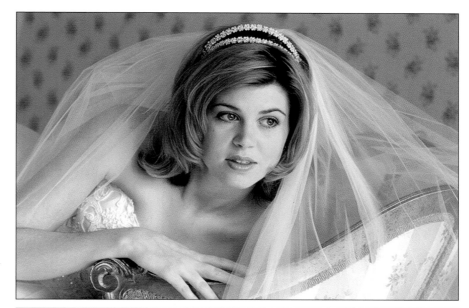

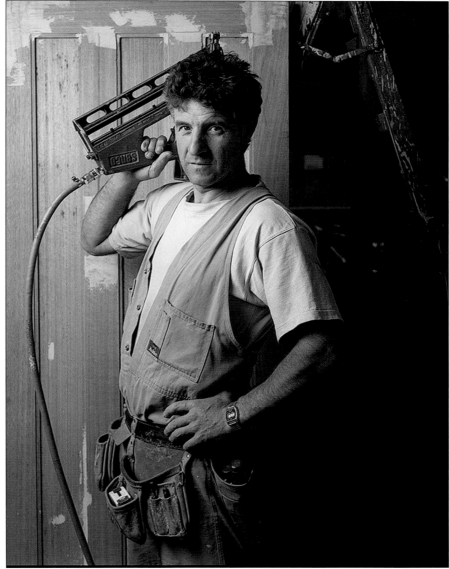

ing. The hair light, however, is often used a little closer to the subject for more brilliant highlights in the hair. The background light is in the standard position.

In Rembrandt lighting, kickers are often used to delineate the sides of the face and to add brilliant highlights. Be careful when setting such lights not to allow them to shine directly into the camera lens. The best way to check is to place your hand between the subject and the camera on the axis of the kicker, and see if your hand casts a shadow when it is placed in front of the lens. If so, then the kicker is shining directly into the lens and should be adjusted.

Split Lighting. Split lighting is when the key light illuminates only

half the face. It is an ideal slimming light. It can be used to narrow a wide face or a wide nose. It can also be used with a weak fill to hide facial irregularities. Split lighting can be used with no fill light for a highly dramatic effect.

In split lighting, the key light is moved farther to the side of the subject and lower. In some cases, the key light is slightly behind the subject, depending on how far the subject is turned from the camera. The fill light, hair light, and background light are used normally for split lighting.

Rim Lighting. Rim or profile lighting is used when the subject's head is turned 90 degrees from the camera lens. It is a dramatic style of lighting used to accent elegant features. It is used less frequently now than in the past, but it is still a stylish type of portrait lighting, even today.

In rim lighting, the key light is placed behind the subject so that it illuminates the profile and leaves a highlight along the edge of the face. The key light will also highlight the hair and neck of the subject. Care should be taken so that the core of the light is centered on the face and not too much on the hair or neck.

The fill light is moved to the same side of the camera as the key light and a reflector is used to fill in the shadows (see rim lighting diagram). An optional hair light can be used on the opposite side of the key light for better tonal separation of the hair from the background. The background light is used normally.

□ **THE FINER POINTS**

In setting the lights for the basic portrait lighting patterns discussed here, it is important that you position the lights with sensitivity. If you merely aim the light directly at the subject, there is a good chance you will overlight the subject, producing pasty highlights with no delicate detail. You must adjust the lights carefully, and then observe the effects from the camera position.

Feathering. Instead of aiming the light so that the core of light strikes the subject, feather the light so that you employ the edge of the light to illuminate your subject. This is one way to add *brilliance* to your highlights, minute specular (pure white) highlights that further enhance the illusion of depth in a portrait. However, since you are using the edge of the light, you will sometimes cause the level of light to drop off

If handled well, rim lighting is one of the most beautiful types of lighting you can use. Here, the photographer used dual key lights, both 30-inch softboxes. A third softbox was used to light the background. The baby is lit with the combination of both lights; the mother is one stop brighter than the father to emphasize the bond between mother and child.

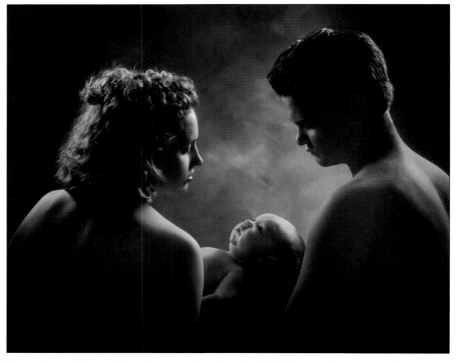

The only fill light is light bouncing around from the key lights. Metering was done for the highlight on the mother's face. Dale Hansen used a Mamiya RZ67 camera with a 120mm lens to create this image. Kodak NC 400 film was exposed for $^1/_{125}$ second at f/11.

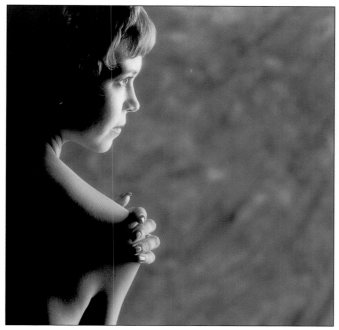

Here is another example of expertly handled rim lighting. In this instance, the key light is moved closer to parallel to the subject's face so that more of the frontal planes of her face are illuminated. No fill light is used so the shadow areas seem to "fade to black." Photograph by Tony Corbell.

High-key portraits don't have to be all whites. In this image by Fuzzy Duenkel, the ratio between the soft window-light key and the reflector fill is kept very close to a 2:1 ratio. In addition, the image was slightly overexposed to move the tonal scale towards the highlights. The darkest tone in the image is roughly an 18 percent gray. The photo was made with a Nikon D1X and Nikkor 80–200mm f/2.8 zoom lens.

appreciably with no noticeable increase in highlight brilliance. In these cases, it is better to make a slight lateral adjustment of the light in one direction or another. Then check the result in the viewfinder.

Sometimes you will not be able to get the skin to "pop" regardless of how many slight adjustments you make to the key light. This usually means that your light is too close to the subject and you are overlighting your subject. Move the light back. A good working distance for your key light, depending on your room dimensions and the light intensity, is eight to 12 feet.

Fill Light Placement. The fill light can pose its own set of problems. If too close to the subject, the fill light often produces specular highlights on the shadow area of the face that make the skin appear oily. If this is the case, move the camera and fill light back slightly, or move the fill light laterally away from the camera slightly. You might also try feathering the light a bit. This method of limiting the fill light is preferable to closing down the barn doors of the light to lower the intensity of the fill light.

Another problem that the fill light often creates is multiple catchlights. These are the small specular high-

lights (pure white) that appear on the iris of the eye. When you use a fill light, you will get a set of catchlights from the fill as well as the primary set from the key light. The effect of two catchlights is to give the subject a "dumb stare"; a directionless gaze. This second set of catchlights is usually removed in retouching.

◻ LIGHTING RATIOS

The term "lighting ratio" is used to describe the difference in intensity between the shadow and the highlight sides of the face. It is usually expressed numerically. For example, a ratio of 3:1 means that the highlight

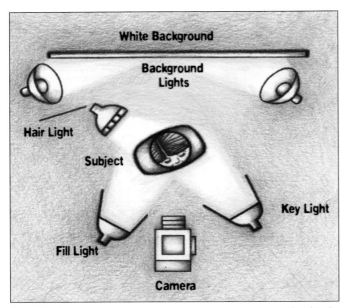

In a high-key lighting setup, you must over-light the background if you want it pure white in the photo. Here, two floodlights were used to light the background so that it was one stop greater than the frontal subject lighting.

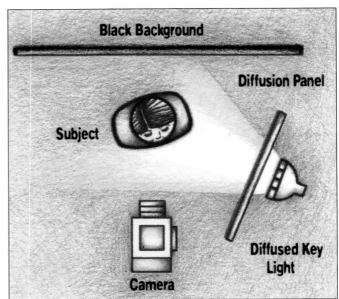

In low-key lighting, only one light is used from the side. To keep the shot dark throughout, no background or hair lights are used.

side of the face is three times brighter than the shadow side of the face.

Ratios are determined by measuring the intensity of the fill light on both sides of the face with a light meter, and then measuring the intensity of the key-light side of the face. If the fill light is next to the camera, it will cast one unit of light on each side (shadow and highlight sides) of the face. The key light, however, only illuminates the highlight side of the face, not the shadows it creates. If the key is the same intensity as the fill light, then you have a 2:1 lighting ratio. (There is one unit of light on each side of the face from the fill light, and one unit of light on the highlight side only from the key light. This means that the light on the highlight side of the face is twice as bright as on the shadow side; thus a 2:1 ratio.)

Ratios do not determine the overall contrast of the scene (the subject's clothing, the background, and the tone of the face determine that), but they do describe how much contrast the light is creating on the subject. Ratios also show how much the light will slim the face of the subject. The higher the lighting ratio (the greater the tonal difference between highlight and shadow side of the face), the thinner the subject's face will appear. Since lighting ratios reflect the difference in intensity between the fill light and the key light, the

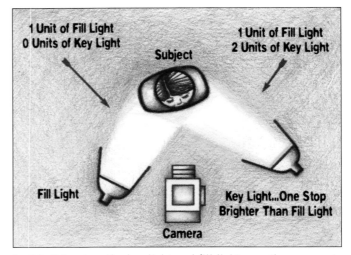

In this 3:1 setup, the key light and fill lights are the same output, but the key light is closer to the subject and as a result is one stop brighter. The fill light casts one unit of light on the shadow side and one unit of light on the highlight side of the face. The key light, being twice as bright, casts two units of light on the highlight side of the face only. The key light casts no light on the shadow side. Therefore, the lighting ratio is 3:1.

ratio also indicates how much shadow detail you will have in the final portrait.

A 2:1 ratio is the lowest lighting ratio you should employ. This ratio shows only minimal roundness in the face and is most desirable for high-key effects. High-key portraits are those with low lighting ratios,

light tones, and usually either a white or light-colored background.

A 3:1 lighting ratio is produced when the key light is one stop greater in intensity than the fill light. (One unit of light on both sides of the face from the fill light, two units of light on the highlight side from the key light; thus a 3:1 ratio.) This ratio is preferred for color and black & white because it will yield an exposure with excellent shadow and highlight detail. It shows good roundness in the face and is ideal for rendering average faces.

A 4:1 ratio (the key light is two stops greater in intensity than the fill light) is used when a slimming or dramatic effect is desired. In a 4:1 ratio, the shadow side of the face loses its slight glow and the accent of the portrait becomes the highlights. Ratios of 4:1 and higher are appropriate for low key portraits, characterized by dark tones and, usually, a dark background.

A 5:1 ratio (the key light is three stops greater than the fill light) and beyond is considered almost a high-contrast rendition. It is ideal for conveying a dramatic effect to your subject and is often used in character studies. Shadow detail is minimal at the higher ratios and, as a result, these ratios are not recommended for color films unless your only concern is highlight detail.

When determining the best lighting ratio to use, the medium you are using must be considered. A desirable ratio for color film is 3:1 because of the rather lim-

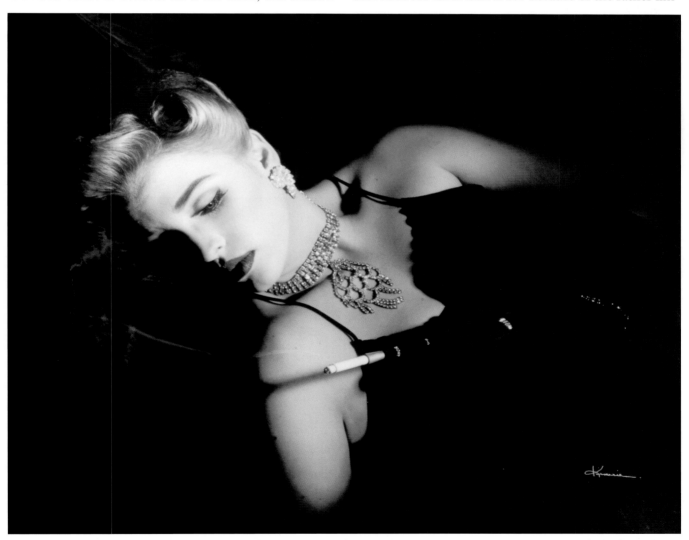

Low-key lighting is dramatic and reminiscent of the '40s style of portraiture. Here, the photographer used two softboxes together to act as a single, wrap-around key light. No fill light was used. Kimarie Richardson used a Mamiya 645 camera with an 80mm lens to create this image on T-Max 100 film. The lighting in the image comes from two Norman LH4a lights in softboxes, placed 45 degrees to camera left and right.

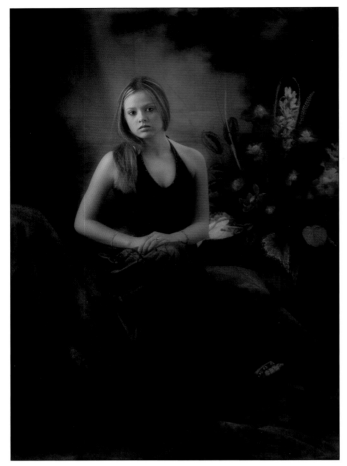

In this series of illustrations, Claude Jodoin shows how to create a low-key image with one light and no key-light fill. The single Alien Bees strobe was fired through two scrims to produce a soft wraparound split light. A silver reflector kicks a little light back onto the model's hair for dimension. Some mild diffusion (Gaussian Blur) was added in Photoshop for a more romantic feeling. Even though the image is low key, the lighting ratio is no more than 2:1. The low key feeling is achieved by biasing the exposure toward the shadows and by using dark tones throughout.

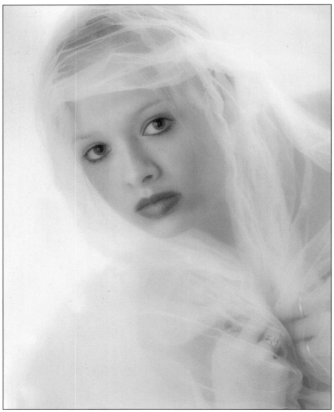

Claude again illustrates a one-light portrait using backlighting through a scrim and another scrim used as a frontal reflector. The same low-powered Alien Bees strobe was aimed down on the model to produce an overhead backlight. The exposure was biased towards the highlights to create a high-key look. In all of these exposures, made with a FujiFilm FinePix S2, a custom white balance reading was made with a Wallace Expo-Disk. According to Claude, who shoots in Fine JPEG mode, he never has to color balance a file in Photoshop since he gets it right in the camera.

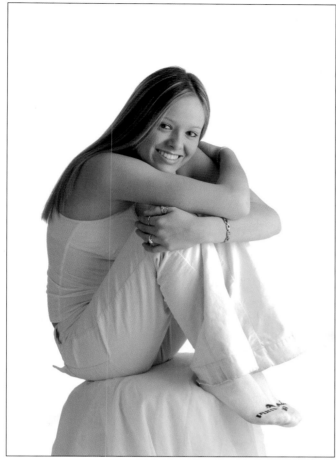

Claude really likes this shot (mainly because of the Puma socks). This high-key image was made, again, with a single Alien Bees strobe on low power. As you can see from the standing pose, the strobe was fired through a scrim while a standing second scrim and white floor covering acted as fill. In this image you can really see how clean the whites are in Claude's brand of digital portraiture—a characteristic he proudly attributes to the Wallace Expo-Disk and good exposures.

ited tonal latitude of color printing papers. Black & white films can stand a greater ratio, up to 8:1—although at this point it takes a near-perfect exposure to hold detail in both highlights and shadows.

☐ SETTING THE LIGHTS

Most photographers have their own procedures for setting the portrait lights. You will develop your own system as you gain experience, but the following is one plan you can start with.

Generally, the first light you should set is the background light (if you're using one). Place the light behind the subject, illuminating the part of the background you want lit. Usually the background light is slightly hotter (brighter) very close to the subject and fades gradually darker the farther out from the subject you look. This is accomplished by angling the light downward. If you have more space in front of than behind the subject in the composition, the light should be brighter behind the subject than in front as seen from the camera. In other words, if the subject is

slightly to the left of center in the frame, the background light should be brighter on the left side of the frame as well. This helps increase the sense of direction in the portrait. The background light is usually set up while all the other lights are turned off.

Next, the hair light (if using one) is set. This is also set up with your frontal lights extinguished so that you can look for stray light falling onto the face. If this happens, adjust the light until it illuminates only the hair. When photographing men, sometimes the hair light can double as a kicker, illuminating the hair and one side of the forehead or cheek simultaneously.

Next, the fill light is set. Usually it is used next to the camera (see the lighting diagrams on pages 46–47). Adjust it for the amount of shadow detail you want to achieve. Examine the subject's face with only the fill light on and determine if the skin looks oily or flat. Sometimes you will have to use pancake makeup to dry up excessively moist skin if adjusting the fill light won't correct the problem. If the skin looks too matte and lifeless, increase the amount of fill.

Next, turn on the key light and adjust it for the lighting pattern you desire. Move it closer or farther from the subject to produce the ratio you want. Ratios are best metered by holding an incident light meter first in front of the shadow side of the face, and then in front of the highlight side, in each case pointing the meter directly at the light source. By determining how many stops of difference there are between your lights you will know the ratio:

0 stops between key and fill = 2:1
1 stop between key and fill = 3:1
2 stops between key and fill = 4:1
3 stops between key and fill = 5:1

□ METERING FOR EXPOSURE

If using an incident meter, hold the meter at the subject's nose and point it directly toward the lens. If any of the back lights (like hair lights or kickers) are shining on the meter's light-sensitive hemisphere, shield the meter from them, as they will adversely affect exposure. You are only interested in the intensity of the frontal lights when determining the correct exposure.

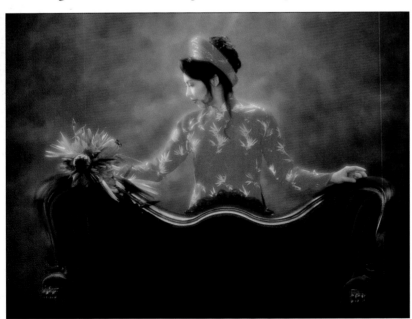

Rita Loy created this bridal portrait in profile. The key light, softened through on-camera diffusion so that it glows, is positioned behind and above the bride to produce a highlight on the shadow side of her cheek. There is good fill-in from a soft light at camera left, producing a 3:1 lighting ratio. The delicate hand posing against the dark mahogany of the loveseat creates a pleasing contrast of opposites.

Another type of professional meter that yields exacting results is the spot meter, which has a very narrow field of view—usually less than 5 degrees. Spot meters are reflected-light meters and for best results should be used with an 18-percent gray card, which will yield the proper exposure settings if held in precisely the same light that will expose your subject. If you wish to check lighting ratios, hold the gray card facing the key-light source and take a reading on that axis. Do the same for the fill light, holding the card on axis and metering on that same axis. Make sure there is no glare on the card from any of the other lights when taking a reading.

□ FLAGS OR GOBOS

Sometimes, because of the nature of the lighting, it is difficult to keep unflattering light off of certain parts of the portrait. A good example of this is hands that receive too much light and then gain too much dominance in the photograph. A good solution is to use a device called a gobo, which is a light blocking card, usually black, held on a boom-type light stand. Gobos, or flags as they're sometimes called, can be positioned between the light and the subject to shade an area from direct light. When placed in the path of a diffused light source, the light will wrap around the flag, creating a very subtle light-blocking effect. The less diffused the light source, the more pronounced will be the effect of the gobo.

□ REFLECTORS

The opposite of a flag is a reflector panel, which may be white, metallic silver, or metallic gold. Reflectors may be flexible or rigid, but their sole purpose is to bounce light into shadow areas of the photograph. A reflector can often take the place of a fill light, especially when using a large diffused key light. There is so much light scatter from the diffused light source that the reflector acts as a light collector, focusing light into needed areas.

*I*n chapter 3, we talked about how basic lights are used to produce the traditional portrait lighting patterns. The use of these lighting patterns, if practiced and refined, will help you produce elegant and professional-looking portraits.

You may find, however, that you prefer a more casual type of lighting that employs only one or two light sources. Your budget, too, may dictate a limited array of lighting equipment. In either case, you will find this chapter of interest.

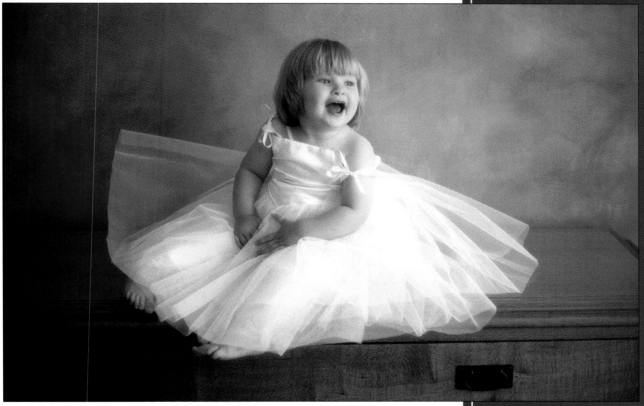

A south-facing studio produces beautiful soft light that requires little or no fill. Here, David Williams posed the little ballerina on a dresser that he often uses as a posing bench for his smaller subjects. She was photographed by window light with no fill. Williams often plays imaginative games with his child subjects to elicit priceless expressions.

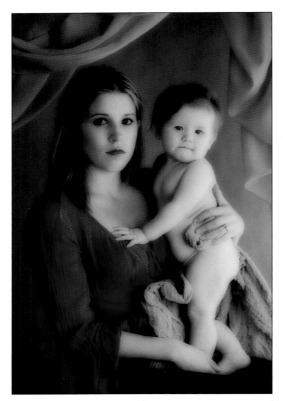

LEFT—Window light is soft but directional. The farther your subject is from the window, the less intense the light gets and the more contrasty it gets. Here, the mother and child are close to the soft window light for a soft look. In Photoshop, even more softness was added. Jennifer George Walker used a Nikon F100, with a Nikkor 70–210mm lens to create this image. The exposure, made using reflector fill, was $^{1}/_{30}$ second at f/5.6 on Kodak TCN 400. The title of the photo is *Madonna and Child*.

RIGHT—Here, the photographer harnessed the beauty of natural window light to photograph a beautiful profile. The window light was softened by the use of a Black Net #2 diffusion filter over the camera lens. Photograph by Rick Ferro.

The lighting techniques to be outlined here are very simple—most of them employ either available light, or at most two individual lights. These lighting techniques are simple and economical and you may find them particularly practical, as well.

◻ WINDOW LIGHT

One of the most flattering types of lighting you can use in portraiture is window lighting. It is a soft light that minimizes facial imperfections, yet it is also directional with good modeling qualities. Window light is usually a fairly bright light source that will allow you to hand-hold the camera if a moderately fast film and wide lens aperture are used. Window light is infinitely variable, changing almost by the minute, allowing a great variety of moods in a single shooting session.

Window lighting has several large drawbacks as well. Since daylight falls off rapidly once it enters a win-dow, and is much weaker several feet from the window than it is close to the window, great care must be taken in determining exposure. If the subject moves, even as little as six to eight inches, exposure will change. Another drawback is that you cannot move the light source, so you must move your subject in relation to the window. This can sometimes set up odd poses. When shooting in buildings not designed for photography, you will sometimes have to work with distracting backgrounds and at uncomfortably close shooting distances.

The best quality of window light is found in the soft light of mid-morning or mid-afternoon. Direct sunlight is difficult to work with because of its intensity and because it will often create shadows of the individual window panes on the subject. It is often said that north light is the best for window-lit portraits. This is not necessarily true. Good quality light can be had

from a window facing any direction, provided the light is soft.

Subject Positioning. One of the most difficult aspects of shooting window light portraits is positioning your subject so that there is good facial modeling. If the subject is placed parallel to the window, you will get a form of split lighting that can be harsh. It is best to position your subject away from the window slightly so that he or she can look back toward the window. Thus, the lighting will highlight more of the face.

You can also position yourself between the window and your subject for a flat type of lighting. Often, however, you'll find that you yourself will block some much-needed light, or that the subject must be quite far from the window to get the proper perspective and composition. Under these circumstances, the light

Basic window light (from a very large window) and a single silver reflector were used to produce this classic portrait with beautiful facial modeling. A Nikon F100, 80–200mm f/2.8 Nikkor lens, and Kodak 3200 TMZ film were used to make this shot. Photograph by Anthony Cava.

level will often be too low to ma
even with a fast film or ISO.

Usually, it is best to positio
five feet from the window. Thi
soft lighting, but also gives yo
produce a flattering pose and ¡

Metering. The best way
with a handheld incident met
subject's face in the same li
pointing the light-sensitive ¹
camera lens.

If using a reflected met
move in close to the subje
subject's face. If the subject is ᵖᵘ·
remember to open up at least one f-stop from the indicated reading. Most camera light meters take an average reading, so if you move in close on a person with an average skin tone, the meter will read the face, hair, and what little clothing and background it can see and give you a fairly good exposure reading.

If using an average ISO (ISO 100), you should be able to make a handheld exposure at a reasonable shutter speed like $\frac{1}{30}$ second with the lens opened up to f/2.8. Of course, this depends on the time of day and intensity of the light, but in most cases a handheld exposure should be possible. Since you will be using the lens at or near its widest aperture, it is important to focus carefully. Focus on the subject's eyes in a full-face or seven-eighths pose. If the subject's head is turned farther from the camera, as in a three-quarter view, focus on the bridge of the nose. Depth of field is minimal at these apertures, so control the pose and focus carefully for maximum sharpness on the face.

White Balance. If shooting digitally, a custom white-balance reading should be taken, since most window-light situations will be mixed light (daylight and room light). The Wallace Expo Disc is ideal for these situations with ambient room light plus daylight. Although preset white-balance values supplied in the camera's firmware may be adequate, it is better to take a custom white-balance reading.

If working in changing light, take another custom white balance reading every 20 minutes or so to ensure that the changing light does not affect the color balance of your scene.

TOP LEFT—Charles Maring found an area that lit the bride's veil with strong reflected direct backlight. The light passing through the veil acts as a diffuser and softens the lighting on the bride's face. He had to construct the pose (particularly the positioning of her eyes, head, and neck) to make this lighting work. He wanted a dramatic lighting, so no fill was used. However, extensive dodging and burning in Photoshop was needed.

TOP RIGHT—Sometimes no fill is possible and the photographer must make the best of the lighting situation. Here, Marcus Bell had his bride stride toward him in a hallway lit by intermittent bay windows. The areas which were unlit, he made black in printing to give the image some drama. He also tinted the image blue in Photoshop and tilted the frame to give it a very fashion-oriented edge. Although it looks like camera movement that is blurring the dress and bouquet, it is actually a little motion blur added in Photoshop.

LEFT—This image by Brian Shindle was lit by a bank of windows roughly 10 feet from the little girl. A single reflector was used on the shadow side of the girl for fill-in. The image was made digitally with a FujiFilm FinePix S2 Pro and 35–70mm f/2.8 Nikkor lens. The ISO was set to 400 and the exposure was $^1/_{90}$ second at f/4.8. Note the matching outfits of the doll and little girl—an effect suggested by the photographer.

Fill-in Illumination. One of the biggest problems commonly encountered with window light is that there is not adequate fill light to illuminate the shadow side of the subject's face. The easiest way to fill the shadows is with a large white or silver reflector placed next to the subject on the side opposite the window. The card has to be angled properly to direct the light back into the face.

If you are shooting a three-quarter- or full-length portrait, a fill card may not be sufficient; you may need to provide another source of illumination to achieve a good fill-in balance. Sometimes, if you flick on a few room lights, you will get good overall fill-in. Other times, you may have to use auxiliary bounce flash.

If using the room lights for fill, be sure they do not overpower the window light, otherwise, you will encounter a strange lighting pattern with an unnatural, double key-light effect. When using daylight-balanced color film or a daylight white-balance setting, you will get a warm glow from the tungsten fill lights when using them for fill-in light. This is not objectionable as long as the light is diffused and not too intense. Measure the intensity of the fill light by taking a light reading from the shadow side of the face, and then another from the highlight side. There should be at least one-half to one full f-stop difference between the highlight and shadow sides of the face.

It is a good idea to have a room light in the background behind the subject. This opens up an otherwise dark background and provides better depth in the por-

LEFT—Basic window light (from a large window) and a single silver reflector were used to produce this timeless wedding portrait. A Nikon F100, 80–200mm f/2.8 Nikkor lens, and Kodak 3200 TMZ film were used. The reflector was placed at a 45-degree angle to the subject for a more frontal fill. Photograph by Anthony Cava.

RIGHT—This photo was taken using the large beautiful window on the left. The photographer dragged the shutter (used a shutter speed that corresponded to the meter reading of the scene with available light only) to show the beautiful ambiance of the hallway and surrounding furnishings. He also added on-camera flash-fill to help whiten the dress. Dale Hansen created this image using a Hasselblad camera with an 80mm lens. The film was Kodak PMC 300, and it was exposed for $^1/_{30}$ second at f/5.6. The flash output was set to f/4.

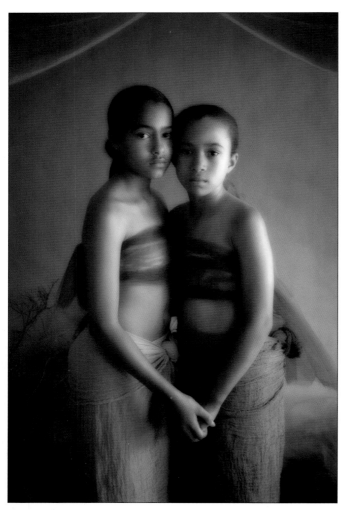

Jennifer George Walker created this wonderful portrait called *Cousins* using window light only. The girls were positioned precisely so that the girl on the right would not block the light falling on the girl to her left. Jennifer used minimal fill to keep the lighting ratio strong and to add a bit of mystery to the background elements. She photographed the image with a Fujifilm FinePix S2 camera and a wide-angle zoom. The ISO was set at 400 and the handheld exposure was $^1/_{45}$ second at f/3.5.

trait. If possible, position the background room light behind the subject, out of view of the camera, or off to the side, out of the camera's field of view. A bright light, if seen behind the subject, can be distracting.

If none of the above methods of fill-in is available to you, use bounce flash. You can bounce the light from a portable electronic flash into an umbrella or off a white card, the ceiling, or a wall, but be sure that it is one-half to one full f-stop less intense than the daylight. It is important when using flash for fill-in to either carry a flash meter for determining the intensity of the flash or to use an automated TTL flash system, which can accurately incorporate the daylight and flash exposures into a proper exposure.

If using a portable electronic flash in manual mode, calculate the distance from the flash to the reflective surface (i.e., the wall, ceiling, or card) and back to the subject. Then consult your flash calculator dial for the given f-stop. Open up 2½ f-stops more than the indicated reading for the proper bounce-flash aperture setting. Remember that the bounce-flash aperture should be one-half to one full stop less than the aperture already established for the window lighting.

Diffusing Window Light. If you find a nice location for a portrait but the light coming through the windows is direct sunlight, you can diffuse the window light with an acetate diffusing flat. These flats are sold commercially in sizes up to eight feet long, but you can also make your own by attaching diffusion material (like frosted shower-curtain material) to a light-weight frame.

Lean the flat in the window (or use masking tape to hold it in place) at a height that diffuses the light falling on your subject. Remember, the larger the diffuser (also called a scrim), the larger and more diffused your light source will be.

You can also use the scrim to diffuse direct sunlight coming through a window for a golden, elegant window light. Light diffused in this manner has the warm feeling of sunlight but without the harsh shadows. In fact, the light is so scattered that it is often difficult to see a defined lighting pattern. Because the sunlight is scattered so much by the diffusing material, you will often find that you don't need a fill-in source at all. Even without fill, it is not unusual to have a low lighting ratio in the 2:1 to 3:1 range.

◻ MASTERING ONE LIGHT

If you want to improve your portrait lighting techniques drastically in a relatively short time, learn to use one light to do the job of many. One light can effectively model the features of a single subject, or even a group of up to three people, with relative ease. Whether you own strobe, portable or studio flash equipment, or tungsten or quartz lighting equipment,

you will get your money's worth from it by learning to use one light well. You will also better understand lighting, and learn to "see" good lighting by mastering a single light.

Portable Flash. Portable flash is the most difficult of one-light applications. Portable flash units do not have modeling lights, so it is impossible to see the lighting effect before you take the picture. However, there are certain ways to use a portable flash in a predictable way to get excellent portrait lighting.

Bounce Flash. Bounce flash is an ideal type of portrait light. It is soft and directional. By bouncing the flash off a side wall or white card aimed at the subject, you can achieve an elegant type of wrap-around lighting that illuminates the subject's face beautifully.

You must gauge angles when using bounce flash. Aim the flash unit at a point on the wall that will produce the widest beam of light reflecting back onto your subject.

If the only available wall is very far from the subject, it might be better to bounce the light off a large

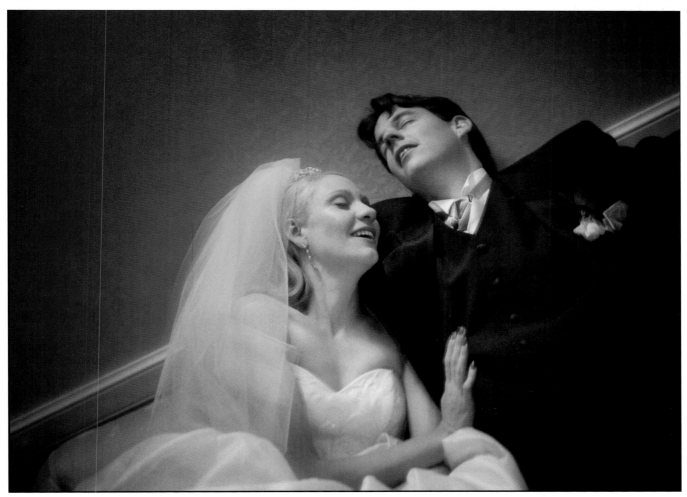

Ultra-fast lenses let you take advantage of all of the different flavors of light that exist on a location shoot. Here, Marcus Bell used his Canon EOS 1DS and EF 35mm f/1.4L lens to capture this priceless expression of the bride and groom exhausted and taking a breather. Marcus photographed the image by available tungsten light, but fired a bounce flash to fill in the harshness created by the overhead "can" lighting. The image was photographed at ISO 800 at $^1\!/_{60}$ second at f/1.6. He delicately burned in the area of wall behind the couple to give it a vignetted feeling.

white card onto the subject. This is an effect similar to umbrella lighting, which will be covered later in this chapter. The card should be between one and three feet away from the flash unit for best results.

This is a marvelous formal bridal portrait that incorporates three dissimilar light sources—daylight, incandescent harbor lights, and flash-fill. What makes this combination work is the ultrafast EF 35mm f/1.4 lens used on a Canon EOS 1DS by Marcus Bell. The white balance of the image was set for daylight, letting the tungsten-lit elements turn red/yellow. The on-camera flash was used only to put a twinkle in the bride's and groom's eyes but didn't do too much else. This is a remarkable portrait that incorporates the environment and the spectacular moment of the day.

You may be wondering how to support the reflector boards and cards you will need for a one-light setup. The best way is to use an assistant. If more than one reflector needs positioning, gaffer's tape and a light stand will work well (or use a second assistant). When on location, don't be afraid to recruit help from friends or family members of the subject.

Bounce Flash Devices. There are a number of devices on the market that make using flash fill a little easier. One such device is the Lumiquest ProMax system, which allows 80 percent of the flash's illumination to bounce off the ceiling while 20 percent is redirected forward as fill light. This solves the overhead problem of bounce flash. The system also includes interchangeable white, gold, and silver inserts as well as a removable frosted diffusion screen.

This same company also offers the Pocket Bouncer, which enlarges and redirects light at a 90-degree angle from the flash to soften the quality of light and distribute it over a wider area.

While no exposure compensation is necessary with TTL flash exposure systems, operating distances are somewhat reduced. With both systems, light loss is approximately $1\frac{1}{3}$ stops, however with the ProMax system, using the gold or silver inserts will lower the light loss to approximately $\frac{2}{3}$ stop.

Bounce Flash Exposure. While wall surfaces and textures differ, making it difficult to give a hard and fast rule for determining bounce flash exposure, you can use the same formula given for determining fill-flash for window-light

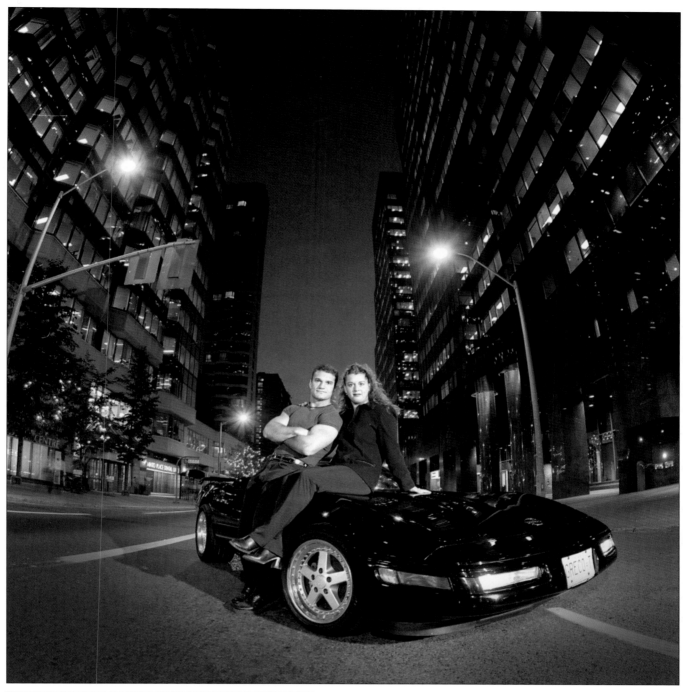

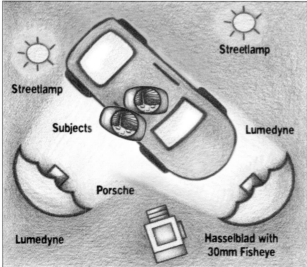

A Lumedyne flash in an umbrella was used to the right of the camera as a key light. A second Lumedyne flash in an umbrella was used on the opposite side of camera as a fill light. Anthony Cava dragged the shutter to record the ambient light in this nighttime scene. A Hasselblad camera and fisheye 30mm lens were used to make the image.

portraits (see pages 63–64). Determine the distance from the flash to the wall and back to the subject and consult the flash calculator dial for the appropriate f-stop with the film speed or ISO setting you are using. Then, open up 2½ f-stops for the right exposure. Since there are so many variables at play with bounce flash, be on the safe side and invest in a flash meter to use in these situations.

Some automatic flash units (portable) allow the flash head to swivel in any direction, while the flash sensor remains pointed at the subject. With these units, set the flash to an aperture recommended for bounce flash and consult the distance scale on the flash calculator dial to make sure that there will be enough light for a bounce-flash exposure.

Some flash units have a test button that allows you to fire the flash in the bounce mode. If a light comes on (it is usually green for "go") then you have enough light for the exposure.

TTL Flash Exposure. TTL flash systems, particularly those made by Nikon and Canon, produce amazingly accurate exposures in bounce-flash mode. Further, the bounce-flash output can be set to correlation to the available light-meter reading in fractions of f-stops, meaning that you can set your flash to fire at $1\frac{1}{3}$ stops less intensity than the daylight reading, for perfect, unnoticeable fill flash. Conversely, you can set your bounce exposure to fire at one stop over your daylight reading to overpower problematic room light. The versatility of these systems is remarkable and both manu-

facturers' systems have been refined over six and seven generations, making them virtually foolproof and fully controllable.

Diffused Flash. On-camera flash should be avoided altogether for making portraits unless it is a fill-in source. Its light is too harsh and flat and it produces no roundness or contouring of the subject's face. However, when you diffuse on-camera flash, you get a softer frontal lighting similar to fashion lighting. While diffused flash is still a flat lighting and frontal in nature, the softness of it produces much better contouring than direct flash. There are various devices that can be used to diffuse on-camera flash. Many can even be used with your flash in auto or TTL mode, making exposure calculation effortless.

All of the classic portrait lighting patterns presented in chapter 3 can be observed in nature. Sunlight is infinitely variable. As the sun rises and falls in the sky, light changes.

You can observe this by studying an object over a period of time. In addition to the changing angle of the sun, the light reflected from nearby objects is always changing, making the light even more variable. The great diversity, then, of outdoor lighting makes for an ideal situation in which to learn about portrait lighting.

Unlike the studio, where you can set the lights to obtain any effect you want, in nature you must take what you find. By far the best place to make outdoor portraits is in the shade, away from direct sunlight. There are ways to utilize direct sun in portraits, as will be shown elsewhere, but first one needs to learn to see lighting in the shade.

Robert and Suzanne Love primarily use natural light, so finding the right light and being able to see it is an absolute must. Here, the family was placed in shade but in order to raise the light level of the shade to match that of the background, a Lumedyne flash head in a 24-inch square softbox was placed behind the camera to create even lighting from side to side. A Bronica SQ-Ai camera with a 135mm lens and Kodak Portra 400 VC film were used to create this image.

LEFT—Available light from the right of scene illuminates this image. Sparkly highlights were added with the use of a Quantum V barebulb flash. In this photo, the basic natural light was beautiful, the photographer merely augmented its softness by adding a specular light source. Rick Ferro created this image using a Hasselblad camera with an 80mm lens and Kodak 400 PMC film. The exposure was $^1/_{30}$ second at f/8.

RIGHT—This beautiful golden outdoor portrait was made with available light and a gold foil reflector aimed in close to the family's faces. The use of the reflector does two positive things. First, it evens out the uneven shade lighting. Second, it adds a warm tone to the shaded light, which is often green because of light reflected from surrounding foliage. Photograph by Heidi Mauracher.

□ SHADE

Shade is nothing more than diffused sunlight. Contrary to popular belief, shade is not directionless light. It has a very definite direction. The best shade for portraiture is found in or near a clearing in the woods. In such areas, where trees provide an overhang above the subject, the light is blocked from above and diffused light filters in from the side. This produces better modeling on the face than open shade, which is overhead in nature and most unflattering. Like noontime sun, open shade leaves deep shadows in the eye sockets and under the nose and chin of the subject. The best kind of shade comes from an angle.

Another popular misconception about shade is that it is always a soft light. Shade can, in many instances, be extremely harsh—particularly on overcast days. Observe a person in open shade and you will see bright highlights and deep shadows on the face. Move under an overhang, such as a tree with low-hanging branches and you will immediately notice that the light is less harsh and that it also has a definite direction. It will also be less overhead in nature; coming from the side of the person that is not obscured by the overhang.

□ FILL-IN LIGHT

You are at the mercy of nature when you are looking for a lighting location. Sometimes it is difficult to find the right type of light you need. This can make it necessary to use fill-in light—either by bouncing natural light into the scene or by using a supplementary artificial light source.

Reflected Fill Light. When working outdoors, it is a good idea to carry along a portable light reflector. The size of this reflector should be fairly large—the larger it is the more effective it will be. Portable light discs, reflectors made of fabric mounted on a flexible and collapsible circular frame, come in a variety of diameters and are a very effective means of fill-in illumination. They are available from a number of manufacturers and come in silver (for maximum fill output),

white, gold foil (for a warming fill light), and black (for subtractive effects—more about this in a bit).

When the shadows produced by diffused light are harsh and deep, you will not get a flattering rendition of your subject. There will also be limited shadow detail. Using a reflector, you can fill in those shadows for a more even lighting pattern. With a foil reflector used close to the subject, you can even overpower the overhead nature of the lighting, creating a more pleasing and flattering lighting direction.

Many times nature provides its own fill-in light. Patches of sandy soil, light-colored shrubbery or a nearby building may supply all the fill-in you'll need. But be careful that fill light directed upward from the ground onto your subject does not overpower the key light. Lighting coming from under the eye/nose axis is generally unflattering and often called "ghoul light" for obvious reasons.

The fill-in reflector should be used close to the subject; just out of view of the camera lens. You may need to adjust it several times to fine-tune the effect and create the right amount of fill-in. Always observe lighting effects from the camera position.

Flash Fill Light. Sometimes you will need more fill light than any portable reflector can provide. This is when electronic flash fill-in is called for. With flash, you can use either an on-camera unit, which fills in the lighting on the subject–lens axis, or an auxiliary electronic flash, complete with its own reflector and/or diffusion setup.

Either way, you must be certain the flash doesn't overpower the ambient-light exposure or you will

darken the background too much. Many on-camera TTL flash systems use a mode for TTL fill-in flash that will balance the flash output to the ambient-light exposure for balanced fill-flash. Many such systems are also controllable by virtue of flash-output compensation that allows you to dial in full- or fractional-stop

You can make beautiful images even in direct sunlight, providing you fill in the harshest shadows. Here, the low angle of the sun made the sunlight very pleasing as a portrait light. An on-camera flash (a Sunpak 555) helped lessen the overall contrast of the light and fill in the under-chin shadows. Kimarie Richardson used a Mamiya 645 camera with an 80mm lens and Kodak T400CN film to create this image. The exposure was $^1/_{60}$ second at f/16.

output changes for the desired ratio of ambient-to-fill illumination.

□ SUBTRACTIVE LIGHTING

There are occasions when the light is so diffuse that it provides no modeling of the facial features. In other words, there is no dimension or direction to the light source. In these cases, you would use a black fill card or disc close to the subject. A black reflector literally reflects black into the subject, effectively subtracting light from one side of the face, creating a ratio between the highlight and shadow sides of the face. This differ-ence in illumination will show depth and roundness better than will the flat overall light.

□ ELIMINATING OVERHEAD LIGHT

If you find a nice location for your portrait but the light is too overhead in nature (creating dark eye sockets and unpleasant shadows under the nose and chin), you can use a card directly over the subject's head to block the overhead illumination. The light that strikes the subject from either side will then become the dom-inant light source. There are two drawbacks to using an over-head card. First, you will need to have an assistant to hold the card in place over the subject. Second, using the overhead card lowers the overall light level, meaning that you may have to shoot at a slower shut-ter speed or wider lens aperture than anticipated.

□ SCRIMS

If you find an ideal location, but the light filtering through trees is a mixture of direct and diffused light

ABOVE—Here is a delicately lit outdoor portrait that uses an overhang to subtract light, much like a reflector adds light. Notice the roundness and contouring of the light on the boys' faces—an effect created by the light being blocked overhead, but coming in from the sides. Photograph by Heidi Mauracher.

BOTTOM—An overhang, such as the corner of a building, is the perfect overhead light blocker—as you can see in this lovely portrait by Caresse Muir. As you can see by examining the light on the subject's cheek and hair, the late-afternoon day-light came from behind the subject. No fill reflector or light was added to the scene, but a building opposite the barn kicked up enough reflective light for an elegantly lit outdoor portrait. The image was made with a Fuji FinePix S2 Pro digital camera and a 70–300mm f/4 Nikkor zoom lens. The ISO was set to 200 and the image was exposed at $^1/_{60}$ second at f/4. The background was blurred by virtue of the wide tak-ing aperture.

(i.e., spotty light), you can use a scrim held between the subject and the light source to provide directional but diffused lighting.

Scrims, sometimes called diffusion flats, are available commercially from a number of manufacturers and come in sizes up to 6 x 8 feet. These devices are made of translucent material on a semi-rigid frame, so they need to be held by an assistant or assistants to be effectively used. Scrims are great when you want to photograph your subject in direct sunlight. Simply position the scrim between the light source and the subject to soften and change the available lighting. The closer the scrim is to the subject, the softer the light will be on the subject.

The scrim will lower the amount of light on the subject, so meter the scene with the device held in place. Since the light will be lower on your subject than for the background and the rest of the scene, the background may be somewhat overexposed—but this is not necessarily an unflattering effect. To avoid the background completely washing out, choose a dark- to mid-colored background so the effect will not be as noticeable. This type of diffusion works best with head and shoulders portraits since the size of the diffuser can be much smaller and held much closer to the subject.

Another use for this type of scrim is in combination with a reflector. With backlit subjects, the scrim can be held above and behind the subjects and a simple reflector used as fill-in for a dramatically soft type of outdoor lighting.

□ BACKGROUND CONTROL

The best type of background for a portrait made in the shade is one that is monochromatic. If the background is all the same color, the subject will stand out from it.

Seeing great light is everything. Here is Monte Zucker's account of the process he used to create this image: "Everywhere around this family was the cool blue light of early evening, but where they were positioned was in the middle of the magical warm glow of the setting sun. I fit the family into the spot, using the natural light almost as I would a spotlight. I was thrilled to see the natural vignetting of light around their faces and bodies. Again, all natural light."

Problems arise when there are patches of sunlight in the background. These can be minimized by shooting at wide lens apertures. The shallow depth of field blurs the background so that light and dark tones merge. You can also use some type of diffuser over the camera lens, such as a soft-focus filter or some mesh material taped to the lens. This will give your portrait a misty feeling, as well as minimizing a distracting background.

You can also minimize the impact of a distracting image using specialized printing techniques or digital retouching. When printing a film image, the background can be darkened by giving the image more exposure from the enlarger ("burning in") while protecting the rest of the image from the excess light by moving a card or your hand over it during the expo-

This is another great portrait made by available light only. Here, Heidi Mauracher used a low-angle, skimming light for a very flattering lighting. The golden sand dunes provided a natural source of fill light. The rest is just great composition. A Hasselblad camera with a MegaVision digital back was used to create this image.

sure. When working with a digital image, the burn tool in Photoshop can be used to selectively darken the background without affecting the exposure on the subject.

□ DIRECT SUNLIGHT

While shade is the preferable outdoor light for making portraits, successful images can also be created in direct sunlight. The two main problems with direct sunlight are the harshness (contrast) of the light and the subject's expression as a result of this harshness. If the person is looking toward a bright area, he or she will naturally squint—a very unnatural expression at best.

Skimming the Light. To control the harshness of the light, position your subject so that the light skims the person's face rather than striking it head-on. This will bring out the roundness in the face, reducing the pasty, blocked-up skin tones often associated with portraits made in direct sun.

Cross Lighting. When the sun is low in the sky, you can achieve good cross lighting, with the light coming from the side of the subject so almost half of the face is in shadow while the other half is highlighted. In the studio, this is known as split lighting. In this situation, it is an easy matter to position a fill card close to the subject to reduce the ratio between the highlight and shadow sides. The additional benefit of working with the sun at a low angle is that the subject will not squint, particularly if looking away from the sun. You must be careful to position the subject's head so that the side lighting does not hollow out the eye socket on the highlight side of the face. Subtle repositioning will usually correct this.

Backlighting. Backlighting is another very good type of direct sun lighting. The subject is backlit when the sun is behind the person, illuminating their hair and the line of their neck and shoulders. With backlighting, it is essential to use good fill-in light. When

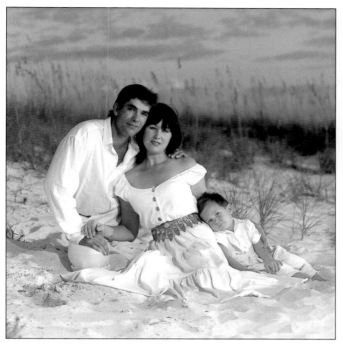

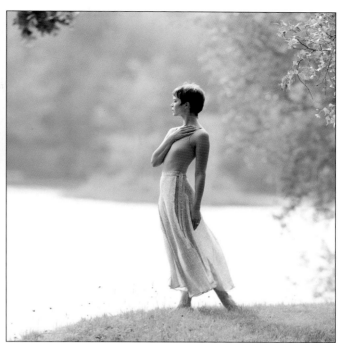

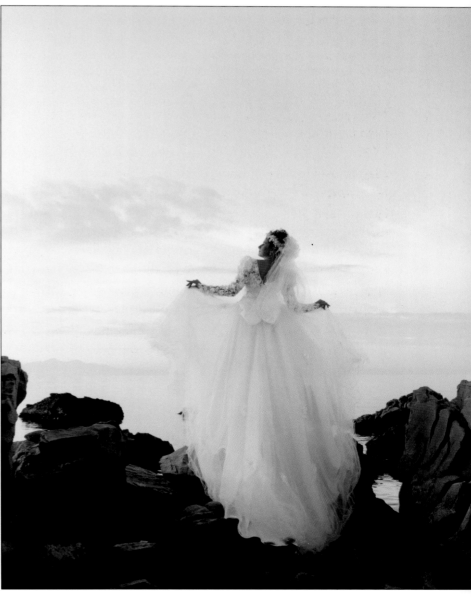

ABOVE—Cross lighting is the key to this image's success. However, with strong direct sun (even late in the day), harshness becomes a problem. Here, according to Monte Zucker, "I split-lighted the family with the direct sunlight and then brought a strong Quantum flash in from my left side to wrap the light around onto the shadow half of their faces. I exposed for the bright sunlight side of their faces and added the flash at one f-stop less than the daylight exposure reading."

TOP RIGHT—In backlit portraits, it is crucial to avoid underexposure. You can almost count on your in-camera meter reading being wrong. It is critical to use adequate fill light or to bias the exposure towards the shadow side of the subject, sacrificing highlight detail in the background. Here, the elegant pose is complemented by the elegant control of the backlighting, which produced open shadows and beautiful highlights along the contour of the subject's body. Photograph by Tony Corbell.

RIGHT—Here is a masterful backlit portrait in which the maker dared to put a white wedding dress against a near-white sky. The photographer, Bill Duncan, was merely going for a good natural light ratio on the subject's face. Much of the detail in the dress was held by exposure, some was held in printing. Notice that even though the hands are very small within the composition, the posing is expertly done and produces an elegant look. A Mamiya RB67 camera with a 65mm lens was used to create this image. The exposure was $^1/_{125}$ second at f/8.

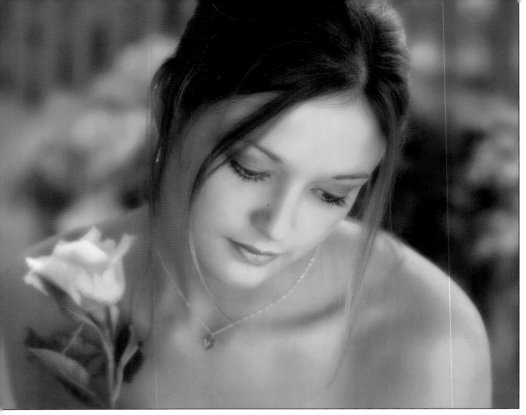

Would you believe this elegant lighting is all natural? It is, and it is how Fuzzy Duenkel likes to work. Soft backlight was magnified by the use of a silvered reflector, making the light more directional and crisp. The reflector was close and beneath the subject's face to provide a beautiful lighting pattern. Selective focus was employed by the use of a wide aperture, and Gaussian blur was added in Photoshop to create a subtle mask of sharpness, accentuating the girl's elegant features.

using a reflector, place it as close as possible to the subject without being in view of the camera lens. The reflector is normally positioned between the subject and the camera (beneath the lens) and angled upward into the subject's face.

Don't trust your in-camera meter in backlit situations. It will read the bright background and highlights on the hair instead of the exposure on the face. If you expose for the background light intensity, you will silhouette the subject. If you have no other meter than the in camera one, move in close and take a reading

HINTS AND TIPS

Be wary of lens flare in backlit situations. Use a lens shade if you have one or else angle the camera so it does not receive any direct rays of light on the lens. Lens flare will degrade the image in the areas of sharpness and contrast. Flare may not always be obvious at the lens's maximum aperture, so stop down and preview the shot to double-check for flare.

on the subject's face, being careful not to block the light from the reflector.

It is important to check the background while composing a portrait in direct sunlight. Since there is considerably more light than in a portrait made in the shade, the tendency is to use an average shutter speed like $\frac{1}{250}$ second with a smaller-than-usual aperture like f/11. Smaller apertures will sharpen up the background and distract from your subject. Preview the depth of field to analyze the background. Use a faster shutter speed and wider lens aperture to minimize background effects.

□ USING FLASH OUTDOORS

There are two ways to use electronic flash outdoors—you can use flash fill, which means the ambient light is your main light and the flash simply fills in the shadows, or you can use flash key, in which the flash overpowers the ambient light to become the main light.

Flash Fill. Electronic flash units have a flash calculator dial, that makes it easy to compute exposure. If you want to use the flash as a fill light, first take a meter reading of the ambient light. Since you want the flash to act as a secondary light, it must be less powerful than the ambient light. The best way to control the power output of your electronic flash for flash-fill situations is to use its auto-aperture flash setting. Automatic flash units can be set to a specific auto-aperture that will limit the flash duration to produce the exact amount of light specified. For example, imagine the meter reading for the ambient light calls for an exposure of $\frac{1}{60}$ second at f/8. In this case you would want to set the auto-flash so that it would produce an exposure of f/5.6 or f/4—one or two stops less than the daylight exposure. Note that a flash output of f/5.6 produces half as much light as a setting of f/8; a

flash output of f/4 produces half as much flash output as a setting of f/5.6.

Another popular flash-fill system involves using on-camera TTL flash. Many on-camera TTL flash systems include a mode for TTL fill-in flash that will balance the flash output to the ambient-light exposure. These systems are variable, allowing you dial in full- or fractional-stop output adjustments for the desired ratio of ambient-to-fill illumination. They are marvelous systems and, more importantly, they are reliable and predictable. Some of these systems also allow you to remove the flash from the camera with a TTL remote cord.

If you are using a studio-type strobe, like a monolight or bare-bulb flash, for which the power output is rated in watt-seconds, you must rely on a different means of varying flash output.

With an incident flash meter, take a reading of the daylight exposure in "ambient" mode. Next, in "flash-only" mode, take a reading of just the flash, positioned where you'd like it for the exposure. The flash will either be on a light stand or held by an assistant. The flash output can be regulated by adjusting the flash unit's power settings, which are usually fractional—$\frac{1}{2}$, $\frac{1}{4}$, $\frac{1}{8}$ and so forth.

As in the above example, if meter reading for the daylight

Fuzzy Duenkel uses light, posing, and color to create beautiful portraits. Here, the natural-looking pose is manipulated into a beautiful "S" curve that highlights the subject's shapely curves. Fuzzy manipulated the light, both in the original exposure with reflectors, and later in Photoshop with blending, to create a perfectly soft, sculpted light. Lastly, the photographer softened the background and enhanced the color to create a truly memorable portrait.

exposure is $\frac{1}{60}$ second at f/8, set your flash output so that the flash exposure is f/5.6 or less to create good flash-fill illumination.

Flash Key. To use your flash as a key light that overrides the daylight, adjust the flash-to-subject distance so that the flash produces an exposure greater than the ambient-light exposure. In the example used thus far, you would want a flash output setting of f/11 or f/16. This may entail bringing the flash in close to the subject. With auto-flash, adjust the f-stop control so that the flash output will equal f/11 or f/16. It is unwise to override the ambient light exposure by more than two f-stops. This will cause a spotlight effect that will make the portrait appear as if it were shot at night. It will also substantially darken the background.

When using the flash-key technique, it is best if the flash can be removed from the camera and positioned above and to one side of the subject. This will more closely imitate nature's light, which always comes from above and never head-on. Moving the flash to the side will improve the modeling qualities of the light and show more roundness in the face.

Modern TTL-flash metering, again, makes this type of calculation effortless.

□ ADDITIONAL TIPS FOR OUTDOOR LIGHTING

Create Separation. One thing you must beware of outdoors is to watch for subject separation from the background. A dark-haired subject against a dark background will not tonally separate, creating a tonal merger. You must find a way to reflect light onto the hair so that it separates from the background. Sometimes a reflector placed in close to the subject's face will do the job.

Use Care in Subject Positioning. Natural-looking subject positioning is often a problem when on outdoor location. If possible, a fence makes a good support for the subject. If you have to pose the subject on the ground, be sure it is not wet or dirty. Bring along a small blanket, which, when folded, can be hidden under the subject. It will ease the discomfort of a long shooting session and also keep the subject clean.

Employ a Tripod. If you are not using flash, you should use a tripod when shooting outdoor portraits. Shutter speeds will generally be on the slow side, especially when you are shooting in shade. Also a tripod helps you compose your portrait more carefully, and gives you the freedom to walk around the scene and adjust things as well as to converse freely with your subject. A tripod is also a handy device for positioning a reflector—the large ones often come with loops that can be attached to the legs or

Location is everything. Here, the location was perfect. However, time was short and the late-afternoon light was not completely cooperative. To lower contrast and warm the scene, Ferdinand Neubauer used a Leon Vignetter and a Stephen Rudd #2 Warm/Soft filter. The on-camera diffusion lowered contrast as well as provided a romantic feeling. A Hasselblad 500CN camera with a 100mm lens was used to create this image on Kodak Portra 400NC film rated at ISO 320.

Joe Photo created this beautiful engagement portrait of the couple in the middle of an open canyon. The lighting provided excellent facial modeling, but the overhead blue sky made the scene entirely too cyan. He chose one of the white balance presets on his Nikon D1X for afternoon shade to neutralize the excess cyan. Notice how clean the whites are in this image.

ground (without sacrificing the critical focus on the subject). Simply duplicate the background layer (which contains the original image) and apply the desired diffusion to the duplicate layer. Then, use the eraser on the duplicate layer to allow the sharp detail on the original underlying layer to show through only where you want it to.

Watch the Color in the Shadows. Another problem you may encounter is excess cool coloration in portraits taken in shade. If your subject is standing in a grove of trees surrounded by green foliage, there is a good chance that green will be reflected into the subject's face. If the subject is exposed to clear, blue, open sky, there may be an excess of cyan in the skin tones. This won't affect your black & white shots, but when working in color, you should beware.

In order to correct green or cyan coloration, you must first observe it. Although your eyes will quickly neutralize the color cast, color film will not be as forgiving. Study the subject's face carefully and especially note the coloration of the shadow areas of the face. If the color of the light is neutral, you will see gray in the shadows. If not, you will see either green or cyan.

When shooting film, you'll need to use a color compensating (CC) filter in a complementary color over the lens to correct this problem. These are gelatin filters that fit in a gel filter holder. With digital, which is much easier, you only need to create a custom white-balance setting or use one of the camera's existing white-balance settings, like "open shade." Those who use the Wallace Expo Disc swear by its accuracy in these kinds of situations. By correcting the white balance, there is no need to color-correct the scene with filters. (Of course, the color can also be refined in Photoshop using the selective color adjustments, curves, or other color-correction tools.)

knobs of the tripod when you are working without an assistant.

Fix it in Photoshop. Sometimes you may choose a beautiful location for a portrait, but find that the background is totally unworkable. It may be a bald sky or a cluttered background. The best way to handle such backgrounds is in Photoshop. This is true whether the image was recorded digitally, or on film and scanned later. Using Photoshop, you can create transparent vignettes of any color to deemphasize the background. You can also selectively diffuse the back-

6.
Spontaneous Portraits

*S*ome of the finest portraits are those made without the subject being aware of the camera. This style of portraiture is based on the images made popular by contemporary wedding photojournalists. The objective is to let the scene tell the story, recording a delicate slice of life that captures the greater meaning of the events shown in the lives of those pictured.

The most important aspect of shooting spontaneous portraits is to work unobserved, which can be next to impossible when the subject is seated in front of lights in one of the most artificial of settings—the portrait studio. However, while the studio portrait photographer cannot work unobserved like the wedding photojournalist, he or she can be observant and quick to react. Many fine portrait artists rely on their ability to observe and appraise the subject's features and personality while looking for those moments that reveal the essence of the person.

Dennis Orchard, a talented English wedding photographer, is not above "restaging" a shot to get a good one. Here, this mother had just given her two boys a fierce hug and Orchard missed it. He grabbed a chair to get above the crowd and asked for another hug. She complied and Orchard recreated the moment.

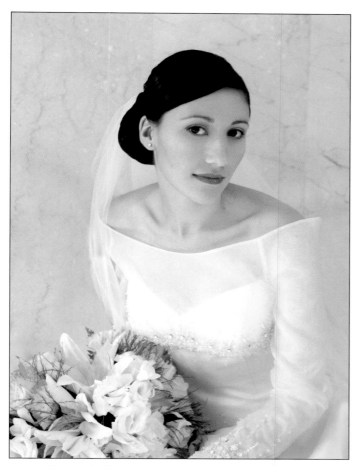

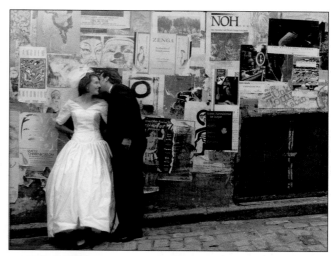

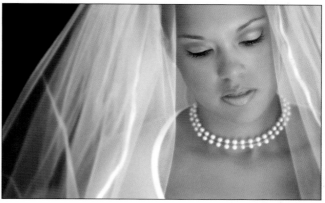

LEFT—Marcus Bell captured the natural beauty of this bride *and* her personality. In this high-key study of whites and off-whites, offset by her almost black eyes, the photographer has created a compelling portrait that forces you to analyze her eyes, which reveal a quiet confidence and intelligence. This image was made by available light with no flash or supplemental fill-in.

TOP RIGHT—The good journalistic photographer is like a fly on the wall—invisible. He or she may not necessarily direct the action, but set up a situation in which the subject(s) interact naturally, as was done here. Photograph by Craig Larsen.

BOTTOM RIGHT—Parker Pfister is a gifted wedding photographer. Here, he used diffused sunlight bounced up onto the bride's face from below—normally not an attractive lighting. He chose to photograph her beautiful eyes in a dreamy pose that reveals the beauty of her eye makeup and sensuous lips. The image was made with a Nikon D1X and 80–200mm zoom lens set at the 150mm setting. The daylight exposure was made at $^1/_{90}$ second at f/2.8.

Tim Kelly, a modern day portrait master, says, "Watch your subjects before you capture the image. Sometimes the things they do naturally become great artistic poses." For this reason, Kelly does not warn his clients when he is ready to start a portrait session. "I don't believe in faking the spontaneity of the subject's expression," Kelly says.

While the pure wedding photojournalist does not intrude on the scene, it is sometimes necessary to inject a bit of "direction" into the scene. I am reminded of a story related by Dennis Orchard, a well known wed-ding photographer from the U.K. He observed a mother embracing her two sons at a wedding and it was a priceless moment. By the time he got up on a chair the shot had disappeared. Because he prides him-self on learning peoples' names at the weddings he cov-ers, he called over to the mom and said, "How about another hug?" Since the emotion was still fresh, she complied and Orchard got an award-winning shot.

Marcus Bell, an Australian wedding and portrait photographer, is never in a rush to take his portraits. He uses rapport and his ability to relate to people and

put them at ease to infuse his personality into the session. In this way, he leaves nothing to chance, but also lets his subjects define their own poses. He says, "I want to capture the true individuality and personality of the person. The posing needs to be natural to the person you're photographing and to emulate the person's personality or features and not detract from them. I use several techniques to ensure the posing relates to the subject, but to do this you first need to do your groundwork and include your subject in your preparations."

Bell uses a number of techniques to begin the interaction—like having a coffee, walking to the shooting location—in order to provide ample opportunity to talk and get the relationship established. "Where possible," he says, "I want to minimize the direction that I'm giving them and to allow them to be themselves. Because of the relationship and trust that we have started, though, I can give them directions to pose in a way that appears to the subject to be more like normal conversation rather than them feeling I'm just telling them what to do. They also start feeling more involved in the whole process."

Marcus Bell uses the large LCD screens of his digital cameras as social and posing prompts, showing his clients between shots what's going on and offering

LEFT—Very low light was harnessed by using fast film and a wide-open aperture. Note, too, that when shooting 35mm film or digital, using the motor drive or burst mode will sometimes pay dividends—since sometime the keeper is the shot made right after the posed portrait. Photograph by Craig Larsen.

BELOW—David Williams captured this moment before the wedding. The bride seems lost in her thoughts and was probably unaware of his presence.

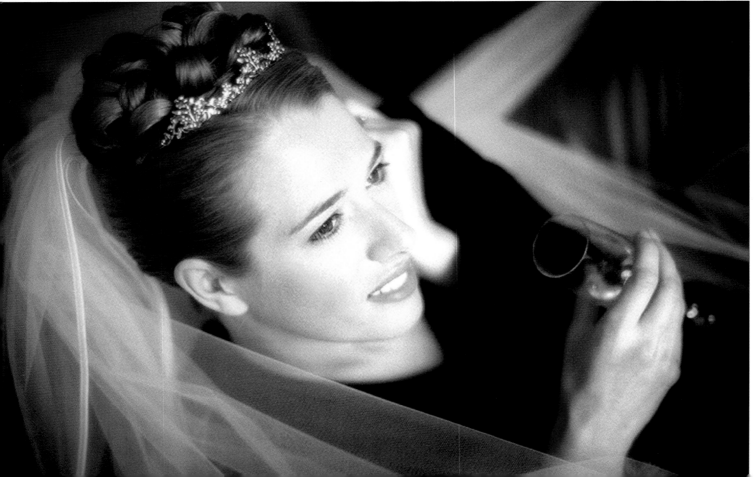

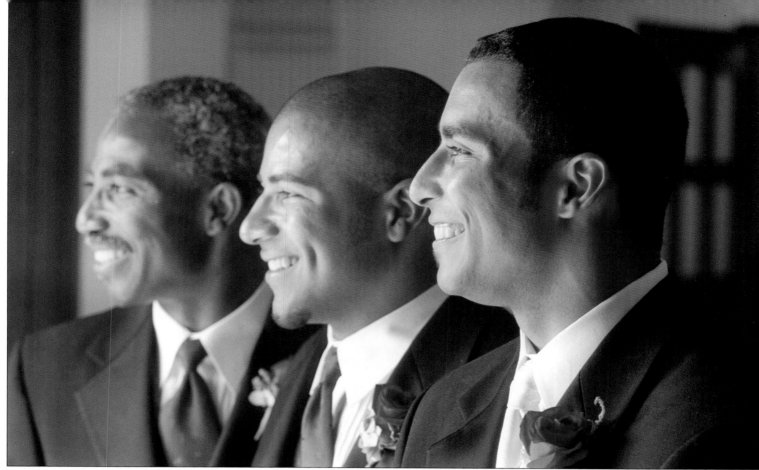

ABOVE—As a working photojournalist, Scott Eklund makes his living by his reflexes and when he encounters a scene like this, he waits for the moment to define itself. With beautiful daylight filtering in, Scott focused on the groom and waited until a smile enveloped all three men.

RIGHT—David Williams captured a real, poignant moment between bride and groom on wedding day. He later gave it a treatment reminiscent of a Polaroid transfer print.

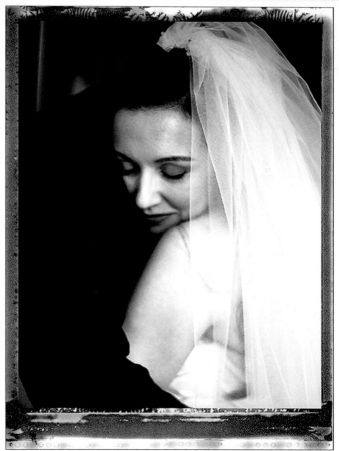

friendly ways to improve on the pose. He will often take an image of the scene, showing them images even before he has included them in the scene. According to Marcus, "This builds rapport, trust, and unity as you have their cooperation and enthusiasm."

Jerry Ghionis, another successful Australian wedding and portrait photographer, believes in making his couples look glamorous but natural at the same time. Of his studio's work he says, "A consistent comment we hear from our clients is that our photos look too good to be true, too glamorous to be unposed but too natural to be posed."

Jerry does not pose his clients, he "prompts" them. "I prompt them in situations that appear natural," he

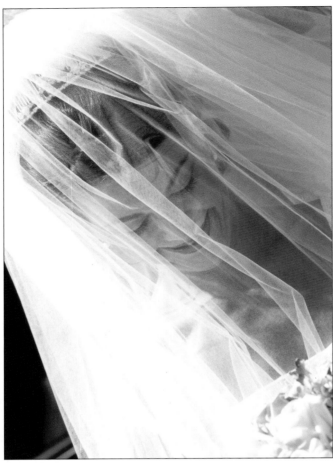

This informal portrait was made during a break from a formal portrait session. Michelle Celentano used a Canon EOS A2 camera with a 28–135mm lens and Kodak TMZ 3200 film.

says. He first chooses the lighting, selects the background and foreground, and then directs his clients into a "rough" pose—a romantic hug, a casual walk, the bride adjusting her veil, and so forth. The spontaneous moments he gets are directed and seem to evolve during the shoot, depending on what suits the different personalities he is working with.

A technique Jerry relies on is the "wouldn't it be great" principle. For example, if he thinks to himself, "Wouldn't it be great if the bride cracked up laughing, with her eyes closed and the groom leaning towards her?" Then he will ask for the pose. Some would argue that the shot has been manufactured. Jerry thinks it's no more manufactured than a scene in a movie. "Who cares how you got there—the end justifies the means. You first have to previsualize the shot you want before you can direct it."

The net result of the techniques described by these photographers—Kelly, Orchard, Bell and Ghionis—is the release and capturing of spontaneous expressions.

□ SHOOTING TECHNIQUES

In spontaneous portraiture, the aesthetic aspects of lighting, composition, and posing should not be discarded in favor of merely recording a special scene with enough exposure so the participants and situations are recognizable.

Composition. You are depending on the action to give you the impact of the photograph. Therefore, you should compose the scene loosely so that it may be cropped later for better composition. Leave plenty of space around the subject(s) and concentrate on the scene and the action itself.

Shutter Speed. At slow shutter speeds, steady camera handling is all-important. To help steady the camera, keep your elbows in close to your body when the camera is held up to your eye. Position the thumb of your right hand on the camera base-plate so that it acts as a counter-support for your index finger, which depresses the shutter button. Practice this method of shooting and it will extend your potential handheld-shooting range down to $\frac{1}{8}$ or $\frac{1}{15}$ second.

Squeeze the shutter button rather than pressing down firmly. Try to use just the tip of your finger to press down to avoid camera shake.

If you are not confident working at $\frac{1}{60}$- or $\frac{1}{30}$-second shutter speeds, brace yourself against a doorjamb or wall for better support. You can also position the camera on a chair or table top to steady it. Monopods are also great supports that allow you to be mobile but give you the needed camera support to work in low and ultra-low light.

Don't Skimp. Whether you are working digitally or with film, shoot plenty of images. These moments are fleeting, you'll probably shoot quite a few not-so-great images for every really good one you get.

Master Your Camera Controls. The best journalistic photographers have their camera-handling technique down cold. Focusing, composing, and exposing should be second nature. The better your skill level at quick and efficient camera handling, the better your portraits will be.

7.
Corrective Techniques

The art of good portraiture is found in the photographer's ability to idealize a subject. This demands that the photographer know practical methods of correcting the subject's physical flaws and irregularities.

It's important to understand that people don't see themselves the way they *actually* appear. Subconsciously, they shorten their noses, imagine they have more hair than they really do, and in short, pretend they are better looking than they really are. A good portrait photographer knows this and acts on it the instant a person arrives. As a matter of procedure, the photographer analyzes the face and body and makes mental notes as to how best to light, pose, and compose the subject to produce a flattering likeness.

This chapter deals with practical ways to idealize the subject. Within reason, a list of the possible physical shortcomings of people has been given, along with a practical method to cure that particular ill. To the serious portrait photographer, this type of corrective photography is as important as lighting, posing, and composition basics.

□ FACIAL ANALYSIS

The expert portrait photographer should be able to analyze a subject's face with a brief examination, much like a doctor examines a patient for symptoms. Under flat lighting, examine the subject from straight on and gradually move to the right to examine one side of the face from an angle, and then repeat on the left side. You can do this while conversing with the person and they will feel less self-conscious. Examine the face on both sides from full face to profile. In your analysis, you are looking for:

1. The most flattering angle from which to photograph the person. It will usually be at the seven-eighths or three-quarters facial view, as opposed to head-on or in profile.
2. A difference in eye size. Most people's eyes are not exactly the same size, but both eyes can be made to look the same size by positioning the smaller eye closest to the lens so that natural perspective takes over and the smaller eye looks larger than it is because it is closer to the lens.

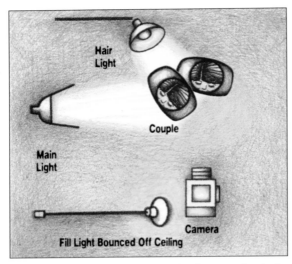

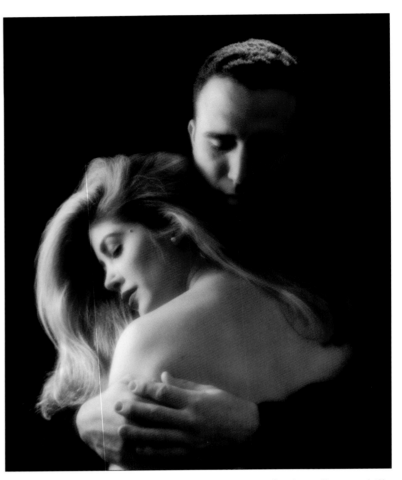

Soft focus is not only a "disguising" corrective technique, but provides a romantic mood. Robert Lino used a Mamiya RB67 camera with a Mamiya-Sekor SF (soft focus) 150mm lens to create this portrait on Kodak VPS 160 film, which he exposed for $^{1}/_{125}$ second at f/11. The key light was a Speedotron Force 10 with a Beauty Light parabolic reflector. For fill light, Lino used a Norman 808, set at full power and bounced off of the ceiling. The hair light was a Norman 808 set at half power.

3. Changes in the face's shape and character as you move around and to the side of your subject. Watch the cheekbones become more or less prominent from different angles. High and/or pronounced cheekbones are a flattering feature in males or females. A square jaw line may be softened when viewed from one angle; a round face may appear more oval-shaped and flattering from a different angle; a slim face may seem wider and healthier when viewed from head on, and so forth.

4. The person's best expression. Through conversation, determine which expression best modifies the best angle—a smile, a half-smile, no smile, head up, head down, etc.

□ SOFT FOCUS AND DIFFUSION

Skin problems are the most frequent physical problem the portrait photographer encounters. Young subjects have generally poor skin—blemishes or pockmarks. Older subjects have wrinkles, age lines, and age spots.

In subjects of all ages, the effects of aging, diet, and illness are mirrored in the face.

Soft focus or diffusion on the camera lens minimizes facial defects and can instantly take years off an elderly subject. Softer images are often more flattering than portraits in which every facial detail is visible. Soft-focus images have also come to connote a romantic mood in portraits and pictorial photography.

There are four ways to diffuse the image for soft-focus effects. First, you can use a soft-focus lens, which is a lens designed to produce a sharp image point sur-

HINTS AND TIPS

With both spherical-aberration soft-focus lenses and diffusion filters, the soft-focus effect is diminished by stopping down the lens. Therefore, the lens is used wide open, close to or at its maximum aperture for the softest image. Another type of soft-focus lens, which is not too popular today, uses controlled chromatic aberration, and is unaffected by stopping the lens down.

rounded by an out-of-focus halo. These lenses produce this effect because they are uncorrected in some degree for spherical aberration. Soft-focus lenses do not produce an out-of-focus image; rather, they give a sharp image with an out-of-focus halation around it.

The second means of diffusing an image is with a soft-focus or diffusion filter. These blend the highlights of the image into the shadow areas by diffusing the light rays as they pass through the filter. Soft-focus or diffusion filters come in degrees of softness and are often sold in sets with varying degrees of diffusion.

The third method of image diffusion is diffusing the negative during printing. This has the opposite effect of on-camera diffusion, and blends shadows into highlights. Unfortunately, this sometimes produces muddy prints with lifeless highlights, depending on the technique, time of diffusion, and material used.

Perhaps the best way to minimize facial flaws is in Photoshop using selective focus. This technique will be outlined in chapter 8. Selective diffusion allows you to keep crucial areas of the face sharp—the eyes, lips, nose, and eyebrows—while diffusing the problem areas of the face. The viewer is fooled by seeing important parts of the face in focus, making the technique foolproof.

Regardless of how you diffuse the image, you will want to be judicious about the amount of softness you

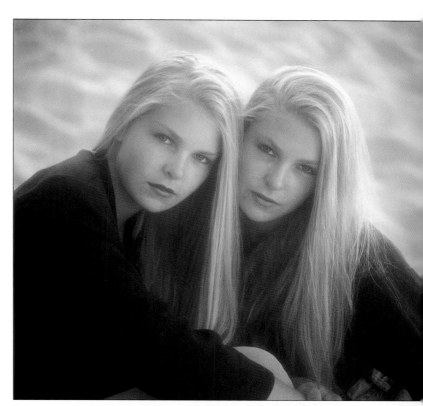

TOP—This portrait was made by available light from an open sky, with the sun setting behind the girls. A gold reflector was placed in front of them to warm the fill light. On-camera diffusion was used with soft light and slight overexposure to key the exposure towards the highlights. Robert and Suzanne Love used a Bronica SQ-Ai camera with a 150mm lens and Kodak Portra 400 VC film to create this image.

BOTTOM—Expert portrait photographers carefully analyze every face they photograph. They tell themselves how high the camera should be, what kind of lighting (short/broad, diffused/specular, etc.), and what facial angle and pose will most flatter the person. In this interesting portrait by Anthony Cava, the pose and angle of her face are perfect. The photographer has optimized his subject beautifully. The treatment, a kind of cross-processed digital effect, leaves the lips red and everything else in the yellow spectrum. This image was made with a Nikon D1X and short Nikkor zoom at the 70mm setting; the image was exposed for $^1/_{640}$ second at f/2.8.

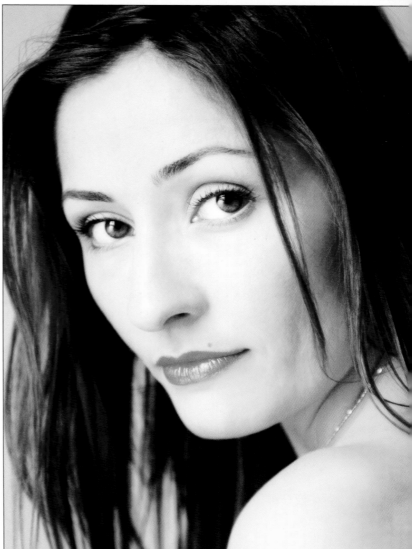

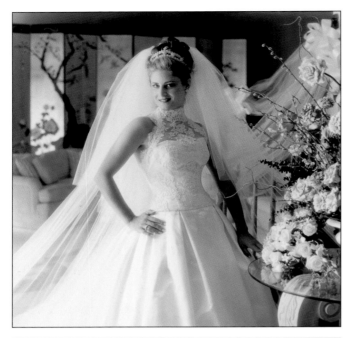

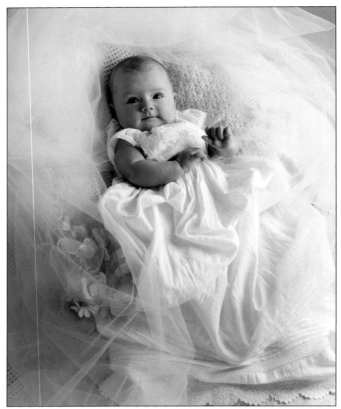

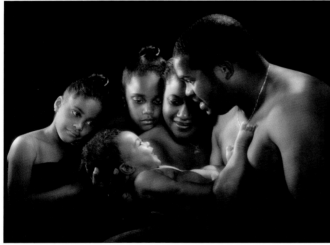

give your subject. Men do not want to be photographed too softly, as it may appear effeminate to them. Women with lovely skin will not want to be photographed too softly either, as their good skin is a personal asset they want to show off. In these cases, you may want to use a moderate amount of softness just to blend the skin a little. Use a smaller aperture like f/5.6 or f/8; this will still give some softness, but considerably less than if the lens is used wide open.

□ CAMERA HEIGHT AND PERSPECTIVE

When photographing people with average features, there are a few general rules that govern camera height in relation to the subject. These rules will produce normal perspective with average people.

TOP LEFT—This is a study in perspective. If you draw a line straight out from the camera lens, you will see the camera height was exactly midway between the top of her head and her knees. Placing the camera not too high or low produces ideal perspective. Also note the slimming, low-key lighting. A Bronica SQ-Ai camera, with a 150mm lens and Kodak T400 CN film, was used to create this image by Michele Celentano. It was exposed for $^1/_8$ second at f/5.6. No reflector was used with the available side light in order to build up a ratio.

ABOVE—A "full-length" baby portrait can be tricky. Here the camera position is high with a relatively small image size so that the baby is pictured in proper perspective. Photograph by David Bentley.

LEFT—This is an amazing portrait of a family with their newborn taken by Joseph and Louise Simone. A hair light, set to output at f/16, lit the baby and the hair of the mother, father, and the daughter next to the mom. An umbrella fill at the camera position produced soft fill light at f/8. The main light, a parabolic reflector with diffusion and barn doors was positioned to the left of the family and set to f/16. The image was made with a Hasselblad camera and a 120 mm lens at an exposure of $^1/_{100}$ second at f/16.

For average people being photographed in a head-and-shoulders view, the rule of thumb is that camera

height should be the same height as the tip of the subject's nose. For three-quarter-length portraits, the camera should be at a height midway between the subject's waist and neck. In full-length portraits, the camera should be the same height as the subject's waist.

In each case, the camera is at a height that divides the subject in two equal halves in the viewfinder. This is so that the features above and below the lens/subject axis are the same distance from the lens, and thus recede equally for "normal" perspective. As you will see, when the camera is raised or lowered, the perspective (the size relationship between parts of the photo) changes. By controlling perspective, you can alter the physical traits of your subject.

By raising the camera height in a three-quarter- or full-length portrait, you can enlarge the head-and-shoulder region of the subject, but slim the hips and legs. Conversely, if you lower the camera, you reduce the size of the head, and enlarge the size of the legs and thighs. Tilting the camera down when raising the camera, and up when lowering the camera increases these effects. The closer the camera is to the subject, the more pronounced the changes are. If you find that after you make an adjustment of camera height for a desired effect there is no change, move the camera in closer to the subject and observe the effect again.

When you raise or lower the camera in a head-and-shoulders portrait, the effects are even more dramatic. This is a prime means of correcting facial irregularities. Raising the camera height lengthens the nose, slims the chin and jaw lines, and broadens the forehead. Lowering camera height shortens the nose, de-emphasizes the forehead, and widens the jaw while accentuating the chin.

❑ CORRECTING SPECIFIC PROBLEMS

This section deals with methods to correct specific physical traits you will encounter with everyday people. Be tactful about making any corrective suggestions.

Overweight Subjects. Have an overweight subject dress in dark clothing, which will make him or her

appear 10 to 15 pounds slimmer. Use a pose that has the subject turned at a 45-degree angle to the camera. Never photograph a larger person head-on—unless you are trying to accent their size.

Use a low-key lighting pattern and use short lighting so that most of the subject is in shadow. The higher lighting ratio that produces low-key lighting will make your subject appear slimmer. Use a dark-colored background and if possible, try to merge the tone of the background with that of the subject's clothes. To do this, minimize or eliminate the background light and eliminate any kickers you might otherwise use to highlight the shadow-side edge of the subject.

Standing poses are more flattering. Seated, excess weight accumulates around the waistline. A dark vignette at the bottom of the portrait is another trick to minimize the appearance of extra weight.

If the overweight person has excess skin under their chin, keep the light off the neck, or use a gobo, a light-blocking card placed between light and subject, to keep light off the chin and neck.

Thin or Underweight Subjects. A thin person is much easier to photograph than an overweight person. Have the person wear light-colored clothing and use a high-key lighting ratio and light-colored background. When posing a thin person, have him or her face the camera more to provide more width. A seven-eighths angle is ideal for people on the thin side.

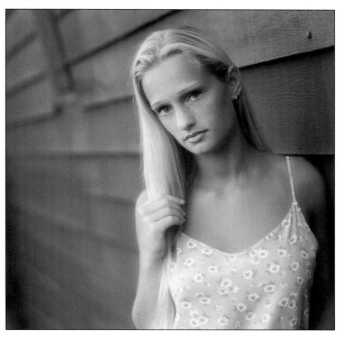

Slender subjects can be photographed "head on" with no angle to the shoulder axis. A very broad highlight area and the pose enhance this girl's natural beauty. Photograph by Tony Corbell.

If the person is extremely thin, do not allow him or her to wear sleeveless shirts or blouses. For a man, a light-colored sports coat will help fill him out; for a woman, fluffy dresses or blouses will disguise thin arms.

For a thin face, use broad lighting and a lighting ratio in the 2:1 or 3:1 range. Since the side of the face turned toward the camera is highlighted, it will appear wider than if short lighting is used. The general rule is, the broader the person's face, the more of it should be kept in shadow, and the more narrow the face, the more of it should be highlighted—the basic differences between broad and short lighting.

Elderly Subjects. The older the subject, the more wrinkles he or she will have. It is best to use some type of diffusion, but do not soften the image to the point that none of the wrinkles are visible. Men, especially, should not be overly softened as their wrinkles are often considered "character lines."

Use a frontal type of lighting so that there are no deep shadows in the wrinkles and deep furrows of the face. Use a softer, diffused type of lighting, such as umbrella light. Soft lighting will de-emphasize wrinkles.

A smaller image size is also called for in photographing elderly people. Even when making a head-and-shoulders portrait, the image size should be about 10–15 percent smaller, so that the signs of age are not as noticeable.

Eyeglasses. The best way to photograph eyeglasses is to use blanks (frames without lenses), obtained from the sitter's optometrist. If the portrait is scheduled far enough in advance, arrangements can usually be made with the optometrist for a set of loaner blank frames. If blanks are not available, have the person slide his glasses down on his or her nose slightly. This changes the angle of incidence and helps to eliminate unwanted reflections.

When photographing a subject wearing eyeglasses, the key light should be diffused so that the frames do not cast a shadow that darkens the eyes. Place the key light even with or just higher than the subject's head height, then move it out to the side so that its reflection is not visible in the eyeglasses as seen from the camera. This produces a split or 45-degree lighting pattern. The fill light should also be adjusted laterally away from the camera until its reflection disappears. If you cannot eliminate the fill light's reflection, try bouncing the fill light off the ceiling or the back wall of the studio.

When your subject is wearing thick glasses, it is not unusual for the eyes to be darker than the rest of the face. This is because the thickness of the glass reduces the intensity of light being transmitted to the eyes. If

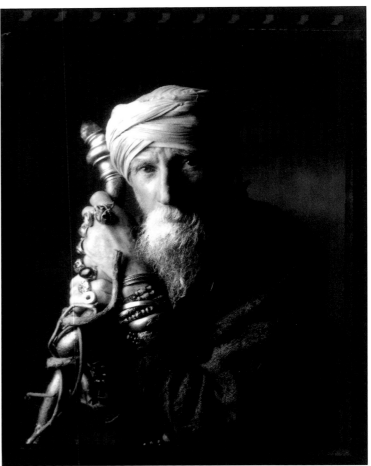

The image of "Dez" is a natural one, in that the clothing he is wearing is his everyday clothing. According to the photographer, Giorgio Karayiannis, Dez is a spiritual healer and roams the streets of Melbourne using God's power through his hands to heal. Giorgio says, "I have heard some remarkable stories about him. He never takes money for his practice—he only accepts gifts, such as the rings that his fingers ubiquitously display." To obtain maximum detail, Giorgio used a large, soft scrim on the subject's right side. He used a small headlight from the rear, a strip light to his left for contrast and added impact, and a white reflector to balance the light (and not make it too contrasty from one side of the face to the other).

this happens, there is nothing you can do about it during the shooting session, but the area can be dodged digitally or during printing to restore the same print density as in the rest of the face.

If your subject wears "photo-gray" or any other type of self-adjusting, light-sensitive lenses, have him keep his glasses in his pocket until you are ready to shoot. This will keep the lenses from getting dark prematurely from the shooting lights. Of course, once the light strikes them they will darken, so you might want to encourage your subject to remove his or her glasses for the portrait.

One Eye Smaller than the Other. Most people have one eye smaller than the other. This should be one of the first things you observe about your subject. If you want both eyes to look the same size in the portrait, pose the subject in a seven-eighths to three-quarters view, and seat the person so that the smaller eye is closest to the camera. Because objects farther from the camera look smaller, and nearer objects look larger, both eyes should appear to be about the same size.

Baldness. If your subject is bald, lower the camera height so less of the top of his head is visible. Use a gobo between the main light and the subject to shield the bald part of his head from light. Another trick is to feather the main light so that the light falls off rapidly on the top and back of his head. The darker in tone the bald area is, the less noticeable it will be. Do not use a hair light, and employ only minimal background light. If possible, try to blend the tone of the background with the top of your subject's head.

Double Chins. To reduce the view of the area beneath the chin, raise the camera height so that area is less prominent. Tilt the chin upward and raise the main light so that much of the area under the chin is in shadow.

Wide Faces. To slim a wide face, pose the person in a three-quarters view, and use short lighting so that most of the face is in shadow. The wider the face, the higher the lighting ratio should be. If the face is extremely wide, even a 5:1 ratio would be suitable.

Thin Faces. To widen a thin face, the solution is to highlight as much of the face as possible. This means using broad lighting, where the side of the face most visible to the camera is highlighted. You should use a

Placing the smallest eye near the camera helps make both eyes appear the same size. All people have one eye slightly smaller than the other. Photograph by David Bentley.

frontal pose, such as a seven-eighths view, and keep the lighting ratio on the low side—in the 2:1 to 3:1 range. Kickers and hair lights will add depth and dimension to the portrait, and further widen a thin face.

Broad Foreheads. To diminish a wide or high forehead, lower the camera height and tilt the person's chin upward slightly. Remember, the closer the camera is to the subject, the more noticeable these corrective measures will be. If you find that by lowering the camera and raising the chin, the forehead is only marginally smaller, move the camera in closer and observe the effect again—but watch out for other distortions.

Deep-Set Eyes and Protruding Eyes. To correct deep-set eyes, keep the main light low to fill the eye sockets with light. Keep the lighting ratio low so there is as much fill light as possible to lighten the eyes. Raising the chin will also help diminish the look of deep-set eyes. To correct protruding eyes, raise the main light and have the person look downward so that more of the eyelid is showing.

Large Ears. To scale down large ears, the best thing to do is to hide the far ear by placing the person in a three-quarters view, making sure that the far ear is out of view or in shadow (either by using a gobo to block the light from the ear or by feathering the main light). If the subject's ears are very large, examine the person in a profile pose. A profile pose will totally eliminate the problem.

Very Dark Skin Tones. Unusually dark skin tones must be compensated for in exposure if you are to obtain a full tonal range in the portrait. For the darkest skin tones, open up a full f-stop over the indicated incident meter reading. For moderately dark subjects, like deeply suntanned people, open up one-half stop over the indicated exposure.

Uneven Mouths. If your subject has an uneven mouth (one side higher than the other, for example) or a crooked smile, turn his ir her head so that the higher side of the mouth is closest to the camera, or tilt the subject's head so that the line of the mouth is more or less even.

Long Noses and Pug Noses. To reduce the appearance of a long nose, lower the camera and tilt the chin upward slightly. Lower the key light so that, if you have to shoot from much below nose height, there are no deep shadows under the nose. You should use a frontal pose, either a full-face or seven-eighths view, to disguise the length of your subject's nose.

For a pug nose or short nose, raise the camera height to give a longer line to the nose. Have the subject look downward slightly and try to place a specular highlight along the ridge of the nose. The highlight tends to lengthen a short nose.

Long Necks and Short Necks. While a long neck can be considered sophisticated, it can also appear unnatural—especially in a head-and-shoulders portrait. By raising the camera height, lowering the chin, keeping the neck partially in shadow, and pulling up the shirt or coat-collar, you will shorten an overly long neck. If you see the subject's neck as graceful and elegant, back up and make a three-quarter- or full-length portrait and emphasize the graceful line of the neck in the composition.

For short or stubby necks, place light from the key light on the neck. This is accomplished by lowering the key light, or feathering it downward. Increase the fill light on the neck so there is more light on the shadow side of the neck. Lowering the camera height and suggesting a V-neck collar will also lengthen the appearance of a short neck.

Wide Mouths and Narrow Mouths. To reduce an overly wide mouth, photograph the person in three-quarters view and with no smile. For a narrow or small

Using a black background, gloves, and hat helped to accentuate the subject's beauty in this portrait by Kimarie Richardson. The photographer flooded the set with soft light in almost a fashion type of lighting. A Mamiya 645 camera, with an 80mm lens and Kodak T400CN film, was used to create this portrait. Two Norman LH4As in softboxes, set 45-degrees to camera left and right, were used to light the subject.

mouth, photograph the person in a more frontal pose and have him or her smile broadly.

Long Chins and Stubby Chins. Choose a higher camera angle and turn the face to the side to correct a long chin. For a stubby chin, use a lower camera angle and photograph the person in a frontal pose.

Oily Skin. Excessively oily skin looks shiny in a portrait. If you combine oily skin with sharp, undiffused lighting, the effect will be unappealing. Always keep a powder puff and a tin of face powder on hand to pat down oily areas. The areas to watch are the frontal planes of the face—the center of the forehead and chin, and the cheekbones. The appearance of oily skin can also be minimized by using a diffused main light, such as umbrella or softbox lighting.

Dry Skin. Excessively dry skin looks dull and lifeless in a portrait. To give dry skin dimension, use a sharp, undiffused main light. If the skin still looks dull and without texture, use a little hand lotion or body oil on the person's face to create small specular highlights in the skin. Don't overdo it with the lotion or oil, or you will have the reverse problem—oily skin.

Skin Defects. Facial imperfections like scars and discoloration are best disguised by placing them in

shadow, using a short lighting setup and a strong lighting ratio. Many of these issues can now also be addressed using digital retouching.

□ BE DISCRIMINATING

Here's a problem you may not have thought of: what if the person is proud of the trait you consider a difficulty? Or what should you do when you encounter more than one problem?

The first question is best settled in a brief conversation with your subject. You can comment on his or her features by saying something like, "You have large eyes, and the line of your nose is quite elegant." If the person is at all self-conscious about either one of these traits, he or she will usually say something like, "Oh, my nose is too long, I wish I could change it." Then you will know that the person is unhappy with his nose, but happy with his eyes, and you'll know how to proceed.

The second question is a little more difficult. It takes experience before you can discern which of the problems is the more serious one, and most in need of correction. Generally, by handholding the camera and moving into the corrective positions (i.e., a higher or lower camera angle) you can see how the physical characteristics are altered. By experimenting with various lighting, poses, and camera angles, you should be able to come up with the best posing strategy.

More than good lighting, posing, and composition techniques, the successful portrait photographer knows how to deal with the irregularities of the human face. All of the great portrait photographers know that their success lies in being able to make ordinary people look absolutely extraordinary.

LEFT—Brian King framed his subject's face with her black hair and had her wear a black, high-necked top so that her face would be the center of interest. Lit by a large bay window and photographed from an elevated angle, her face is beautifully rendered.

RIGHT—This is the type of portrait one might not attempt with a teenage subject a few years ago because the retouching might have been extensive. Now with the many retouching techniques available in Photoshop, it is easy to smooth the entire complexion in a manner of minutes. Photo by Brian King.

8.
Photoshop Retouching Techniques

*I*n the first edition of this book there was no section on Photoshop retouching techniques. Although that edition was published only a few years ago, most photographers still employed traditional retouching techniques at that time—or more often, employed full-time retouchers.

Everything has changed, however, and even those photographers who still shoot with film usually have the image digitized (scanned) for output. As a result, conventional retouching techniques have given way to digital methods. It's already clear that the impact of Adobe Photoshop has permanently changed the style and scope of portrait images.

The photographer, in the comfort of his or her home or studio, can now routinely accomplish special effects that could only be achieved by an expert darkroom technician in years past. Conventional retouching is just the tip of the iceberg where Photoshop is concerned. Retouching a digital image in Photoshop is much less difficult than conventional retouching and the image is "worked" as a positive, unlike traditional negative retouching. Creative effects include blurring the background, selective diffusion in key areas of the face, transparent vignettes, swapping heads in group photos—the list is endless. Literally, if it can be imagined, it can be performed in Photoshop and other creative software applications like Corel Painter.

◻ RETOUCHING THEN

Traditional retouching involved the use of a large- or medium-format negative and a highly skilled retoucher, who would apply a series of applications of leads and/or retouching dyes to the negative. The idea behind this traditional retouching was to blend the uneven densities of the negative for a smoother, more polished look. By building up the tone in the slightly less dense areas, the skin became cleaner and more uniform; in short, it came closer to the ideal.

Before retouching could begin the negative was often "doped"—meaning that retouching medium was applied to give the negative "tooth," or a surface receptive to accepting leads and dyes. Then, the

These are some of the various leads used in traditional retouching. They are hard and soft for different applications. Colored lead holders were used to differentiate lead types. The 4 x 5-inch negative envelope is fitted with sandpaper for sharpening the leads to an ultra-fine tip.

Basic retouching tools include abrading tools (left) and print abrading tools (middle) as well as an etching knife (right). All are used in traditional retouching to reduce density or imperfections on the negative or print. Photo by Bill Hurter.

retoucher worked on a retouching stand with a brightly backlit panel. The negative was mounted above the light and a powerful magnifying glass on a gooseneck stand was used to enlarge the area of the negative for the retoucher. With leads of various hardnesses that were sharpened to perfection, the retoucher would begin blending areas of the negative, using the leads to build up density. Starting out with the retouching pencils, using the emulsion side of the negative, the retoucher would usually start with the harder lead for average retouching. The softer leads were then used for deeper shadow areas. The lead needed to be constantly resharpened to maintain an extremely sharp point.

Using these techniques lines were softened, blemishes removed, smile lines and deep furrows minimized, catchlights repaired, age spots removed, and all the myriad of items covered by the retoucher were handled in turn. It was a painstaking and time-consuming skill that one had to spend years training to do well. One of the constant problems for a retoucher was when a negative refused to accept any more lead. It would then have to be flipped and more lead (or dye) applied to the other side of the negative. And to make matters worse, the techniques involved for lead retouching are somewhat different than those for dyes, which involve using an almost dry brush to apply very thin applications in very small areas.

Other tools used by the conventional retoucher were the abrading tool (a needle used to remove pinholes and other completely opaque spots on the negative), the etching knife (used to "shave" density in microscopic dimensions from the negative—to repair blown-out highlights, for example) and the spotting brushes and dyes (which were used to retouch the print from over-retouching or dust spots produced in enlargement).

□ RETOUCHING NOW

The fact that most photographers moved away from the large-format negative towards the medium- and small-format negative, and now to digital, has all but put a halt to conventional retouching. Retouching is now done to the digital file and the image is conveniently "worked as a positive," so that what you see on the monitor is what you get. Retouching a scanned or native digital image in software applications like Adobe Photoshop is much easier and less time consuming. The retouched digital image file can either be output directly to an inkjet media or to conventional photographic paper using a lab's digital printer.

Retouching a digital image in Photoshop allows you to view any portion of the image at up to a 1600-percent enlargement on screen, making it possible to rework virtually any detail in the image. A wide variety of brushes and pencils and erasers can be selected, and the opacity and transparency of each tool is easily adjusted in minute increments. Photoshop allows you to select an area you want to retouch, confining your

changes to only that selected area (thereby eliminating misplaced brush strokes, etc.).

Photoshop also has some amazing tools for retouching, such as the healing brush. With this tool, you can conceal a problem area by covering it with "cloned" material from an adjacent area of the image—and Photoshop automatically takes care of blending the lighting angles and textures for you. Take for instance the lines under a person's eyes. With the healing brush, you can sample the smooth area directly under the facial lines and then with a click of the mouse apply the smooth area to the creased area, thus gradually wiping out the facial irregularities. Blemishes are so simply removed it's almost laughable, compared to the work that went into that operation in the conventional retoucher's studio.

Not only can facial irregularities be eliminated digitally, but drastic retouching tasks, like swapping the head from one image and placing it in another, are now a routine matter—just select, copy, and paste. There is almost no end to the complex effects that can be produced digitally.

The following is a collection of Photoshop techniques that you will find useful for various retouching tasks.

❑ BACKGROUND COPY LAYER

Many different creative effects involve using Photoshop's layers. When you open an image and go to the layers palette, you will see your background layer with a padlock icon next to it, meaning that this is your original image. Make a copy of the background layer by clicking and dragging the background layer onto the new-layer icon.

Immediately save the image in the PSD (Photoshop Document) or TIFF file format, which will allow you to preserve the layers, including the original background layer and background copy layer. Other file

David Williams likes to use the selective focus effect on many of his portraits, even in images like this one of Jeff Moorfoot, an Australian photographer. Here, the lines in the forehead and under the eyes are untreated, as they reveal character, but in the areas of the cheeks some very minor softening is done with the technique described in this chapter.

formats will require you to flatten the layers, which merges all the layers into one and obliterates your working layers. If for some reason you need to revert to the original image, you can simply delete all layers except your original background layer.

Once you've done this, you can continue working, doing all of your work in the background copy layer. Because you are working on a duplicate of your original, it's easy to compare the "before" and "after" version of your image as you work and to revert back to the original if need be.

□ ERASER TOOL

Once you've made a copy of the background layer, the eraser tool allows you to selectively permit the underlying background layer to show through—good for creating selective effects.

For example, working on the background copy layer, you can apply the Gaussian blur filter (Filter> Blur>Gaussian Blur). This will blur the entire image. To restore the original sharpness to selected areas, you can then use the eraser tool to "erase" the blurred background copy layer and allow the sharp background layer to show through. You can set the eraser opacity and flow to 100 percent to reveal the hidden original background layer completely, or you can set the opacity to around 50 percent and bring back the sharpness gradually.

As you work, you'll probably want to enlarge the image to ensure that you erase accurately. You can also switch between brushes, depending on the area you need to erase. Your selection of a soft- or hard-edged brush, and its size, will change the sharpness of the perimeter edge of the erased area. A good middle ground is a small- to medium-sized, soft-edged brush.

This technique is ideal for retouching the entire face and then bringing back select areas of the face that need to be sharp—the eyes and eyebrows, the nose, the lips and teeth, and so forth. It also works well with special effects filters, like nik ColorEfex's Monday Morning Sepia—a moody, soft focus, warm tone filter. Simply perform the effect on the background copy layer, then bring back any of the original detail you want by allowing the original background layer to show through.

Here's what Brian King says about retouching: "Basically, I take the images a bit further than my lab (Buckeye Color in Canton, OH) by adding additional work under the eyes and smoothing out facial areas with larger pores using the blur tool. My favorite treatment so far is to clean up the whites of the eyes with either a brush tool or the dodge tool and then deepen the existing eye color. I have been having fun playing with the saturation levels and also the Gaussian blur filter to create a more defined selective focus."

In this David Williams portrait of mother and child, you can really see the effects of his selective focus technique. He has idealized the complexions, leaving only the eyes, teeth, lips, eyebrows and part of the hair sharp. The technique takes years off middle-aged skin and makes children almost angelic.

Deborah Ferro created this beautiful portrait of a teenage girl and helped minimize retouching by basically blowing out the highlights in Photoshop's levels control. She finished off the portrait with dry brush strokes and a custom border treatment resembling a Polaroid Type 57 negative/print.

☐ SELECTIVE FOCUS

This is like the effect described above. To begin, duplicate the background layer as described above. Blur the background copy layer using the Gaussian blur filter (Filter>Blur>Gaussian Blur) at a pixel radius of 10 or less. From there, you can employ one of two different methods.

Method one entails using the eraser tool with a soft-edged, medium-sized brush at an opacity of 100 percent to reveal the hidden original background layer.

Method two involves using the lasso tool to make selections. Holding down the Shift key allows you to make multiple selections. Select the areas around the eyes and eyebrows, the hairline, the tip of the nose, the lips and teeth, the front edge of the ears, any jewelry that shows and other surface details that should be sharp. Next, you'll need to feather the selection, blurring its edges so that the two layers will blend seamlessly. To do this, go to Select>Feather and set the feather

radius at up to 25 pixels. Next, hide the selections (Command + H) so that the marching ants disappear. Then, simply hit Delete and the original background layer will show through. If you missed something, hit deselect (Command + D) and select the new area (or areas). Once these are feathered, hit Delete.

☐ REMOVING BLEMISHES

To remove small blemishes, dust spots, marks, or wrinkles, select the healing brush (the clone tool in Photoshop 6 or lower). When this tool is selected, an options bar will appear at the top of the screen. Select the normal mode and choose the "sampled as the source" setting. Next, select a soft-edged brush that is slightly larger than the area you are going to repair. Press Opt/Alt and click on a nearby area with the same tone and texture as the area you wish to fix. Then, click on the blemish and the sample will replace it. If it doesn't work, undo the operation (Command + Z), sample

another area and try again. The healing brush differs from the clone tool (also called the rubber stamp tool in older versions of Photoshop) in that the healing brush automatically blends the sampled tonality with the area surrounding the blemish or mark.

□ SHININESS AND WRINKLES

Shininess and wrinkles are both easily fixed using the identical tool and techniques.

To reduce the appearance of wrinkles and shiny areas, select the clone tool and set its opacity to 25 percent. The mode should be set to normal and the brush should, again, be soft-edged. Like the healing brush, sample an unblemished area by hitting Opt/Alt and clicking once on the area you want to sample. As you use the tool, keep an eye on the cross-hair symbol that appears to show you the sampled area you are about to apply with your next click of the tool. If this area begins to move into a zone that is not the right color or texture, hit Opt/Alt and resample the desired area.

The clone tool is a very forgiving tool that can be applied numerous times in succession to restore a relatively large area. As you work, you will find that the more you apply the cloned area the lighter the wrinkle becomes or the darker the shiny area becomes. Be sure to zoom out and check to make sure you haven't overdone it. This is one reason why it is always safer to work on a copy of the background layer instead of the background layer itself.

When reducing shine, don't remove the highlight entirely, just subdue it. The same goes for most wrinkles. For a natural look, they should be significantly subdued, but not completely eliminated.

□ TEETH AND EYES

By quickly cleaning up eyes and teeth, you can put real snap back into the image. To do this, use the dodge tool at an exposure of 25 percent. Since the whites of the eyes and teeth are only in the highlight range, set the range to highlights in the options bar.

For the eyes, use a small soft-edged brush and just work the whites of the eyes—but be careful not to overdo it. For teeth, select a brush that is the size of the largest teeth and make one pass. Voilà! That should do it.

For really yellow teeth, first make a selection using the lasso tool. It doesn't have to be extremely precise. Next, go to Image>Adjustments>Selective Color. Select "neutrals" and reduce the yellow. Make sure that the method setting at the bottom of the dialog box is set to absolute, which gives a more definitive result in smaller increments. Remove yellow in small increments (one or two points at a time) and gauge the preview. You will instantly see the teeth whiten. Surrounding areas of pink lips and skin tone will be unaffected because they are a different color.

□ GLARE ON GLASSES

Glare of glasses is a problem that's easily remedied. Enlarge the eyeglasses, one lens at a time. With the clone tool, select a small, soft brush and set its opacity to about 50 percent. The reduced opacity will keep the glass looking like glass. Sample an adjacent area (Option/Alt + click) and start to cover over the high-

Here, Brian King used a slow shutter speed and added grain in Photoshop. His retouching was pretty simple—he basically cleaned up the young lady's eyes, the focal point of the image.

Jerry D, who specializes in digital makeovers, says his clients often love the pictures but sometimes don't love *themselves* in the pictures. One bride said to him, "I love the photo but can't you make me look thinner?" He said he could and proceeded to remove her arm in Photoshop, then paste it back onto her body, which he had made thinner with the liquify command. You cannot tell where the retouching was done and, apparently, the bride was ecstatic over Jerry's magic.

light. Deborah Ferro, a Photoshop expert, recommends using irregularly shaped brushes of different sizes to cover tricky highlights.

□ CONTOURING WITH THE LIQUIFY FILTER

Photoshop has a fascinating suite of tools under the filters menu. The liquify function is a very useful one, as it allows you to bend and twist features either subtly or dramatically. When you activate the liquify function (Filter>Liquify), a full-screen dialog box will appear with your image in the center. To the left of the image are a set of tools that let you warp, pucker, or bloat an area simply by clicking and dragging. There is even a tool that freezes an area, protecting it from the action of the tool. When you want to unprotect the area, simply use the thaw tool. To the right of the image, you'll find settings for the brush size and pressure.

Using this tool, it is a simple matter to give your subject a tummy tuck, or take 15 off pounds with a few well placed clicks on the hips and/or waistline. It is outrageous how simple this tool is to use, and the effects are seamless if done subtly. (If you notice that you have overdone it, however, there is even a reconstruct tool that undoes the effect gradually—like watching a movie in reverse.)

Be careful not to eliminate elements of his or her appearance that the subject actually likes—these "flaws" are, after all, part of what makes every person unique. When this happens, you have gone too far. It is always better to approach this type of reconstructive retouching with a little feedback from your subject and a lot of subtlety.

The liquify function is like a separate application by itself. It will take some practice and experimentation to perfect the techniques. However, for the most commonly needed refinements of subject features, it is a snap.

Because so many photographers have converted to digital, this chapter is all new for this second edition. The first edition dealt with traditional darkroom techniques and products—papers, toners, special enlarging heads, etc.—for portrait photographers. While there are still many conventional prints made in the darkroom, the number and range of darkroom products is diminishing as digital work takes its place.

This chapter deals with some of the Photoshop techniques that replace darkroom techniques. Photoshop, after all, has its roots in the darkroom, so it would stand to reason that many of the digital techniques are similar to the conventional ones.

The timeworn techniques of the expert darkroom practitioner must be honored in this new medium. With traditional printmaking, it took years for one to perfect the craft. Now, because Photoshop is so easy to use, it is all too easy to neglect the discipline required to produce prints that reflect the traditional qualities of fine craftsmanship. Hopefully, this chapter will give some insight into the means and methods of making fine prints digitally.

◻ WHAT IS A FINE PRINT?

In professional print competitions, judges have been asking this question for decades. Generally speaking, a fine print has a good range of tones from pure black to paper-base white with a good range of detailed midtones. This is true regardless of the media and whether the image is black & white or color. The highlights should be detailed, the blacks should be rich, and the image should contain a healthy contrast range.

In a fine print, the subject dominates, either by virtue of tone (being lighter or darker than other tones in the image), or by size, shape, or position in the frame. There are many standards for good subject placement, but it should be noted that of the fine prints you see in this chapter, the subject dominates clearly, even when the image is basically white on white.

◻ GOOD COLOR MANAGEMENT

Whereas in the conventional darkroom, black & white papers have a warm- or cold-tone bias and color printing papers have a predictable

range, in the digital darkroom, accuracy and pre-dictability come from managing color as the image moves from one device to the next—from the digital camera, to the monitor, to the printer, for example. A color management system is, therefore, designed to perform two important functions: it interprets the RGB or CMYK color values embedded in an image file, and it maintains the appearance of those colors from one device to another—from input, to display, to output.

□ MONITOR PROFILES

If you set up three identical monitors and had them display the exact same image, they would each display the image in a slightly different way. Every monitor is different. This is where profiles come into play. Profiling, which uses a calibration device and accompanying software, characterizes the monitor's output so that it displays a neutral (or at least a predictable) range of colors.

A monitor profile is like a color-correction filter. Going back to the example of the three monitors above, one monitor might be slightly green, one magenta, one slightly darker than the other two. Once calibrated and profiled, the resulting profile, stored in your computer, will send a correction to the computer's video card—correcting the excess green, magenta, and brightness, respectively, so that all three monitors represent the same image identically.

Monitor profiling devices range widely in price, beginning in the $250–$500 range and reaching several thousand dollars at their most expensive. However, this is an investment you cannot avoid if you are going to get predictable results from your digital systems.

Specular highlights are those delicate, white highlights with detail. Note the ridge of the subject's nose and along her highlighted cheek. Good specular detail is the hall-mark of a perfectly exposed and printed image. Here, a white background was used to produce middle tones. A double-scrmmed 36-inch softbox was used as a main light at a setting of f/8. A white fill reflector was used, producing an f/4 exposure. The background received no light at all, rendering it medium gray. Norman Phillips used a Pentax 645 camera with a 150mm lens to create this image.

□ PRINTER PROFILES

A custom profile for each inkjet paper you use gives the best color match between what you see on your calibrated monitor and the printed image. Output profiles pro-

duce the correct numeric values that the printer requires, and help the printer to match the image displayed on screen. Custom profiles are essential to getting a color-managed print, and they also ensure that you are getting the full range of colors that your printer can produce.

Printer profiles are built by printing a set of known color patches. A spectrophotometer then reads the color patches so the software can interpret the difference between the original file and the printed patches. This information is stored as an output profile, which is applied to images to ensure they are printed correctly.

Custom profiles, such as the Atkinson profiles, which are highly regarded, can be downloaded from the Epson web site (www.epson.com) as well as a number of other sites. Here's how it works: go to the web site, then download and print out a color chart. Mail it back to the company and they will send you, via e-mail, a profile or set of profiles.

Another great source of custom profiles for a wide variety of papers and printers is Dry Creek Photo (www.drycreekphoto.com/custom/customprofiles.htm). This company offers a profile-update package so that each time you change your printer's ink or ribbons (as in dye-sublimation printing) you can update the profile.

Profiles are available for: inkjet printers; dye-sublimation printers; small event printers, like those from Sony; Kodak 8500- and 8600-series printers; Fuji Pictography printers; RA-4 printers, such as LightJet, Durst Lambda/Epsilon, Fuji Frontier, Noritsu QSS, Gretag Sienna, Kodak LED, Agfa D-Lab, etc.; color laserjet printers; and thermal printers.

Most of the expensive commercial printers that photo labs use include rigorous self-calibration rou-

Where whites meet whites, you have trouble. Throw in a few highly reflective pots and a "screaming" chef and you've got the recipe for trouble. Perfect exposure and expert control of lighting allowed all of the whites to separate with detail throughout. But more importantly, this image is printed extremely well, with detail and separation throughout. Photograph by Norman Phillips.

HINTS AND TIPS

A frequently asked question is why, even in a color-managed system, the print output looks different than the screen image. The answer lies not so much in the color-management question, but in the differences between media. Because monitors and printers have a different color gamut (the fixed range of color values they can produce), the physical properties of these two different devices make it impossible to show exactly the same colors on your screen and on paper. However, effective color management allows you to align the output from all of your devices to simulate how the color values of your image will be reproduced in a print.

tines, which means that a single profile will last until major maintenance is done or until the machine settings are changed.

□ ONE PRINTER, ONE PAPER

Many photographers rely on the same printer and same paper for predictability. Epson includes profiles for many of its own brand of papers in the software with their printers. You can, of course, add other profiles for other brands, as well. When loaded, the profiles appear in your print window and control how your printer interacts with the paper. The Epson 2200, for example, offers six profiles for six premium Epson papers, plus a plain-paper setting for black-only 360dpi printing.

□ ARCHIVAL PERMANENCE

Digital prints made on conventional photographic material have all the longevity and permanence that this highly-evolved technology can provide—now approaching 100 years.

When using inkjet media, different inks offer drastic differences in archival permanence. This is measured in terms of the print's lightfastness, or resistance to fad-

> ### HINTS AND TIPS
> *It is recommended that you set your computer desktop to a neutral gray for the purpose of viewing and optimizing images. Human vision is greatly impacted by the colors and tones we see around what we are looking at. As you make adjustments to color and luminosity, viewing your image against a neutral background will help to reduce potential problems or misperceptions.*

Tone control is one of the secrets to the success of this image. The background is dark but detailed, and the rocks behind, to the right of, and beneath the boy are burned in expertly in printing. The area of the rock where he sits is bright, but not brighter than the little boy. This image, entitled *Little Fisherman*, is an excellent example of controlling the tones for effect in printing. Photograph by Bill Duncan.

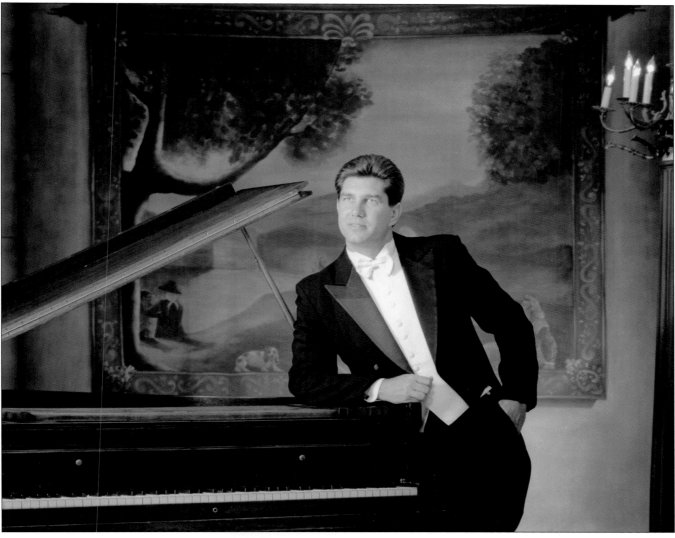

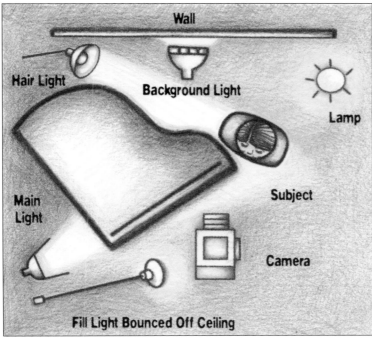

Wall

Hair Light

Background Light

Lamp

Main Light

Subject

Camera

Fill Light Bounced Off Ceiling

The subject's face is the focal point of this portrait. All the other details have been printed down, or accounted for in lighting. Note the color of the white piano keys which would have ordinarily been very bright. Robert Lino used a Mamiya RB67 camera with a Mamiya Sekor SF 150mm lens to create this image, exposing Kodak T-Max 100 film for $^1/_{125}$ second at f/8. The key light was a Speedotron Force 10 with a beauty-light parabolic reflector. The fill light was a Norman 808, set at full power and bounced off of the ceiling. The background light was also a Norman 808, used at half power.

ing. The Epson Ultrachrome pigment inks, on Epson's Radiant White paper, have a rated permanence of 90 years, much higher than their line of dye-based inks, which have a lightfastness rating of between 5 and 10 years, depending on paper used and storage conditions.

As good as Epson's Ultachrome pigment inks are, they do not provide the longevity and archival permanence of Epson's Archival line of pigment inks (which specify a light-fastness rating of up to 200 years).

The bottom line is that only with image permanence rivaling conventional photographic materials could inkjet media hope to compete on an even playing field. Now that this media boasts such impressive stability, there is no reason that digitally-printed portraits shouldn't last many generations.

□ **DODGING AND BURNING-IN**

When I was first starting out, I worked for a master photographer/printer, John DiJoseph, who said, "There is no such thing as a straight print." Even though, as part of the job, we would have to make from 25 to 500 prints of the same negative, each print required some burning and dodging. Today, little has changed—even with digital capture, there is no such thing as a straight print. Every image can be improved by the local manipulation of tonal density.

In traditional printing, we used our hands or a small wand with a cardboard circle the size of a quarter for dodging (reducing the exposure on certain areas to lighten them). And we used our hands or an 8 x 10-inch piece of cardboard, with two different sized and shaped holes in it, for burning in (increasing the exposure on certain areas to darken them). The burn and dodge tools in Photoshop are now used to accomplish these same tasks.

When dodging an area of a digital image, select a soft-edged brush that suits the size of the area

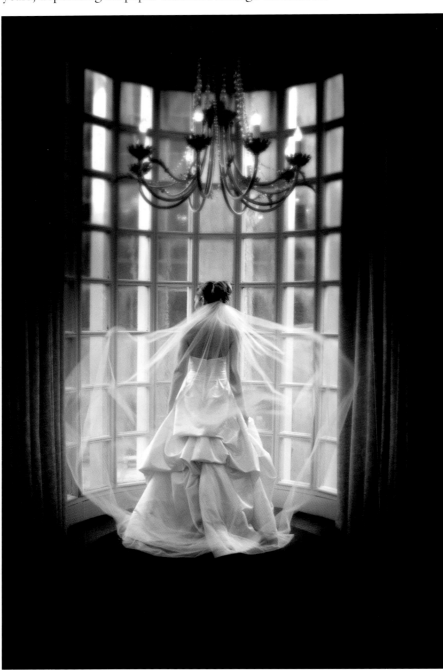

Parker Pfister is a wonderful wedding photographer with a somewhat quirky name. This print, when I first saw it, blew me away. It is in the tradition of fine printmaking. Expert burning-in on the top and in the foreground makes the glass transparent and the bride prominent. To get the veil to float in mid-air, Parker asked the bride to throw her arms up in the air and quickly return them to her side. Her veil was very thin and light, so it hung there just long enough for a few frames.

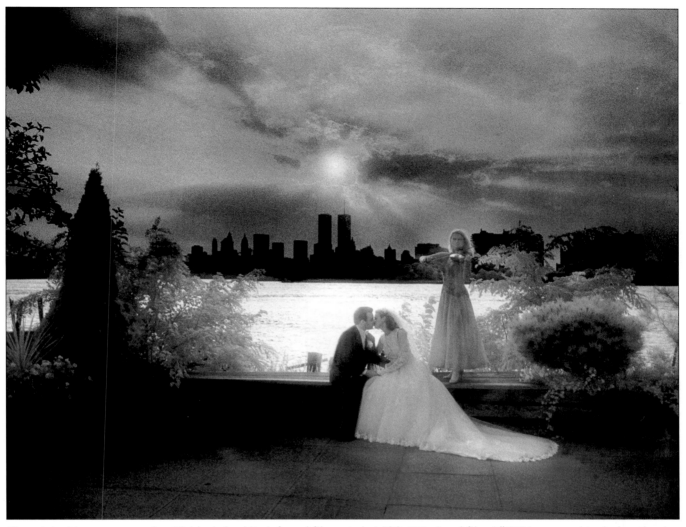

The original image was made with black & white infrared film rated at ISO 400. A red filer (#25A) was used to darken the sky. The final photograph was fine-tuned in Photoshop. The sky was burned in and some minor repair done to the concrete and groom's tuxedo. The image was then toned blue before making the final print on an Epson printer. The cold tone of the image made it appear to have been taken by moonlight. Photograph by Ferdinand Neubauer.

to be dodged. Then, in the options bar at the top of the screen, select the range of tones that you want to lighten (highlights, midtones, or shadows) and set the percentage of exposure. It's best to select a low percentage—8 percent is a good place to start. This way, you can work on a small area and build-up the effect with repeated applications. By repeatedly clicking and dragging the brush over the area to be dodged, you can gradually lighten it in such a way that the manipulation is completely unnoticeable.

The burn tool features the same controls, and the same technique described above can be used for burning in—with the exception that the exposure can be reduced to about 5 percent for a very subtle effect.

If you have an intricate or precariously positioned area to dodge or burn, it is a good idea to select the area you want to affect. For instance, if the area you want to change is adjacent to areas of opposite tone, it will be impossible to not spill the burn or dodge effect into these adjacent areas. In these cases, you should use the lasso or marquee tool, whichever is most appropriate, to select the area to be burned or dodged. Performing your dodge or burn within a selection will ensure that the adjacent areas remain unaffected.

☐ SELECTIVE COLOR

For professionals, the curves are considered Photoshop's most precise tool for color-correcting an image.

Using the curves is, however, a complicated and subjective process that takes some time to learn.

For less advanced Photoshop users, or when only small and isolated changes are needed, the selective color command (Image>Adjustments>Selective Color) can be extremely useful. This tool does not require you to know in advance which channel (R, G, or B) is the one affecting the color shift. It only requires you to select which color needs adjustment.

In the selective color dialog box, you'll see slider controls for cyan, magenta, yellow, and black. At the bottom of the box, make sure that the method is set to absolute, which gives a more definitive result in smaller increments. At the top of the box, choose the color you want to change by selecting it from the pull-down menu. You can choose to alter the reds, yellows, greens, cyans, blues, magentas, whites, "neutrals," or blacks. Once you've selected the color to change, simply adjust the sliders to modify the selected color in whatever way you like.

The changes you make to the sliders in the dialog box will affect only that color. Note, however, that the changed values will affect *every* area of that color. Therefore, if you select "blue" to change the color of the sky, it will also change the blue in the subject's eyes and her blue sweater.

When using the selective color command, most skin tones fall into the range that is considered neutral, so you can color correct the skin tones without affecting the white dress or the brightly colored bridesmaid's gowns, for instance. Skin tones are comprised of varying amounts of magenta and yellow, so these are the sliders that normally need to be adjusted. In outdoor images, however, you will sometimes also pick up excess cyan in the skin tones; this can be eliminated by using the cyan slider. For teeth that are yellowed, select "yellows" and remove yellow with the sliders to brighten teeth.

Wedding dresses will often reflect a nearby color, particularly if the material has a satiny sheen. Outdoors, the dress might go green or blue if shade or grass is reflected into it. In this example, you would select "whites" from the color menu. Then, if the dress is blue, you'd remove a little cyan and judge the preview. If the dress has gone green, add a little magenta and perhaps remove a slight amount of yellow.

In selective color, the black slider adds density to the image and is much like the Levels control in

This image was intentionally warm-toned in Photoshop to give it a more stylized look. Anthony Cava used a Hasselblad camera with a 170mm lens and a drop-in diffusion filter in a Lindahl lens shade to create this image.

Here, the combination of ultrafast film and a high degree of image enlargement (along with a slight amount of negative diffusion in printing) produces a very romantic special effect. Robert and Suzanne Love used a Canon EOS A2 camera with a Tamron 28–200mm AF lens at the 200mm setting to create this image.

Photoshop. Be sure to adjust only the blacks using the black slider, otherwise it will have the effect of fogging the image. When converting images from RGB to CMYK, the black slider is very useful for adding the punch that is missing after the conversion.

◻ USING KODAK COLOR PRINT VIEWING CARDS

If you've spotted a problem in your image but aren't quite sure of the color shift, there is a useful product available from Kodak for making color prints from negatives or slides. It is called the Kodak Color Print Viewing Filter Kit, and is comprised of six cards—cyan, magenta, yellow, red, green, and blue viewing cards. With a medium-gray neutral background on you monitor desktop, inspect the image on the monitor using

the card that is the complementary color of the indicated color shift. For example, if the shift looks blue, use the yellow card to view the image. If the color shift is green, choose the magenta card, and so on. With one

HINTS AND TIPS

Once you have decided on some settings you like for creating toned images, set up actions for them so that you can apply them with a single command. In addition to streamlining your workflow, this will help to ensure consistency in your results. When images will be displayed together, such as in a wedding album, this is a good way to ensure that they will match each other. For more on actions, see page 112.

This is an image originally made on color negative film yet the tonalities and delicate highlight detail make it look as if it were conceived and shot black & white. Darkened corners and edges and slightly burned-in areas of the dress highlight the debutante and her face and hands. Photograph by Robert Lino.

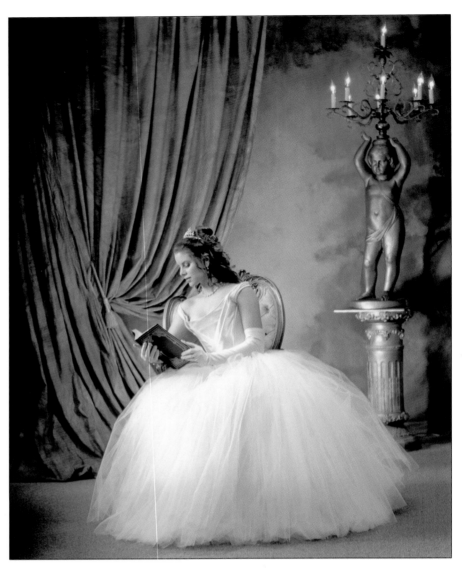

eye closed, flick the appropriate card quickly in and out of your field of view, examining the mid-tones as you do so. Avoid looking at the image highlights, as you will learn nothing from this. If the yellow card neutralizes the color shift in the midtones and shadows, then you are on the right track. There are three densities on each card, so try each one before ruling out a specific color correction. Once you've identified the problem, use the appropriate selection and sliders in the selective-color dialog box (or, if you prefer, the curves command) to neutralize the color shift.

□ SEPIA/BLUE TONE

With your image in RGB color mode, create a copy of the background layer. Working on that layer, go to Image>Adjustments>Desaturate to create a monotone image. Use the levels or curves to adjust the contrast at this point, if so desired. Next go to selective color (Image>Adjustments>Selective Color) and choose "neutrals" from the color menu. Then adjust the magenta and yellow sliders to create a sepia look. Using more magenta than yellow will give you a truer sepia tone. More yellow than magenta will give a brown or selenium image tone. The entire range of warm toners is available using these two controls.

If you want to create a cool-toned image, you can simply add cyan or reduce yellow (or both). Again, a full range of cool tones is available in almost infinite variety.

□ MIXING COLOR AND BLACK & WHITE

A popular effect is to add bits of color to a monochrome image. This technique is done by duplicating the background layer of a color image, then desaturating it (Image>Adjustments>Desaturate). Working on the duplicate layer, adjust brightness and contrast to your liking, then select the eraser tool. Choose a medium-sized soft brush and set the opacity of the eraser to 100 percent. Then, start to erase the areas you want to be in color (allowing the underlying color layer to show through the black & white desaturated layer in the erased areas).

□ VIGNETTES

Vignettes can help focus the viewer's attention on the subject's face. Many photographers vignette every

image in printing, darkening each corner to draw emphasis to the center of interest in the image. Even in high-key portraits, vignetting is a good way to add drama and heightened interest in the main subject.

This particular Photoshop vignetting technique comes from digital artist Deborah Lynn Ferro. To begin, duplicate the background layer. In the layers palette, create a new layer set to the normal mode.

Then, select a color for the vignette by clicking on the foreground color in the main toolbar to bring up the color picker. You can choose any color or sample a color from within the photograph to guarantee a good color match (this is done using the eyedropper tool—click once and the sampled color becomes the foreground color).

Next, use the elliptical marquee tool or the lasso tool to select an area around the subject(s). Inverse the selection (Select> Inverse) and feather it (Select> Feather)—the larger the number, the softer the edge of your vignette will be. Try feathering to a radius of 75 to 100 pixels to keep the edge of the vignette really soft.

Working on the new layer, fill the feathered selection (Edit>Fill) with the foreground color using a low percentage (like 10 percent). Be sure to select the "preserve transparency" option at the bottom of the fill dialog box.

You can also combine the vignette with various other filters. For example, if you want to remove unwanted details, add a motion

blur (Filter>Blur> Motion Blur) to the feathered background. The effect will wash away any unwanted image details and create a beautifully stylized, yet subtle effect.

□ CONTRAST CONTROL AND TONAL RANGE

Many times a digital image is created lacking contrast, which is a good thing because it preserves highlight and shadow detail in the original image. With too little contrast, however, the image will be unsuitable for printing. Overall contrast can be adjusted using the highlight and shadow sliders in the levels (Image> Adjustments>Levels). In the Levels dialog box, by

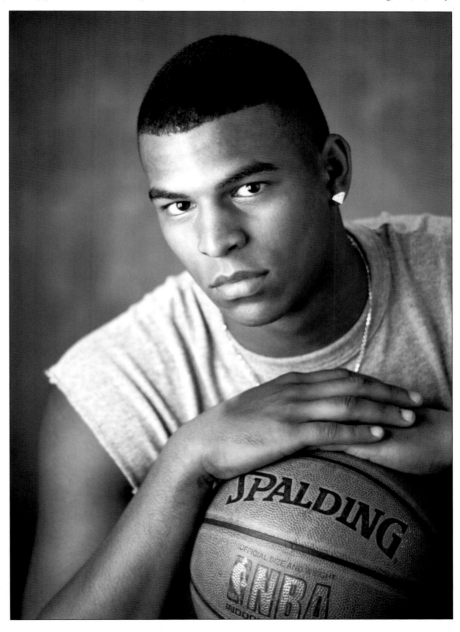

Robert Williams created this beautiful and authentic athlete's portrait, entitled *Hoop Dreams*. The image is fairly straightforward: it was captured on film with a Hasselblad camera and a 180mm lens, and was tinted in printing. Such effects are rather simple to do in Photoshop but effective, nonetheless.

David Williams captured the "really important" members of this wedding party. The "others" are behind them in the shadows. David graphically enhanced this humorous notion by vignetting the background and sides of the image in Photoshop so that only the stars were prominent.

adjusting the shadow slider (the black triangle) to the right, you punch up the blacks. By adjusting the highlight slider (the white triangle) to the left, you clean up the whites.

The trick is to preserve shadow and highlight detail throughout. To review this, look at the Luminosity channel of the image histogram (Window>Histogram). Move your cursor over the black point and white point while keeping an eye on the "level" field in the window below. Basically, a detailed white (for all printers) is around 235 (in RGB mode). A detailed black is around 15–35 (in RGB mode), depending on the printer and paper used.

□ ACTIONS

Photoshop actions are a series of commands that you record as you perform them and then play back to apply the exact same sequence of functions to another image or set of images—with a click of your mouse.

Actions are accessed via the actions palette (Window>Actions).

To create a new action, select "new action" from the pull-down menu at the top right of the actions palette. You will be asked to name it, and then to start recording. Once recording, everything you do to the image will be recorded as part of the action (there are a few exceptions, such as individual brush strokes, that cannot be recorded). When done, simply stop recording by hitting the stop button (the black square) at the bottom of the actions palette. Then, whenever you want to perform that action, go to the actions palette, select the desired action and hit the play button at the bottom of the palette (the black triangle). The action will then run automatically on the open image.

Photoshop also comes with a variety of preloaded actions. You can use these actions as is or customize them to meet your needs. You can also purchase actions from reliable sources on the internet to utilize

the experience of some of the best in the business. For example, Fred Miranda (www.fredmiranda.com) has a site that contains a wide variety of excellent actions for sale at a reasonable price.

□ UNSHARP MASK

As most Photoshop experts will tell you, sharpening is the final step in working an image and one of the most common flaws in an image is over-sharpening. Photoshop's sharpen filters are designed to focus blurry or softened images by increasing the contrast of adjacent pixels. This makes it easy to over-sharpen an image and compress detail out of an area or the entire image.

The most flexible of Photoshop's sharpening tools is the unsharp mask filter, but it needs to be used carefully. If you sharpen the image in RGB mode, you are sharpening all three layers simultaneously. This can lead to color shifts and degradation in quality. A better method is to convert the image to the Lab Color mode (Image>Mode>Lab Color). In the channels palette, click on the lightness channel to deselect the A and B channels (the image will look black & white). Use the unsharp mask filter to sharpen only that channel, then restore the A and B channels by clicking on the composite Lab channel at the top of the channels menu. Go to Image> Mode to convert the image back

the desired mode, and you will be amazed at the results—particularly if you have been sharpening the entire image in past efforts.

Another way to effectively use the unsharp mask filter is to apply it to just one channel in an RGB image. To see the difference this makes, duplicate your image (Image>Duplicate) and place the two identical windows side by side on your screen. On one image, apply the unsharp mask to the image without selecting a channel. In the unsharp mask dialog box, select the following settings: amount—80 percent; radius—1.2 pixels; threshold—0 levels. On the second image, go to the channels palette and look at each channel individually. Select the channel with the most midtones (usually the green channel, but not always) and apply the

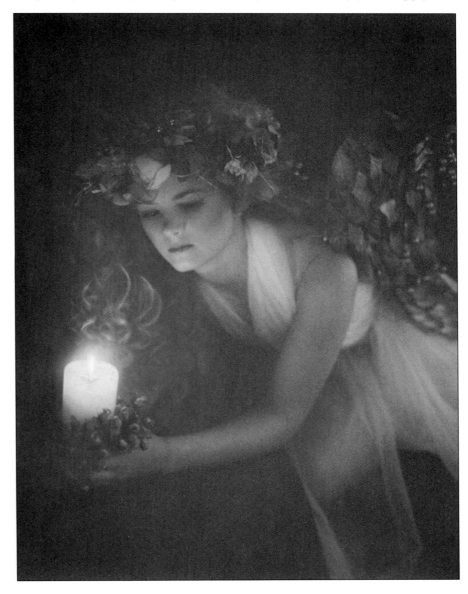

This was the last frame on the roll—and the negative looked so bad that it was actually thrown away and then later retrieved. While severely underexposed, there was quite a bit of detail remaining in the image. The image was photographed by the light from the single candle. While the print is monochrome, color was added to the candle and flowers. Photograph by Kimarie Richardson.

unsharp mask filter using the same settings. Then, turn the other two channels back on. Enlarge a key area, like the face, of both images to exactly the same magnification—say 200 percent. At this level of sharpening, you will probably see artifacts in the image in which all three layers were sharpened simultaneously. In the image where only the green channel was sharpened, you will see a much finer rendition.

☐ CHANGING THE IMAGE RESOLUTION OR FILE SIZE IN PHOTOSHOP

Logic dictates that this technique, which is courtesy of David Williams, shouldn't work at all—but it does. It doesn't work with every file unfortunately, but files that are sharp and well exposed to begin with will enlarge with ease.

Start with an RGB image and convert it to the Lab Color mode. Open the Channels palette and activate the lightness channel. Go to Image>Image Size and increase the size, making sure that you are resampling the image and constraining proportions. For large increases, use two steps. For instance, to go from an 8 x 10-inch image to a 30 x 40-inch image, first increase the size to 16 x 20 inches, and then adjust image size again to 30 x 40 inches.

Next, still working on the lightness channel only, open the unsharp mask dialog box (Filter>Sharpen> Unsharp Mask) and use the following settings:

HINTS AND TIPS

In the unsharp mask dialog box, you can adjust three settings. The amount setting dictates how great the increase the contrast of pixels should be. The radius setting controls the number of pixels surrounding the edge pixels that will be affected in the sharpening (a lower value sharpens only the edge pixels, whereas a higher value sharpens a wider band of pixels). The threshold setting determines how different the sharpened pixels must be from the surrounding area before they are considered edge pixels and sharpened by the filter. The default threshold value of zero sharpens all the pixels in the image.

amount—80 percent; radius—1.2 pixels; threshold—0 levels.

Return to the channels palette and choose the Lab channel, which will restore the color to the image. Return the image to RGB mode for printing or other operations.

The theory behind why this works is that you are readjusting the size of the image by adjusting the architecture of the image, not the color. This technique really works. However, if the quality of the original is not very good or if you are using a very small file that is already suffering from jaggies or other artifacts, the amount of resizing you will be able to do will be minimal.

Conclusion

As much as professional portraiture has changed in three years (since the first edition of this book was published), it will be interesting to see what happens in the next couple of years. Certain conclusions are obvious.

Digital will continue to replace traditional film capture in portraiture and the digital effects inherent in digital imaging will become a bigger part of the genre—just as they did in the world of wedding photography with the advent of digital wedding photojournalism.

It also seems certain that the relaxation of traditional posing and lighting disciplines will also continue as trends. Certainly, there will always be a firm foundation for basic posing and compositional techniques, as these will forever be a part of how the human form is rendered. But what is unclear is how important the "spontaneous portrait" will become in the world of commercial portrait photography. If I took an educated guess, I would imagine that this area will grow as other photographic disciplines impact professional portraiture. Just as editorial photography, the stylized images that appear in every wedding magazine, has changed forever the images brides expect from their own weddings, so the influences of photojournalistic and editorial portraiture seems likely to continue to affect the world of traditional portraits.

The best thing about change is that it reflects a revitalization of the art form. Where there is change, there is no stagnation. And this is a very good thing for all of those who make or aspire to make their living by capturing the essence of people in professional portraits.

—*Bill Hurter*

Glossary

Abrading tool. A needle-tipped retoucher's tool used to remove pin-holes and spots on negatives and prints.

Action. In Adobe Photoshop, a series of commands that you play back on a single file or a batch of files.

Barn doors. Black, metal folding doors that attach to a light's reflector. Used to control the width of the beam of light.

Bit. Stands for binary digit. Smallest unit of information handled by a computer. One bit is expressed as a 1 or a 0 in a binary numeral. A single bit conveys little information a human would consider meaningful. However, a group of eight (8) bits makes up a byte, representing more substantive information.

Bit-depth. Number of bits (smallest units of information handled by a computer) per pixel allocated for storing color information in an image file.

Bounce flash. Bouncing the light of a studio or portable flash off a surface such as a ceiling or wall to produce indirect, shadowless lighting.

Box light. A diffused light source housed in a box-shaped reflector. The front of the box is translucent material; the side pieces of the box are opaque, but they are coated with a reflective material such as foil on the inside to optimize light output.

Broad lighting. One of two basic types of portrait lighting. In broad lighting, the key light illuminates the side of the subject's face turned toward the camera.

Burning-in. A darkroom technique in which specific areas of the print surface are given additional exposure in order to darken them. Simulated in Photoshop with the burn tool.

Butterfly lighting. One of the basic portrait lighting patterns, characterized by a key light placed high and directly in line with the line of the subject's nose. This lighting produces a butterfly-like shadow under the nose. Also called Paramount lighting.

Byte. A unit of data, typically consisting of eight bits. Computer memory and storage are referenced in bytes (i.e. in kilobytes [1000 bytes], megabytes [1 million bytes], or gigabytes [1 trillion bytes]).

Calibration. The process of altering the behavior of a device so that it will function within a known range of performance or output.

Catchlight. The specular highlights that appear in the iris or pupil of the subject's eyes. These are reflections from the portrait lights.

Channel. Used in digital imaging, the channels are a grayscale representation of the amount of each primary color in each area of an image

(plus one composite channel showing the complete color image). The color mode of the image determines the number of color channels created. For example, an RGB image has three channels (one each for red, green, and blue) plus a composite RGB channel. Additional channels can also be created in an image file to preserve masks or selections.

Color Management. A system of software-based checks and balances that ensures consistent color through a variety of capture, display, editing, and output device profiles.

Color Space. The range of colors that a given output device (such as a monitor or printer) is able to produce.

Color temperature. The degrees Kelvin of a light source or film sensitivity. Color films are balanced for 5500°K (daylight), 3200°K (tungsten), or 3400°K (photoflood).

Cross-lighting. Lighting that comes from the side of the subject, skimming across the facial surfaces to reveal the maximum texture in the skin. Also called side-lighting.

Depth of field. The distance that is sharp beyond and in front of the focus point at a given f-stop.

Depth of focus. The amount of sharpness that extends in front of and behind the focus point. Some lenses' depth of focus extends 50 percent in front of and 50 percent behind the focus point. Other lenses vary.

Diffusion flat. A portable, translucent diffuser that can be positioned in a window frame or near the subject to diffuse the light striking the subject.

Dodging. Darkroom technique in which specific areas of the print are given less exposure by blocking the light to those areas of the print, making them lighter. Simulated in Photoshop by the dodge tool.

Dope. Retouching medium that is often applied to negatives to give them a suitable retouching surface.

Dragging the shutter. Using a shutter speed slower than the X-sync speed in order to capture the ambient light in a scene.

E.I. (Exposure Index). The term refers to a film speed other than the rated ISO of the film.

Embedding. The process of including a color profile as part of the data within an image file.

Etching. A subtractive retouching technique that is used to selectively reduce density in an area of the negative.

Fashion lighting. A shadowless type of lighting that is created by placing the main light on the lens axis. Fashion lighting is usually very soft in quality.

Feathering a light. Misdirecting the light deliberately so that the edge of the beam of light illuminates the subject.

Fill card. A white or silver foil–covered card used to reflect light back into the shadow areas of the subject.

Fill light. A secondary light source used to illuminate the shadows created by the key light.

Flash fill. A flash technique that uses electronic flash to fill in the shadows created by the main light source.

Flashing. A darkroom technique used in printing to darken an area of the print by exposing it to raw light. The same technique can be achieved in Photoshop using a transparent vignette.

Flash key. A technique in which the flash becomes the main light source and the ambient light in the scene fills the shadows created by the flash.

Flashmeter. A handheld incident light meter that measures both the ambient light of a scene and, when connected to an electronic flash, will read flash only or a combination of flash and ambient light. This is invaluable for determining outdoor flash exposures and lighting ratios.

Focusing an umbrella. Adjusting the distance between the light source and inside surface of an umbrella to optimize light output.

Foreshortening. A distortion of normal perspective caused by close proximity of the camera/lens to the subject. Foreshortening exaggerates subject features—noses appear elongated, chins jut out, and the backs of heads may appear smaller than normal.

45-degree lighting. A portrait lighting pattern that is characterized by a triangular highlight on the shadow side of the face. Also known as Rembrandt lighting.

Full-length portrait. A pose that includes the full figure of the model. Full-length portraits can show the subject standing, seated, or reclining.

Furrows. The vertical grooves in the face adjacent to the mouth. Furrows are made deeper when the subject smiles. Often called laugh lines.

Gaussian blur. Photoshop filter that diffuses a digital image.

Gobo. A light-blocking card that is supported on a stand or boom and positioned between the light source and subject to selectively block light from portions of the scene.

Golden mean. A rule of composition that provides a guideline for the most dynamic area in which to place the subject. Determined by drawing a diagonal line from one corner of the frame to the other, then drawing a line from either remaining corner of the frame so that the diagonal is intersected perpendicularly.

Grayscale. A color model consisting of up to 254 shades of gray plus absolute black and absolute white. Every pixel of a grayscale image displays as a brightness value ranging from 0 (black) to 255 (white). Grayscale values can also be measured as percentages of black ink coverage (0 percent is equal to white, 100 percent is equal to black). The exact range of grays represented in a grayscale image can vary.

Head-and-shoulder axis. Imaginary lines running horizontally through the shoulders (shoulder axis) and vertically down the ridge of the nose (head axis). These lines should never be perpendicular to the line of the lens axis.

High-key lighting. A type of lighting characterized by a low lighting ratio and a predominance of light tones.

Highlight brilliance. Refers to the specularity of highlights on the skin. A negative with good highlight brilliance shows specular highlights (paper base white) within a major highlight area. This is achieved through good lighting and exposure techniques.

Histogram. A graphic representation (unique for each image) that indicates the number of pixels that exist for each brightness level. The range of the histogram extends from "absolute" black (on the left) to "absolute" white (on the right).

Hot spot. A highlight area of the negative that is overexposed and without detail. In film photography, these areas can sometimes be etched down to a printable density.

ICC Profile. Device-specific information that describes how the device behaves in terms of color density and color gamut. Since all devices perform differently where color is concerned, profiles enable the color management system to convert device-dependent colors into or out of each specific color space based on the profile for each component in the workflow. ICC profiles can utilize a device-independent color space to act as a translator between two or more different devices.

Incident light meter. A handheld light meter that measures the amount of light falling on its light-sensitive dome.

JPEG. JPEG (an acronym for Joint Photographic Experts Group) is an image file format with various compression levels. The higher the compression rate, the lower the image quality, when the file is expanded (restored). Although there are types of JPEG formatting that employ lossless compression (like JPEG 2000 and JPEG-LS), the most commonly used forms of JPEG employ lossy compression algorithms, which discard varying amounts of the original image data in order to reduce the file storage size.

Key light. The main light in portraiture used to establish the lighting pattern and define the facial features of the subject.

Kicker. A light coming from behind the subject that highlights the hair or contour of the body.

Lead-in line. In compositions, a pleasing line in the scene that leads the viewer's eye toward the main subject.

Lens circle. The area of focused light rays falling on the film plane or digital imaging chip.

Levels. A tool in Photoshop that allows you to correct the tonal range and color balance of an image.

Lighting ratio. The difference in intensity between the highlight side of the face and the shadow side of the face. A 3:1 ratio implies that the highlight side is three times brighter than the shadow side of the face.

Loop lighting. A portrait lighting pattern characterized by a loop-like shadow on the shadow side of the subject's face. This differs from Paramount or butterfly lighting because the main light is slightly lower and farther to the side of the subject.

Low-key lighting. A type of lighting characterized by a high lighting ratio and strong scene contrast as well as a predominance of dark tones.

Main light. Synonymous with key light.

Mask. In Photoshop, an adjustment tool that allows you to isolate areas of an image as you apply color changes, filters, or other effects to the overall image. When you select part of an image, the area that is not selected is "masked" or protected from editing.

Matte box. A lens accessory with retractable bellows that holds filters, masks, and vignettes for modifying the image.

Modeling light. A secondary light mounted in the center of a studio flash head that gives a close approximation of the lighting that the flash tube will produce. Usually, modeling lights employ high intensity, low heat-output quartz bulbs.

Optimum lens aperture. The aperture on a lens that produces the sharpest image. It is usually two stops stopped down from wide open. If the maximum aperture is f/2.8, for example, the optimum aperture would be f/5.6.

Over-lighting. A condition that occurs when the main light is either too close to the subject or too intense. This excessive light makes it impossible to record detail in highlighted areas. This is best corrected by feathering the light or moving it back from the subject.

Parabolic reflector. An oval-shaped dish that houses a light and directs its beam outward in an even and controlled manner.

Paramount lighting. One of the basic portrait lighting patterns, Paramount lighting is characterized by a key light placed high and directly in line with the subject's nose. This lighting produces a butterfly-like shadow under the nose. Also called butterfly lighting.

Perspective. The appearance of objects in a scene as determined by their relative distance and position.

Pixel (picture element). The smallest element used to form a digital image.

Point light source. A small light source, like the sun, which produces sharp-edged shadows without diffusion.

Print driver. Software that interprets data from a device, usually a computer, into instructions that a specific printer uses to create a graphical representation of that data on paper or other media.

Profiling. The method by which the color reproduction characteristics of a device are measured and recorded in a standardized fashion. Profiles are used to ensure color consistency in throughout the digital workflow.

PSD. The default file format in Photoshop. The PSD format saves all image layers created within the file.

Push-processing. Extended development of film, sometimes in a special developer, that increases the effective speed of the film.

RAW file. A file format that records the picture data from a digital sensor without applying any in-camera corrections. In order to use images recorded in the RAW format, the files must first be processed by compatible software. RAW processing includes the option to adjust exposure, white balance, and color of the image, all the while leaving the original RAW picture data unchanged.

Reflected light meter. A meter that measures the amount of light reflected from a surface or scene. All in-camera meters are of the reflected type.

Reflector. (1) Same as fill card. (2) A housing on a light that reflects the light outward in a controlled beam.

Rembrandt lighting. Same as 45-degree lighting.

RGB. A color mode common in digital imaging in which all of the colors in an image are made up of varying shades of red (R), green (G), and blue (B) used in combination with each other.

Rim lighting. Portrait lighting pattern where the key light is placed behind the subject and illuminates the edge of the subject. This is most often used with profile poses.

Rule of thirds. A guideline for composition that divides the image area into thirds, horizontally and vertically. The intersection of any two lines in this resulting grid is considered a dynamic point where the subject can be placed for the most visual impact.

Scrim. A panel used to diffuse sunlight. Scrims can be mounted in panels and set in windows, used on stands, or they can be suspended in front of a light source to diffuse the light.

Seven-eighths view. Facial pose that shows approximately seven-eighths of the face. Almost a full-face view as seen from the camera.

Sharpening. In Photoshop, filters that increase apparent sharpness of an image by increasing the contrast of adjacent pixels within it.

Short lighting. One of two basic types of portrait lighting. In short lighting, the key light illuminates the side of the face turned away from the camera.

Slave. A remote triggering device used to fire auxiliary flash units. These may be optical or radio-controlled.

Softbox. Same as a box light. It can contain one or more light heads and employ either a single or double-diffused scrim.

Soft-focus lens. A special lens that uses spherical or chromatic aberration in its design to diffuse the image points.

Specular highlights. Very small, bright highlights.

Split lighting. A type of portrait lighting that splits the face into two distinct areas: a shadow side and a highlight side. The key light is placed far to the side of the subject and slightly higher than the subject's head height.

Straight flash. The light of an on-camera flash unit that is used without diffusion.

Subtractive fill-in. Lighting technique that uses a black card to subtract light out of a subject area in order to create a better defined lighting ratio. Also refers to the placement of a black card over the subject in outdoor portraiture to make the light more frontal and less overhead.

Three-quarter-length pose. A pose that includes all but the lower portion of the subject's anatomy. This can be from above the knees and up, or below the knees and up.

Three-quarter view. A facial pose that allows the camera to see three-quarters of the facial area. The subject's face is usually turned 45-degrees away from the lens so that the far ear disappears from the camera view.

TIFF. A file format commonly used for digital images. TIFF files employ lossless compression, meaning that no matter how many times they are opened and closed, the data remains the same (unlike JPEG files, which are designated as lossy files, meaning that data is lost each time the files are re-saved).

Tooth. Refers to a negative that has a built-in retouching surface that will accept retouching leads.

TTL-balanced fill flash. A flash exposure system that reads the flash exposure through the camera lens and adjusts the flash output relative to the ambient light for a balanced flash–ambient exposure.

Umbrella lighting. A type of soft lighting that uses one or more photographic umbrellas to diffuse the light source(s).

Unsharp mask. A sharpening tool in Adobe Photoshop that is usually the last step in preparing an image for printing.

Vignette. A semicircular, soft-edged border around the main subject. Vignettes can be either light or dark in tone and can be included at the time of shooting, or added later in printing or in Photoshop.

Watt-seconds. Numerical system used to rate the power output of electronic flash units. This is primarily used to rate studio strobe systems.

Wraparound lighting. A soft type of light that wraps around subjects to produce a low lighting ratio and open, well-illuminated highlight areas.

Index

COLOR CORRECTION AND ENHANCEMENT WITH ADOBE® PHOTOSHOP®

Michelle Perkins

Master precision color correction and artistic color enhancement techniques for scanned and digital photos. $29.95 list, 8½x11, 128p, 300 color images, index, order no. 1776.

POWER MARKETING FOR WEDDING AND PORTRAIT PHOTOGRAPHERS

Mitche Graf

Set your business apart and create clients for life with this comprehensive guide to achieving your professional goals. $29.95 list, 8½x11, 128p, 100 color images, index, order no. 1788.

BEGINNER'S GUIDE TO ADOBE® PHOTOSHOP® ELEMENTS®

Michelle Perkins

Packed with easy lessons for improving virtually every aspect of your images—from color balance, to creative effects, and more. $29.95 list, 8½x11, 128p, 300 color images, index, order no. 1790.

BEGINNER'S GUIDE TO PHOTOGRAPHIC LIGHTING

Don Marr

Create high-impact photographs of any subject with Marr's simple techniques. From edgy and dynamic to subdued and natural, this book will show you how to get the myriad effects you're after. $29.95 list, 8½x11, 128p, 150 color photos, index, order no. 1785.

POSING FOR PORTRAIT PHOTOGRAPHY

A HEAD-TO-TOE GUIDE

Jeff Smith

Author Jeff Smith teaches surefire techniques for fine-tuning every aspect of the pose for the most flattering results. $34.95 list, 8½x11, 128p, 150 color photos, index, order no. 1786.

PROFESSIONAL MODEL PORTFOLIOS

A STEP-BY-STEP GUIDE FOR PHOTOGRAPHERS

Billy Pegram

Learn how to create dazzling portfolios that will get your clients noticed—and hired! $34.95 list, 8½x11, 128p, 100 color images, index, order no. 1789.

MASTER LIGHTING GUIDE

FOR PORTRAIT PHOTOGRAPHERS

Christopher Grey

Efficiently light executive and model portraits, high and low key images, and more. Master traditional lighting styles and use creative modi-fications that will maximize your results. $29.95 list, 8½x11, 128p, 300 color photos, index, order no. 1778.

INTO YOUR DIGITAL DARKROOM STEP BY STEP

Peter Cope

Make the most of every image—digital or film—with these techniques for photographers. Learn to enhance color, add special effects, and much more. $29.95 list, 8½x11, 128p, 300 color images, index, order no. 1794.

LIGHTING TECHNIQUES FOR

FASHION AND GLAMOUR PHOTOGRAPHY

Stephen A. Dantzig, PsyD.

In fashion and glamour photography, light is the key to producing images with impact. With these techniques, you'll be primed for success! $29.95 list, 8½x11, 128p, over 200 color images, index, order no. 1795.

WEDDING AND PORTRAIT PHOTOGRAPHERS' LEGAL HANDBOOK

N. Phillips and C. Nudo, Esq.

Don't leave yourself exposed! Sample forms and practical discussions help you protect yourself and your business. $29.95 list, 8½x11, 128p, 25 sample forms, index, order no. 1796.

Also by Bill Hurter . . .

THE BEST OF FAMILY PORTRAIT PHOTOGRAPHY

An array of acclaimed professional photographers reveal the secrets behind their most successful family portraits. This book is packed with award-winning portraits and failsafe techniques you'll rely on time and again. $34.95 list, 8½x11, 128p, 150 color photos, index, order no. 1812.

THE BEST OF WEDDING PHOTOJOURNALISM

Learn how the industry's top professionals capture these fleeting moments of laughter, tears, and romance. Features images from over twenty renowned wedding photographers. $34.95 list, 8½x11, 128p, 150 color photos, index, order no. 1774.

THE BEST OF PHOTOGRAPHIC LIGHTING

Top professionals reveal the secrets behind their successful strategies for producing and capturing unforgettable, high-impact studio, location, and outdoor lighting. This must-have book is packed with tips for portraits, still lifes, and more. $34.95 list, 8½x11, 128p, 150 color photos, index, order no. 1808.

THE BEST OF ADOBE® PHOTOSHOP®

Bill Hurter

Rangefinder editor Bill Hurter calls on the industry's top photographers to share their strategies for using Photoshop to intensify and sculpt their images. No matter your specialty, you'll find inspiration here. $34.95 list, 8½x11, 128p, 170 color photos, 10 screen shots, index, order no. 1818.

THE BEST OF PROFESSIONAL DIGITAL PHOTOGRAPHY

Digital imaging has a stronghold on the photographic industry. This book spotlights the methods that world-renowned photographers use to create their standout images. $34.95 list, 8½x11, 128p, 180 color photos, 20 screen shots, index, order no. 1824.

RANGEFINDER'S PROFESSIONAL PHOTOGRAPHY

edited by Bill Hurter

Hurter shares over one hundred "recipes" from *Rangefinder's* ever-popular cookbook series, showing you how to shoot, pose, light, and edit fabulous images. $34.95 list, 8½x11, 128p, 150 color photos, index, order no. 1828.

PROFITABLE PORTRAITS

THE PHOTOGRAPHER'S GUIDE TO CREATING PORTRAITS THAT SELL

Jeff Smith

Learn how to design images that are precisely tailored to your clients' tastes—portraits that will practically sell themselves! $29.95 list, 8½x11, 128p, 100 color photos, index, order no. 1797.

ARTISTIC TECHNIQUES WITH ADOBE® PHOTOSHOP® AND COREL® PAINTER®

Deborah Lynn Ferro

Flex your creative skills and learn how to transform photographs into fine-art masterpieces. Step-by-step techniques make it easy! $34.95 list, 8½x11, 128p, 200 color images, index, order no. 1806.

MARKETING & SELLING TECHNIQUES

FOR DIGITAL PORTRAIT PHOTOGRAPHY

Kathleen Hawkins

Great portraits aren't enough to ensure the success of your business! Learn how to attract clients and boost your sales. $34.95 list, 8½x11, 128p, 150 color photos, index, order no. 1804.

MASTER GUIDE FOR UNDERWATER DIGITAL PHOTOGRAPHY

Jack and Sue Drafahl

Make the most of your underwater digital photography! Jack and Sue Drafahl take you from equipment selection to underwater shooting techniques. $34.95 list, 8½x11, 128p, 250 color images, index, order no. 1807.

DIGITAL PHOTOGRAPHY BOOT CAMP

Kevin Kubota

Kevin Kubota's popular workshop is now a book! A down-and-dirty, step-by-step course in building a professional photography workflow and creating digital images that sell! $34.95 list, 8½x11, 128p, 250 color images, index, order no. 1809.

PROFESSIONAL POSING TECHNIQUES FOR WEDDING AND PORTRAIT PHOTOGRAPHERS

Norman Phillips

Master the techniques you need to pose subjects successfully—whether you are working with men, women, children, or groups. $34.95 list, 8½x11, 128p, 260 color photos, index, order no. 1810.

BLACK & WHITE PHOTOGRAPHY TECHNIQUES WITH ADOBE® PHOTOSHOP®

Maurice Hamilton

Become a master of the black & white digital darkroom! Covers all the skills required to perfect your black & white images and produce dazzling fine-art prints. $34.95 list, 8½x11, 128p, 150 color/b&w images, index, order no. 1813.

NIGHT AND LOW-LIGHT TECHNIQUES FOR DIGITAL PHOTOGRAPHY

Peter Cope

With even simple point-and-shoot digital cameras, you can create dazzling nighttime photos. Get started quickly with this step-by-step guide. $34.95 list, 8½x11, 128p, 100 color photos, index, order no. 1814.

PROFESSIONAL MARKETING & SELLING TECHNIQUES FOR DIGITAL WEDDING PHOTOGRAPHERS, SECOND EDITION

Jeff Hawkins and Kathleen Hawkins

Taking great photos isn't enough to ensure success! Become a master marketer and salesperson with these easy techniques. $34.95 list, 8½x11, 128p, 150 color photos, index, order no. 1815.

MASTER COMPOSITION GUIDE FOR DIGITAL PHOTOGRAPHERS

Ernst Wildi

Composition can truly make or break an image. Master photographer Ernst Wildi shows you how to analyze your scene or subject and produce the best-possible image. $34.95 list, 8½x11, 128p, 150 color photos, index, order no. 1817.

HOW TO CREATE A HIGH PROFIT PHOTOGRAPHY BUSINESS IN ANY MARKET

James Williams

Whether your studio is located in a rural or urban area, you'll learn to identify your ideal client type, create the images they want, and watch your financial and artistic dreams spring to life! $34.95 list, 8½x11, 128p, 200 color photos, index, order no. 1819.

ADVANCED STUDIO LIGHTING TECHNIQUES FOR DIGITAL PORTRAIT PHOTOGRAPHERS

Norman Phillips

Learn the simple tips and techniques that allow you to adapt your traditional lighting setups to create high-impact, cutting-edge portraits with a fine-art feel. $34.95 list, 8½x11, 128p, 126 color photos, diagrams, index, order no. 1822.

BEGINNER'S GUIDE TO ADOBE® PHOTOSHOP®, 3rd Ed.

Michelle Perkins

Enhance your photos, create original artwork, or add unique effects to any image. Topics are presented in short, easy-to-digest sections that will boost confidence and ensure outstanding images. $34.95 list, 8½x11, 128p, 80 color images, 120 screen shots, order no. 1823.

ADOBE® PHOTOSHOP® FOR UNDERWATER PHOTOGRAPHERS

Jack and Sue Drafahl

In this sequel to *Digital Imaging for the Underwater Photographer*, Jack and Sue Drafahl show you advanced techniques for solving a wide range of image problems that are unique to underwater photography. $39.95 list, 6x9, 224p, 100 color photos, 120 screen shots, index, order no. 1825.

PROFESSIONAL PORTRAIT LIGHTING TECHNIQUES AND IMAGES FROM MASTER PHOTOGRAPHERS

Michelle Perkins

Get a behind-the-scenes look at the lighting techniques employed by the world's top portrait photographers. Includes techniques for fashion, glamour, and wedding portraiture, both in the studio and on location. $34.95 list, 8½x11, 128p, 200 color photos, index, order no. 2000.

By Photographers Featured in this Book . . .

PORTRAIT PHOTOGRAPHY

THE ART OF SEEING LIGHT

Don Blair with Peter Skinner

Learn to harness the best light both in studio and on location, and get the secrets behind the magical portraiture captured by this award-winning, seasoned pro. $29.95 list, 8½x11, 128p, 100 color photos, index, order no. 1783.

WEDDING PHOTOGRAPHY

CREATIVE TECHNIQUES FOR LIGHTING, POSING, AND MARKETING, *3rd Ed.*

Rick Ferro

Creative techniques for lighting and posing wedding portraits that will set your work apart from the competition. Covers every phase of wedding photography. $29.95 list, 8½x11, 128p, 80 color photos, index, order no. 1649.

WEDDING PHOTOGRAPHY WITH ADOBE® PHOTOSHOP®

Rick Ferro and Deborah Lynn Ferro

Get the skills you need to make your images look their best, add artistic effects, and boost your wedding photography sales with savvy marketing ideas. $34.95 list, 8½x11, 128p, 100 color images, index, order no. 1753.

MASTER LIGHTING TECHNIQUES

FOR OUTDOOR AND LOCATION DIGITAL PORTRAIT PHOTOGRAPHY

Stephen A. Dantzig

Learn how to use natural light alone or with flash fill, barebulb, and strobes to create perfect portraits all day long. $34.95 list, 8½x11, 128p, 175 color photos, diagrams, index, order no. 1821.

CLASSIC PORTRAIT PHOTOGRAPHY

Bill McIntosh

Acclaimed portrait photographer Bill McIntosh shows you the qualities that make an image a classic—a work of art that will never go out of style. $29.95 list, 8½x11, 128p, 100 color images, index, order no. 1784.

PROFESSIONAL PHOTOGRAPHER'S GUIDE TO

SUCCESS IN PRINT COMPETITION

Patrick Rice

Learn from PPA and WPPI judges how you can improve your print presentations and increase your scores. $29.95 list, 8½x11, 128p, 100 color photos, index, order no. 1754.

DIGITAL INFRARED PHOTOGRAPHY

Patrick Rice

The dramatic look of infrared photography has long made it popular—but with digital it's actually *easy* too! Add digital IR to your repertoire with this comprehensive book. $29.95 list, 8½x11, 128p, 100 b&w and color photos, index, order no. 1792.

MASTER GUIDE

FOR PROFESSIONAL PHOTOGRAPHERS

Patrick Rice

Turn your hobby into a thriving profession. This book covers equipment essentials, capture strategies, lighting, posing, digital effects, and more, providing a solid footing for a successful career. $34.95 list, 8½x11, 128p, 200 color images, order no. 1830.

FANTASY PORTRAIT PHOTOGRAPHY

Kimarie Richardson

Learn how to create stunning portraits with fantasy themes—from fairies and angels, to 1940s glamour shots. Includes portrait ideas for infants through adults. $29.95 list, 8½x11, 128p, 60 color photos index, order no. 1777.

MASTER POSING GUIDE

FOR CHILDREN'S PORTRAIT PHOTOGRAPHY

Norman Phillips

Create perfect portraits of infants, tots, kids, and teens. Includes techniques for standing, sitting, and floor poses for boys and girls, individuals, and groups. $34.95 list, 8½x11, 128p, 305 color images, order no. 1826.

LEGAL HANDBOOK FOR PHOTOGRAPHERS, 2nd Ed.

Bert P. Krages, Esq.

Learn what you can and cannot photograph, how to handle conflicts should they arise, how to protect your rights to your images in the digital age, and more. $34.95 list, 8½x11, 128p, 80 b&w photos, index, order no. 1829.

PROFESSIONAL FILTER TECHNIQUES
FOR DIGITAL PHOTOGRAPHERS

Stan Sholik

Select the best filter options for your photographic style and discover how their use will affect your images. $34.95 list, 8½x11, 128p, 150 color images, index, order no. 1831.

MASTER'S GUIDE TO WEDDING PHOTOGRAPHY
CAPTURING UNFORGETTABLE MOMENTS AND LASTING IMPRESSIONS

Marcus Bell

Learn to capture the unique energy and mood of each wedding and build a lifelong client relationship. $34.95 list, 8½x11, 128p, 200 color photos, index, order no. 1832.

MASTER LIGHTING GUIDE
FOR COMMERCIAL PHOTOGRAPHERS

Robert Morrissey

Learn to use the tools and techniques the pros rely upon to land corporate clients. Includes diagrams, images, and techniques for a failsafe approach to creating shots that sell. $34.95 list, 8½x11, 128p, 110 color photos, 125 diagrams, index, order no. 1833.

DIGITAL CAPTURE AND WORKFLOW
FOR PROFESSIONAL PHOTOGRAPHERS

Tom Lee

Cut your image-processing time by fine-tuning your workflow. Includes tips for working with Photoshop and Adobe Bridge, plus framing, matting, and more. $34.95 list, 8½x11, 128p, 150 color images, index, order no. 1835.

THE ART OF BRIDAL PORTRAIT PHOTOGRAPHY

Marty Seefer

Learn to give every client your best and create timeless images that are sure to become family heirlooms. Seefer takes readers through every step of the bridal shoot, ensuring flawless results. $29.95 list, 8½x11, 128p, 70 color photos, order no. 1730.

CORRECTIVE LIGHTING, POSING & RETOUCHING FOR
DIGITAL PORTRAIT PHOTOGRAPHERS, 2nd Ed.

Jeff Smith

Learn to make every client look his or her best by using lighting and posing to conceal real or imagined flaws—from baldness, to acne, to figure flaws. $34.95 list, 8½x11, 120p, 150 color photos, order no. 1711.

MASTER POSING GUIDE FOR PORTRAIT PHOTOGRAPHERS

J. D. Wacker

Learn the techniques you need to pose single portrait subjects, couples, and groups for studio or location portraits. Includes techniques for photographing weddings, teams, children, special events, and much more. $34.95 list, 8½x11, 128p, 80 photos, order no. 1722.

POSING AND LIGHTING TECHNIQUES FOR STUDIO PHOTOGRAPHERS

J. J. Allen

Master the skills you need to create beautiful lighting for portraits. Posing techniques for flattering, classic images help turn every portrait into a work of art. $34.95 list, 8½x11, 120p, 125 color photos, order no. 1697.